WHAT PEOPLE ARE SAYING ABOUT

INCOMPATIBLE BALLERINA AND OTHER ESSAYS

Bewildering, provocative, insightful and in places brilliant, Johns' relentless writing style leaves the reader gasping for air, yet carried along seamlessly into chaos. The term chaos though, is hardly pejorative and possibly undeserving of the clearly high level of erudition that underpins the work. Reminiscent of Deleuze yet peculiarly its own thing, this book is a worthy addition to the ongoing discussions of Desire, the non-human, and the meaning of thinking.
Graham Freestone, co-founder and director of The Lincoln Philosophy Forum Group

Very interesting and well-written.
Hedi El Kholti, Semiotexte

Philosophically astute, rigorous and creative writing.
Simon O'Sullivan, Senior Lecturer at Goldsmiths College London and author of *Art Encounters Deleuze and Guattari: Thought Beyond Representation* and *On the Production of Subjectivity: Five Diagrams of the Finite-Infinite Relation* (Palgrave Macmillan)

A compelling read!
Kirsten Wilkinson, Executive Director, Dance Legacies Worldwide

Charlie seeks to capture something which ultimately cannot be captured but the process is informed with rare philosophical intelligence and insight.
Mike Gothorp, Head of Philosophy, Lincoln College U.K.

This is what Charlie's book is helping us with. We may start to see the beauty of our own momentum, wherever we are. He explores as a philosopher: to show the dark edges to the light and the light edges to the dark – and how these become part of his personal neurosis... We should reclaim it as researchers, as philosophers, as people; we should note our values, we should experience their absence and we should intensify our thinking.

Gerard de Zeeuw
Emeritus Professor of Mathematical Modelling in the social sciences, University of Amsterdam
Emeritus Professor of Social Work and Adult Education, University of Amsterdam
Ex-visiting Professor of Systems, Research and other topics, University of Wageningen, University of Lincoln
Senior Professor of architectural design research, University of Leuven

When William Cullen, professor of medicine in Edinburgh and a celebrated philosopher in his own right (he founded the Royal Charter for the Philosophical Society, the predecessor of the Royal Society, and was the personal physician of David Hume) coined the term 'neurosis' and defined it as 'a disorder of sense and motion caused by general affection' in the eighteenth century, he could not have foreseen that at the start of the twenty-first century a young philosopher would take this concept as the basis of his reflections. But this is exactly what Charlie Johns has done. Feeling that his thoughts are determined by fundamental neurosis, he manages to reflect on a variety of themes with great insight. The reader of these four essays will find philosophical explorations of most important human themes such as desire (which he considers – as Freud does – to be the main constituting factor of man), power, language, values, morality, and finally death (the clearest opposition of desire). At the same time the constant theme of freedom comes up and the question is raised to

what extent we are enslaved in a capitalist system that inhibits 'the Real Self' (in a Winnicottian sense) – Man then becomes a 'body without organs', acting as a 'desiring machine', as Gilles Deleuze would call it. Throughout this book, the writer quotes or refers to the great thinkers of Western Philosophy, which is enriching in itself.

As one, privileged enough to be the author's fellow-participant in the discussions of the Philosophy Forum at the University of Lincoln, I am pleased that Charlie has been able to activate his neurosis, and have us share his personal as well as academic thoughts. From time to time readers may feel challenged in their beliefs, but was it not likewise Socrates, under the name of philosophy, who challenged engrained opinions, provoking genuine and authentic thinking?

Dr Frans Lohman
Clinical Psychologist/Psychotherapist and visiting senior fellow at University of Lincoln. Latest article: Lohman, F. (2014) Hubris in Greek Philosophy, in 1914 and 2014. Paper presented at the 26th

Incompatible Ballerina and Other Essays

Incompatible Ballerina and Other Essays

Charles William Johns

Forewords by Graham Freestone
and Kirsten Wilkinson

Winchester, UK
Washington, USA

First published by iff Books, 2015
iff Books is an imprint of John Hunt Publishing Ltd., Laurel House, Station Approach,
Alresford, Hants, SO24 9JH, UK
office1@jhpbooks.net
www.johnhuntpublishing.com
www.iff-books.com

For distributor details and how to order please visit the 'Ordering' section on our website.

Text copyright: Charles William Johns 2015

ISBN: 978 1 78279 875 0
Library of Congress Control Number: 2015933325

A CIP catalogue record for this book is available from the British Library.

Design: Lee Nash

Printed and bound by CPI Group (UK) Ltd, Croydon, CRO 4YY, UK

We operate a distinctive and ethical publishing philosophy in all
areas of our business, from our global network of authors to
production and worldwide distribution.

CONTENTS

The anguish of the neurotic individual is the same as that of the saint. The neurotic, the saint are engaged in the same battle. Their blood flows from similar wounds. But the first one gasps and the other one gives.
Georges Bataille (1897 – 1962)

We photograph things in order to drive them out of our minds. My stories are a way of shutting my eyes.
Roland Barthes quoting Franz Kafka

Kierkegaard, the Danish philosopher fell in love with an attractive girl, Regine Olsen, and then he had concluded that they would be incompatible, that the love was mistaken, that he himself was so complex and she was simple, and he contrived to break the engagement so as to give the appearance that it was the young lady's fault, not his.

He succeeded in breaking the engagement, in never marrying her. Cowardice was probably involved here. Kierkegaard wished to believe that the fault lay with the nature of love itself, the problem of love, its fate in his life. From the personal he extrapolated to the general. A philosopher's trick. Regine married another man and moved away from Copenhagen to the West Indies, but Kierkegaard, the knight of faith, carried a burning torch for her, in the form of his philosophy, the rest of his days. This is madness of a complex lifelong variety. He spent his career writing philosophy that would, among other things, justify his actions towards Regine Olsen. He died of a warped spine.
Charles Baxter

'Philosophy' (one form of neurosis) is the proper place for *thinking* neurosis. It is there where one form of thinking conflicts with another. It is there where the determination of thought, its process, judgement and project, collide with another – the hysterical rebellious 'subject' who attempts to out-think this very medium of thought itself (fighting fire with fire, or, neurosis with neurosis). The construction of this division, between subject and environment, activity and passivity, response and stimulus is yet another form of neurosis (one that we blindly obey and one which produces prolific results). The victor of this battle, hence, is neither the autonomy of the 'subject' nor the conditions and vectors of this determinate terrain of thought, but rather whichever thought is most pervasive and intensive; whichever thought process gives rise to the continuation and orientation of life. In short – whichever neurosis ascends and triumphs as *the picture of consciousness we follow*.

It is sometimes a pleasure to follow the slipstream of neurosis (how the painter mobilises neurosis, how the sports player enacts neurosis, how the psychoanalyst diagnoses neurosis) but observing its creation/assimilation can also be quite daunting and exhausting (to know that you are always connected to it even whilst you attempt to diverge, hide or leap from it).

I admire neurosis and wish to liberate it from its limited psychoanalytic instantiation and its relation to a purely human picture of consciousness-thought, process and activity. However I too wish to rid myself of its power from time to time (like Barthes and Kafka) precisely because no-one would wish to 'have' it; we do not want to give it a home within us, and in this sense it is lonely and lost.

Charles Johns (18/11/14)

Acknowledgements

I would like to thank the following people, in no particular order: Kirsten Wilkinson, Graham Freestone, Nik Farell Fox, Gerard de Zeeuw, Roderick Orner, Frans Lohman, Leon Niemoczynski, Raymond Brassier, Simon O' Sullivan, Edgar Schmitz, Leonard Lawlor, Hedi El Kholti at Semiotexte, everyone at John Hunt Publishing (especially my personal publishing team at IFF), Eileen Joy at Punctum Books, Mike Gothorp and Ties Nijssen of Springer Publishing. Special thanks to Mr Jan Timmer of the Center for Innovation and Cooperative Technology for backing the publication of the book through the C.I.C.T Support Fund. Many thanks to the financial and intellectual support given to me by the members of the Lincoln Philosophy Forum.

For any enquiries you can email me at:
cwjohns@hotmail.co.uk

Neurotic Ontology

I have drunk quite a lot of tea with Charlie Johns. In almost equal degree I have comprehended and failed to comprehend what he attempts to convey – though in both cases I have been left exhilarated by the conversations. The intensity of these encounters is here inscribed in this text – both in this response to it and his essays. Indeed the way in which this foreword feeds off the text is reminiscent of the neurotic/assimilative process. That is, as I have assimilated in part through my own neurotic nature the material herein, it infects my own neuroses, attaches too, feeds them and feeds off them; it breeds with them and spawns new ideas which in turn mutate and take flight (Deleuze rejected dialectics but possibly he missed the desiring status of the neurotic vector itself, the violent sexualised proliferation of the concept).

But what is this neurotic/assimilative action of which he speaks? Assimilation is probably the more comprehensible of the two concepts. Beings assimilate each other on multiple horizons: comestible, physical (forceful interactions), informational, through perception and spoken/written language (it will be understood here that beings may be material or immaterial). However, it is then the first of these two terms that we must really attempt to address, for without forging some idea of what neurosis is, the work will become nigh on impossible to comprehend or indeed assimilate. So, we can establish beings assimilate beings, but it is neurosis that determines what the beings will assimilate.

Neurosis [for Johns], is a concept that must no longer be considered a psychological/pathological condition; rather the work attempts to create a lens through which the Neurotic is seen as the most appropriate way to conceive of Being. That is,

neurosis is taken to be an ontological category. This does not discount the psychological phenomenon, indeed in my interpretation, the psychological phenomenon of neurosis is the clue to the ontological. I see it as something akin to a transcendental argument in which the everyday (ontic) manifestation of neurosis has as the condition of its possibility a wider neurotic force.

In this way neurosis spills speculatively out of its psychological home into its quasi-transcendental status. Its hypostasis reveals it as a force greater than the individual psyche; ironically of course its hypostasis is uncovered by its own action [neurosis is neurotically disclosed]. This force is essentially unhuman, yet it is ironically brought to its highest manifestation in the paradox of the human subject. We might say that the individual history of the subject, in all its joy and trauma, has the possibility to transcend itself by tapping into the power of neurosis. At one stage in this process it will seem as if the process is being done by the subject itself, but in the final overcoming it is the neurosis itself that speaks, not Man: think of Being in Heidegger or Will-to-Power in Nietzsche, even logic in Russell.

In making this claim, we can immediately see the breadth that neurosis must cover: language, desire, philosophy, science; it becomes impossible to escape it, for either in conscious or materialist mode, the relentless movement of the different planes of being can be perceived in this way: guiding the assimilation. So is neurosis supposed to be an illuminating apophansis, or does it aim to be the supreme category of Being? I think we must go with the former (and this is not to deprecate the concept), for all putative concepts set themselves against other illuminating disclosures, and the criteria by which we might differentiate between them are impossible to discern (though historical movements disclose some as more important than others). That being said it will be instructive to dwell on this matter with regard to another philosopher of restless motion, i.e. Hegel

Is there any sense of identity between neurosis/assimilation

and the dialectic, if purely as a heuristic aid to comprehension? Well before language falls through our fingers, let us say these concepts are not equivalent but that there is a certain family resemblance. The dialectic is not insane enough, or at least the normal interpretation of the dialectic does not usually convey the obsessive nature that is clearly implied by neurosis. The most cogent sense I find between the two is that in which the Hegelian concept exposes itself to its own incoherencies. The sad result of this attempt at greater coherence is of course the unceasing gnawing of a given notion upon itself – its own destruction ('a bit like a little creature that gets put into a box full of other creatures and eventually is eaten to death.'). The concept's autosarcophagy, its autoassimilation, is ultimately the birth of the subject – the suffering idea brings forth the subject (this is at least how I come to comprehend parts of the Lost and the Lonely).

Possibly a more accurate description of the state of affairs – from the text's perspective – would be to say that dialectical understanding is the product of neurosis: it is the form neurosis took in the overcoming of Hegel (as neurotic vehicle). Simultaneously we must grant that the coming into being of neurosis is also conceivable as the product of certain dialectical processes. Indeed we can conceive of it as the conversion of the earlier mentioned transcendental move (neurosis as the condition of possibility) into the inadequacy of the neurosis (as psychological condition) to withstand its own conceptual boundaries, thus transmuting itself into neurosis.

As it happens I do have a concern in this area, for in moving from the psychological condition to the ontological I feel we are drawn into taking another concept with us: the concept of psychosis. The neurotic, by definition, has an awareness of his/her obsession, the psychotic does not. To this end, whilst I see the apophantic value of neurosis, I end up seeing it largely as forming consciousness and self-consciousness and seeing the possibility of an ontological psychosis driving putatively unconscious and

material forces – this is an unfinished debate I have had with Charlie.

The reader may well notice a certain titan whose presence pervades this text. Prometheus of course has his trace in this afore-mentioned conceptual self-devouring, though the trace is not of this precise ilk, but rather the related structure of being-eaten-alive (which is necessarily true of the autosarcophage). Prometheus owns this text – it is almost a subtitle (What Prometheus Did Next…) and a foreword necessarily also belongs with this myth. For promethean can mean fore-thinking. Thought and word are neurotically related. The phenomenology which attaches them is impossible to extirpate from out of the psyche even when repre-sentation as a dominant force can be shown to be false.

Furthermore at least some fore-thinking is fore-wording: the thinking which brings forth the spoken or written concept. This has the echo of at least three other senses i) all fore-thinking is a fore-warning (and there is a warning in this text – a self-help manual lurks within her[e]) ii) all fore-wording is fore-being where word emanates – homologically, not linguistically, from sein (werden), and lastly of course (for Heidegger) fore-thinking is fore-thanking.

So in our temporal openness to Being, our thinking brings this openness into visibility and yet simultaneously we are grateful for this granting. Here again the non-human part becomes visible, for in saying that we thought the thoughts which disclosed the beings for which we express our gratitude, we become aware that this disclosure is part of something bigger than any individual psyche. This non-human power is here described as neurosis.

This Heideggerian angle also generates considerations that the neurotic power may be of use in grounding anxiety – as used in Being and Time. Neurosis generates contingent obsession. Psychological (ontic) neurosis, as mentioned, turns on awareness of the condition. This issue of awareness is interesting from two

interwoven issues.

Firstly if we take (from Being and Time) Heidegger's notion of Dasein being the being for which its own Being is an issue, then awareness of the existential situation is described as essentially constitutive of it (i.e. that the being obsesses about the facticity of its own existence is intrinsically its nature). As such the usage of the term neurotic here seems highly appropriate.

Secondly we have grounds here for a reconsideration of the contingency of anxiety as the mood which discloses authentic Dasein's being-towards-death. The standard criticism being that this particular mood does not deserve the privileged position it is given for Dasein's authentic disclosure, rather it is contingent upon the epoch in which we dwell. However, now we can invoke anxiety on the basis of the factical obsession. That is, I am suggesting that we might derive the necessity of anxiety by neurosis as a [psycho-]ontological source of anxiety.

The two points are thus related: the viewing of Dasein as a being obsessed (neurotic) with its own existence is precisely what generates the anxiety of which Heidegger speaks and thus renders both as ontologically legitimate, insofar as we accept the questioning as constitutive and identify neurosis with this essential questioning.

This version does not deny the inhuman power of neurosis – it can be said to belong to Being –, but neither does it support its more metaphysical side (as the desiring aspect of material being). This idea of the will of materiality would, for me, come under the aforementioned transcendental psychotic.

Lastly, I just had some Wittgensteinian musings. These were inspired by the mentioning of Christ within the text. I am not a Christian, though I can scarcely deny the power of that particular egregore. Christ died, either symbolically or actually, we can agree on one of these with no dent to any given atheism or belief in an alternative deity. This choice brings into sharp relief an aspect of meaning easily obscured by some ways of seeing Wittgenstein's

meaning as use. As a card carrying pseudo-Wittgensteinian I adhere to this mantra. But highlighted here is how this kind of meaning is only the meaning of things on various horizons, or possibly the horizons of use have not been thought enough.

We might ask 'what is death?' And maybe we answer that the word (and its verbal forms) death is purely its use in certain situations: 'did you know that Wilson is dead?' Here we must be careful not to hypostatize. Death is still not a thing (unless it is a pneuminous thing). It's a language game played in a variety of situations. 'Did he die?' 'No actually he was ok.' It's a way of talking about certain events and possibilities of events. What happens afterwards is anybody's phantasy.

But Christ's death? If it has any meaning it is not in simply saying that he died, it's that there is a teleology at work here transcendent to death. It doesn't matter whether or not you are a Christian to see this point; we can expand it in other directions which may or may not prove fruitful in explaining what on earth Mr Johns is talking about.

If we substitute 'died' for 'ate' and 'Christ' for 'Johnson' and 'for our sins' for 'because he was hungry' then we say that 'Johnson ate because he was hungry' is the same as 'Christ died for our sins'. That these two sentences are clearly not equivalent is hardly the point. That is, in the instantiation the excess of the latter comes to light. If we say that 'ate' is defined only in terms of usage (in a limited sense), we understand why Deleuze accuses Wittgenstein of pulling dead fish out of a pool; 'ate' then becomes an activity which not only escapes a certain analytic definition but moves beyond meaning as use as it is often conceived.

The teleology of the verb is always immanent to it (think of incorporeal transformation in Thousand Plateaus, or of the Goethean perception of a phenomenon). Johnson ate because he was hungry (it implies an in-order-to), there is a putative inter-action of physical bodies and a transformation brought about by the verb, the difference between the composite parts of a scene

and the seeing of them as interacting with each other, the seeing of that verb. Language can try to capture an event: one plane of happening.

But this extension of the notion is insufficient for Christ's death. The meaning of Christ's death is teleological in its crude opening of the possibility that there is meaning at all on the metaphysical level. We would still however need faith to open the door to this possibility and then we still have a different situation of meaning because Christ's death, whether or not he was the son of God, presents us with the minimum binary choice of he was/wasn't precisely because he has been presented as such. This in turn begs the question of what it would mean that God existed and that he had a son (what is a son? a real son? an adopted son? – meaning as use seems to creep in again). There is a proliferation of meaning that occurs in Christ's death beyond that of Johnson eating his baked potato. This proliferation is again something akin to the higher order neurosis mentioned herein (a Christian neurosis, a madness of faith and speculation exemplified by debates on the 'truth' of the nature of the resurrection etc.)

When we accept meaning as use, I believe we follow an essentially correct insight. What we must be careful to remember is that there are many horizons of use and that the criteria for the applicability of certain language games are not always readily visible. Christ's death as a language game goes beyond the language game of death and yet relates to it. The excess within use is within the use, yet ironically what use is excess? It creates a seeking for meaning that is endless: the proliferation of an infinite series. Even if meaning could in one respect be totalizable, other phenomenological horizons of it would render it open to questioning. Such a seeking can of course be characterised aptly as Neurotic...

Graham Freestone
Co-founder of The Lincoln Philosophy Forum, U.K.

Foreword Two

Ballet as a Sleeping Beauty

Ballet by nature is both beautiful and tragic; both whimsical and stern; embodying both elements of feather lightness and steel strength. Throughout its long and illustrious history, Ballet has brought forth the ideal of perfection in stance, posture, shapes, steps, curves, symmetry, and breath. So much so, in fact, that it has sparked artistic revolutions, influenced opulent courts, and inspired divine kings to learn its positions and twirls. Even today ballet continues to be a two faced coin, flipping between representations of both classical and modern movement philosophies. There is a dichotomy that has always been a thin curtain within the ballet world, with dancers and artists constantly having to pass from one side to the other; a side of tradition, grandeur, repose, and elegance and the other side of contemporaries, experimenters, with boundless and evolving creative scope. Ironically, ballet has continued to be one of the few art forms that has survived its own chimera challenges. It never quite lets go of its past and it never quite leaps with both feet into the future. And yet, that is part of the appeal of ballet; it is both everlasting and ephemeral. And with this pliability has come constancy. Ballet has been successful in withstanding war, poverty and plague, maintaining its movement vocabulary and its metaphorical artistically structural backbone while still strategically dancing around political regimes, economic strife, and destabilizing global pandemics. Ballet has cultivated the theory surrounding a human ideal, defining and symbolizing what perfection in motion can look like, and should, according to patrons and non-patrons of the art form.

Johns brings forth many cerebral points about ballet, its history and its continued revolutionary ideas in this book. As you

probe through this intellectual text, I encourage you to grab onto the author's suggestions and hints as he uses ballet, and the ballerina specifically, to bring to light not the process of a revolution or even how beauty can influence a revolution, but that moment when a revolution happens and then fades to become a commercialized commodity for the masses to consume, evaluate, question and accept as something that can represent beauty. It is difficult to only view ballet in one spotlight because there are so many angles to examine the art form from. However, if we were to pick two bulbs to examine the ballet dancer from, let us choose beauty and tragedy for this brief discussion. What is it that makes ballet beautiful? And not only beautiful, but aesthetically appealing on a global scale?

For example, bringing certain opera forms to a country where musicality is defined by a certain tone of notes and the elements which make up the ideal sounds, then the opera may seem annoying and disjointed for the outside listener. But bring a ballet (with sets, costumes, and music) to any foreign audience and it will be rare to find a spectator who does not find at least one thing about the production beautiful. Why is this true? Possibly in the idea of watching a human form we can all aspire to its universal appeal. We are all human and so no matter our background we can all relate to and strive for the aesthetic perfection we see in the poised limbs and sculpted muscles of another human body in movement. And Johns' text pulls even more concepts to the forefront, suggesting that the ballerina makes a conscience decision to be seen as beautiful, even though she is mostly the creative outlet of the choreographer. Does she see herself as beautiful? Does she feel obligated to perpetuate this beautiful ideal? Why? Johns even goes so far as to ask us, in no uncertain terms, who is it that believes she is beautiful and why? The author writes "Philosophically she is a nihilist, and not a good one at that, because she doesn't believe in what she is trying to represent, and makes herself art as a consequence

(hence destroying the aura between art and subject, further making art/meaning ubiquitous)." Johns challenges the reader throughout this text, especially with this statement, to really look at the ballerina as an entity of her own, not just an object or a representation. I find this vain of theory compelling because it sparks so many other paths of thought.

Why is it that within ballet beauty and strength may coexist so harmoniously? A man can be both beautiful and strong within the realm of ballet; a woman can be both waspish and fearless within the realm of ballet. Beauty is not defined by gender in ballet. Both Maria Tallcheif and Rudolf Nureyev have been described as beautiful dancers. So what allows ballet to have traditional male/female roles within its story lines, but embrace such androgens definitions of beauty? Possibly because the structure of ballet as an art form is beautiful all on its own, with the dancers being just the vessel which emanates that beauty. Yet, how can something that is itself beautiful also be tragic? I have heard of someone describing something as tragically beautiful, but what does that actually mean? Is it tragically beautiful because it has no equal, nothing it can compare to in the sense of alliance or compatibility? Is it tragically beautiful because it is alone on a pedestal as a single emblem of beauty? Is ballet tragically beautiful because of the facade it cultivates; something that is outwardly beautiful, but inwardly becomes sacrificial to obtain that beauty, thus creating tragedy. Can something be beautifully tragic rather than tragically beautiful? Would that be a better description of ballet; when humiliation, misfortune and disaster are suddenly depicted through movements that are graceful, angelic and alluring.

How has ballet remained beautiful over time? While certain aspects of ballet have evolved, the essence of the art form has remained relatively resolute unlike other humanities such as music, architecture, visual art, sculpture, theatre, etc. Even as the greater humanities embrace the digital age, incorporating

technology into elements of performance and the creative process, ballet has kept hi-tech components at arms-length causing very little backlash or lethargy concerning the continuance of the art form. Why? Possibly because, plainly speaking, ballet does not require any embellishments or adornments; ballet itself is beauty, and beauty always survives.

Kirsten Wilkinson
Trained ballet dancer and dance archivist

Preface

A Philosophy of Neurosis/Four Fireworks

The essays in this book all hide behind the less demanding/disciplined activity/genre of *creative writing* as opposed to *philosophical literature*[1]. This is because the 'selfless-ness'[2] required to elaborate on difficult philosophical themes (such as what the fundamental constituents of 'reality' are, and how we can manage to adequately inquire and speak of this 'knowledge' *of* reality) is something that I do not possess (however, my[3] *desire* sometimes comes into contact with such systems of thought in these four essays).

The selfishness of creative writing and poetry ("its command is to revere *ones own* soul"[4]) is in a sense 'Evil'[5] in that it stems from necessarily fascist judgements and values (aesthetics)[6]. It is evil also because it refuses to directly correspond to truths, objects, referents (preferring metaphor) in favour of poetical liberation rather than rational, positivist and utilitarian progression. Literature, finally, is evil because it stems from the power to name, such and such *as* object, as good, as right. The determination of who takes these orders of 'naming', and who is included/excluded in their inauguration and dissemination, is yet to be fully realised.

In order for philosophy to equal that of life we must polemically be 'anti-philosophical'; we must be neurotic and obsessive, not disciplined and 'intellectual'. The philosophical meditation hides within it already the neurotic impulse; to speak to oneself, to create a dialogue within ones head to answer ostensibly 'objective', collective, universal and worldly questions. To *write* (the history of philosophy archaically adheres to this medium) is already to write to *oneself* under the guise of an external 'audience'. What results in the history of philosophy is a repressed neurosis subordinated to projects, means and ends,

which nullify neurosis under the less hysterical neurosis of uniformed values 'in-the-world', of *social* neurosis which underpins the ideology of uniform, purposive, valuable consciousness[7].

The insatiable desire I possess in the activity of writing seems to evaporate when confronted with propositions outside the carnal and semantic world (logic, some impersonal 'objective' science etc...), but these concepts too have the pathos of *desire* within them, and because they are *human concepts* they too are shaped by the characteristic of *neurosis*. Presently (and consistent with my theories) *my* neurosis cannot take hold of such 'a-subjective' data for *itself*, as such things as 'logic' defy the terms (my) neurosis demands (objectification, identification with myself, imaging, a return to the irrational)[8]. My thoughts are still determined by fundamental cultural-social neuroses; sexuality, gender, social regulations and values, a western heritage of knowledge/power, the arena of 'the imaginary'. However, at points beyond my will, 'my' neurosis latches onto something obscure and at first irrelevant, turning it into a semantic power, one that can orient my projects, express life differently, transform what is known as lived human life into something more diverse. Metaphysically speaking, one may ask what this neurosis 'is' that can prescribe a 'reality', whilst containing the power to traverse or destroy it.

To have a single thought that drives itself deeper into your everyday consciousness, without intention or integrity, which stems from a somewhat sovereign irrationality; is this a neurosis? And what separates this neurosis from the same perpetual obsessions we have with our symbolic construction of ourselves, our status, our psychological needs and our desire to procure objects of consumerist capitalism? Are these not fundamentally irrational themselves? But it is these neuroses, as I have stated above, that *hold* our reality together: their function, use, exchange value, their strange vicarious belief in something.

Reality itself is a larger form of neurosis, perhaps one that is obsessed with 'the truth of the matter', or simply hides behind the secret fatal need for uniformity of consciousness and its environment (operation) that we humans desire so much. In this sense 'reality' has become a type of belief in *saviour* (theology) as well as being an ideology and dogma. Time 'itself' becomes the ground for fundamentally rational and ideological projects, summed up in the colloquialisms "if it doesn't work out today you can always give it a shot tomorrow", or, "at the end of the day we can say this..." (assuming that time allows for the process of reconciliation, correction and synthesis), or the absurd inverse "live for the present", "carpe diem" as if the ideological construct of the present supplies inexhaustible uses for projects and valuable experiences.

The world is fettered by objects, practices and self-made systems of knowledge/hobbies constituted by our various neuroses. Some may say that there are certain prevailing epochs/ zeitgeists of neurosis which determine and harness various other ones. The more 'universal', collective and abstract a neurosis is, the more integrated it becomes within what constitutes us as historical, social beings[9], and the more it becomes a reflex (like the neurotic reflex of guilt, fear, love, a social behaviour etc.). Whilst these neuroses have power in the sense of mobilising large amounts of people to do certain things (and think certain things), philosophically and creatively, these neuroses are pernicious: the more 'universal', collective and abstract a neurosis is, the more compromised, banal and subdued its power becomes. Power is at its most prominent when it is pin-pointed, focused, intensive as opposed to extensive[10], individualised and at its least expendable (I'm sure we can find that the neurosis of 'matter' (physics) tells us this too)[11].

Perhaps some people have already started aborting the older more humanistic paradigmatic foundations of 'knowledge' (another concatenate form of neuroses) which stems from even

more ancient neurotic preconceptions; sexuality, embodiment, discrimination, social, political and cultural status (power), and have started aligning their neuroses to these 'newer', more dangerous, inhuman vistas such as data found in the 'hard' sciences or the prevailing philosophies that are immoral, pessimistic, anti-Marxist and non-human[12]? Did these new neuroses come from a strange affair with those desires that come from outside of the 'human all too human' world of neurosis?[13] Or perhaps, through the *inhumanity of the concept* (the attempt to make a notion devoid of any socio-political-organic-ethical appeal/neurosis) Man has already speculated/found that the world, through the phenomenology of experience, is fundamentally logical or conceptual and therefore views himself and the world as these things and hence meaningful? Perhaps logic is the harbinger of meaning for this Man?[14] The desire to obtain no desire (or to make desire purely rational) can be seen as one of the oldest neuroses in the book however.

The making neurotic of new information (which is not necessarily/historically meaningful) is the best a philosopher can do (the making meaningful out of the non-meaningful, or not *yet* meaningful), but even though the underbelly of this *neurosis* is usually driven by a *value* foreseen in the mind of the intellectual discoverer ('value' is seen here as being founded within the customs and social/political ideals of a certain civilization) sometimes the individual's neurosis constitutes *its own* value (a neurosis which is impersonal and non-intentional) and this neurosis makes the human believe that it is *his own* (to keep the individual content and enthusiastic about his neurosis (or even to keep him quiet)). In older times this in-human, a-subjective power was named 'inspiration', but the negative debilitating effects of this power were never named anything and hidden from the world of intellectual commerce.

This new 'inhuman' neurosis that I refer to is not necessarily some grand awareness of, or access to, 'the great outdoors'

unfettered from 'human-all-too-human' values, thought and paradigms, but can perhaps be seen as an inhuman exaggeration of human cognition; a vision of what happens to the vulnerability and intensity of thought before and after it has been ostensibly sedated by the orientations and projects of capitalist work and leisure. A vision of thought that is engrossed within itself, its own characteristics and qualities, that it refuses to play the conventional role of operating between stimulation and response within the 'natural' environment (the validity of this 'environment' of stimulations and responses perhaps being another form of neurosis however).

There is perhaps a 'real' inhumanity that is usurped in this insight, a new epistemology based on the antithesis of Parmenides' great proclamation that being is everywhere and unified, but most of all – *that* "nothing can not *be*". For instance, to say that there is no sense in the non-human would be to conflate Being (and non-being) into the purely human remit[15]. Now, if we are to suggest that no entity and its relations can be fully exhausted at any one moment (which most would agree) then everything that escapes this empirical, semantic, linguistic and physical capture does not, in-turn, return to Identity and hence cannot be identified *as* human. Regarding the neurosis of ostensible thoughts, intentions, beliefs, judgements and inferences, how, before the last instance, can we really identify these processes as our own (conferring it to linguistic, empirical, functional, psychological and inhuman sources instead)? Not only this, if hysterical neurosis hides, generates and forms within purposiveness, belief, value, intentions, obsessions and routines of our oppressive conformity to social, capitalist (and even physicalist) realism[16], then, apart from feeding-off the semantic lifeworld of humans, where else would it be inclined to go/proliferate towards? What events have we witnessed where this neurosis has played more master than slave over a human life and its obsession? Could we call the most ostensibly rational,

ascetic, disciplined moral philosophers victims to this 'traumatic' event? If so, the tradition of knowledge and in-fact epistemology would look gravely different. Do we allocate this event within those suicidal neurotic terrorists or harbingers of torment (Nietzsche, Camus, Dostoevsky, Munch, Van Gogh, Nijinsky, Bataille, De Sade)? It is no good merely to *know* (this notion does not in-fact exist), one must *desire* to turn ones insights *into* knowledge, that is into the construct and discourse of knowledge which is understood by a community (of power) at a certain time, so it can be actualized and in-turn validated as such (said to be knowledge).

What neurosis teaches us is that it (neurosis) cannot be traversed. In a sense neurosis tells us that the old fashioned dialectic is horribly complete. Not in the sense of the totality of knowledge (Hegel) but in the sense of the totality of solipsism. The moment Man reaches out to his/her most inhuman vista, the moment s/he attempts to apply cognition and sensibility to instruments and discourses which seem impersonal and barren, is the moment when s/he realizes that this desire – and the results it constitutes – was horribly human in the first place. And vice-versa, we realise in our most 'human' traits some terrifying form of Prometheanism unlike any other creature in the world. For decades people have seen Marquis De Sade's work as a compulsive attempt to superimpose inhuman, immoral and unnatural characteristics onto the human disposition. However, we find, through his literary effects, a desire and representation that is unwaveringly human. It is this mutual transgression and affirmation of the 'human' that is the product of neurosis, in that neurosis leads us to construct radical designations of what Man is and ought to be. Social neurosis is in a sense two steps behind this other form of neurosis. Social neurosis resides as a context *before* this act of promethean designation occurs, as a low ground compared to the heights of this secondary neurosis, as a passive reflex compared to the active torment of obsessive sovereign

neurosis. The neurosis that allows Man to enter into radical transgressions of his/her identity is, of-course, influenced and acted-out through the customs of culture, but it is the neurosis which allows this process to happen, and (this is of the utmost importance) all cultural contexts and physiological contents (reflexes/judgments etc) are a product of neuroses in the first place. In short, you can reduce cultural actions through the conscious, subconscious and unconscious beliefs and desires bought about by neurosis, but you cannot reduce neurosis to these cultural contexts. This is my polemic.

Most philosophers are pushed into exploring their world through three pre-dominant neuroses. Primarily there is the neurosis of a somewhat holistically prescribed historical-social value which sets certain standards and can delimit the individual (let us agree with Friedrich Nietzsche and call this the 'herd-mentality/morality'). Secondly, something usually happens in this neurotic sphere which violates the subject and forces them to have to create a new neurosis to either counteract the older one or distance themselves from it (this neurosis could be the preliminary valuing of a discipline in which they will project and focus their newer antagonistic/liberating neurosis). Thirdly, within this more individuated field (where one's neurosis has been leading and developing, in relation to the experiences and identity they have been constructing within this field) it is then possible for neurosis *itself* to find its own view-point or value; a will-to-truth which is neither reducible to the subjects *own* will or any real form of truth.

Sometimes we find the first neurosis (herd mentality/morality within a prescribed system of social and political norms) being validated through the last process (neurosis itself) but in truth, neurosis *itself* was never given its freedom to take flight, and instead stayed thoroughly close to a value (the ostensible reason or impetus of the neurosis) which supplants neurosis *itself* and names it as 'such-and-such'. Sometimes philosophers cannot find

new values which are incongruent from this first neurosis (the first neurosis being extremely dominant and conditioned within us). Hegel, for example, leads us back, at the end of his neurosis (of experience, the Idea, concept formation, his various terminologies) to the State, and the free subject (the affirmation of concepts found *within* that first neurosis already). Nietzsche, on the other hand, destroys and then transcends the first neurosis (becoming an individualist), and in the second neurosis (his philosophical rigour/discipline) traverses that too (finding it austere) and successfully comes to a point where his neurosis is not his (he is a conduit for the conversion of *desire*[17] into *neurosis*). This conversion Nietzsche calls *Power*. However, this less 'human-all-too-human' neurosis is inextricably tied to the first neurosis in that it uses the medium of the human and his values for its impetus; one neurosis is battling against the other, but productively. Sometimes a neurosis will commandeer or act under the guise of an older value just so it can keep its impetus (fixation/repetition/creation)[18]. Nietzsche's third neurosis (whereby neurosis was the most *itself* / 'inhuman') had to use Nietzsche's anger and passion against older *values* (Morality, Society, Christianity), and this passion *itself* was a value because it is dialectically against, and find its initial impetus, in the first neurosis.

Are we not in-fact made up of these 'opposites', these elusive irreconcilables? Not only does psychological neurosis *manifest* as a violation (or seduction) that appears irreconcilable with our ideological uniformity of existence (moral, social, religious), it also postulates experience itself; the irreconcilability between the brain/organism as *object* and as something which becomes subjectified/personified. Equally the dialectic is found between the 'transcendental' experiencer unifying all experience (Kant), and the constituents of 'material' reality which appear pluralistic and fundamentally not made up of experience, or, not *for us*.

My main interest in the field of philosophy is the rare point

where the neurosis of an intellectual (a person who feels at home in the language of concepts/critique/scepticism/fascination/ obsession = a neurotic) starts giving weight to a theory that is forming itself (through the help of your disposition of course) which has less and less to do with social, political, religious values, which may even disown natural language for an 'artificial language' or deploy a series of images/diagrams instead (Henri Bergson) or prose (Nietzsche). To see where this neurosis takes one is horrendously inhuman, but inescapably 'natural' (this proliferation being possibly the most natural process in the world). Let us be careful though, that this process does not become equated with simply the *empirical* (as it is something which can prescribe certain phenomena without appearing within it) or *naturalism* (in the sense that its intensity cannot be located merely within physical determinations/ properties).

The development of individual neurosis (affectivity/sensitivity/ philosophy/exploration of concepts) is auto-biographical[19]; *desire* needs to feed off something that will give it sustainability and potentiality, and, as lower order (natural) desires have already constituted (and subtly developed) the human as conceptually desiring[20] (in the sense that we naturally want to find/make meaning in things, be compelled, set out principles and values) we become the perfect conduits to carry out *higher order* neurosis. Neurosis is primarily assimilative and creative[21]. The development of neurosis – from inorganic to organic, plant life to animal life (and importantly the neurotic process that makes development possible) can be corresponded to a Darwinian process. Indeed, there is plant neurosis[22] (a specific way that a plant will make desire part of its character) shown through function, self-actualisation and extended relation to other neurotic entities etc.; its neurosis being its consciousness (what Hegel calls *essence*). However, in a similar sense that Henri Bergson talks of human perception, it is specifically the human subject that achieves the vital vectorial character of perception

(the capacity that allows neurosis-in one domain to become more neurotic/ itself), as human perception seems to want to be able to move beyond itself, to see more of some entity, to schematise it holistically, to allow memory to construct experience and objects, to fixate and thus give some entity surplus content. Its capacity to reflect has given it that strangely human neurosis to un-stick itself from any of its more natural/practical determinate characteristics/functions (it is perhaps this hysterical, obsessive and proliferating neurosis which should be seen as the real originary determinate characteristic of all entities and not the material developments, principles and laws that ostensibly operate as a consequence of this). Gilles Deleuze says a similar thing when he states that nature's process of production works on the power of A – X and not (as most would have it) A – B. This human reflexive mechanism that I speak of, acts as the harbinger for the higher neurosis that I wish to expound and disseminate in the many moods and theories of this book. It is this higher type of neurosis (that forgets or deviates from the neurotic tasks of 'cause and effect', utility, and the 'I' of the subject) that challenges the idea of the human, its position in the world, the causation of thinking through the 'I' that thinks, giving determinism a less determinate and more exotic terrain. I am stubbornly a materialist, yet, even though I grant matter the archaic impetus of all things neurotic (all things that *are/is*), the determinations that compel this higher order neurosis (that produce it even) do not seem to exist in the former language of materialism. This higher order neurosis is either going somewhere else completely, or, it is part of a much more complicated and purposive system whereby the 'end' is possibly one that has to 'use' the human, but – regrettably for us – will not stay in its terrain. Perhaps I hold an affinity with Alain Badiou when I say that it is possibly the multiplicity and chaos of neurosis which should be brought to light *before* it is 'counted-as-one' under the category of 'experience'.

The language of materialism is sometimes lacking because,

simply stated, concepts affect what we see as material and call material reality. We are yet to determine how adequate concepts such as cause and effect, the description of certain mental states, and the properties of various 'objects' are in relation to the natural sciences (or a mind independent reality). The functions (functionalism) of certain concepts in relation to experience suggest that we are yet to break through the obstacle of even fully evaluating the relations between our ostensible intentions and our actions, our inferences and our judgements. I believe neurosis has a big part to play within the configuration of these 'functions' (or epi-functions) and hence denies this functionalism as having a rational basis[23]. We have to analyse why neurosis perceives 'the world' through perception.

Equally, if we refuse the 'myth of the Given' (as Wilfrid Sellars did) we must leave room (and sensitivity) for the role meaning (semantics) has within the rationalist study of the human mind. If, like Kant, we take the 'innate' capacity for judgement to be the central cognitive faculty of the rational mind, then we must be sensitive to the plethora of consequences these judgements have when taken out of their specific context. Do certain/specific semantic judgements conflict with one another? Do certain semantic processes conflict with their overall judgement? Can these semantic judgements stop us from going through a certain correct (or advisable) action (as our mind has associated a certain result of a semantic judgement too immediately and has therefore played slave to the assimilative process semantic judgements can make)?

These same conflicts are described by psychologists as the catalyst for neurosis: in psychoanalytic theory neurosis is described as emotional distress and unconscious conflict expressed through various physical, physiological and mental disturbances. Carl Jung sometimes explained it as a reflection of the dissociated world within the individual psyche. Some have described it as the human attempt to reconcile what appears to be

an irreconcilable situation (trauma). So neurosis is the topology of these semantic judgements when their utilisation has become redundant, when they conflict with other judgements in the mind and in the world, when they reside in the shadow lands of untapped resources or derelict compartments of the mental psyche, oozing over what was seen as physical or rational demarcated areas, sinking into one's relationships with objects, self-consciousness and self-actualisation. The result/effect of various uses of meaning within a context *reside* – even when we have finished with their ostensible use – as an *accretion*[24] in the world, which yield powers beyond the agency of the conscious intentional subject.

When we untap the insight of the later Wittgenstein we also find that this conflict (neurosis) manifests not only through the concatenation of *individual* semantic judgements made by Man upon and within 'reality' (somewhat chaotically and irrationally), but also manifests as a sort of chafing quality within a *collective* reality, by residing in various physical, social and linguistic 'uses' ('games') *beyond* our individual judgements, constructing the world *outside* of our ostensible intentions. Hence, the meanings we have given to objects, through judgements and varieties of 'use'/application, conflict with other objects and judgements, and at points this even happens within discourse itself.

Wittgenstein uses the example of a house where a lady, under a mother's instruction, is asked to teach a game to the children of the house in order to keep them entertained. The mother leaves for a moment and when she returns she finds that the children are gambling. Now, obviously, this sort of game is not what the mother envisaged; she had no intention of using the word 'game' for this result, the notion of gambling was not even found within her own mental activity, yet the word, in one of its uses, denoted this activity as a possibility.

Neurosis is here determined not only through the irreconcil-ability of mental judgements with their original object and act of

judging, but through the conflict that certain functioning roles of objects, words and activities have with each other *regardless* of our mental acts. As Wittgenstein states; 'when I obey a rule, I do not choose. I obey the rule *blindly*[25]. Neurosis is here simply a type of pregnant pause or excessive discontinuity/irrationalism within various uses of language which 'blindly' constitutes the 'subject' of language, his or her own disposition and their world-view. The quote below is myself and not Wittgenstein:

> *I am presenting a conference. A colleague has made me a cup of coffee. It is presented to me in the cup my grandmother left me, which I reluctantly placed in the corner of the staffroom kitchen in the confidence that it will never be used. I give a conference yet I am thinking of the cup. Not necessarily the cup itself but the meaning it had accrued which, through the spectre of death, can never be fully transcribed into lived experience. Its meaning detached from its use as container of liquid. Every moment I give to this cup (or that it gives me) I am slowly destroying the fabric of social reality, the function of this conference and the behaviour that is tied to myself as presenter. I do not wish to look or think about this cup hence this meaning is neurotic (the repetition of meaning/images beyond my rational and intentional agency and configuration). Perhaps it is more of an obsession than a neurosis as it is the object's power (within its context of meaning) that draws me to it, and not, my disposition. I feel as if I am constantly checking its location as if I had spotted a spider somewhere in the room and were constantly checking to see if it had moved[26]. I also know that the use of this cup was once very different to its current use. My grandmother and I used to flick coins into it for fun. The taste of copper began to grow in my mouth.*

Not only is this an example of a neurosis which is caused through external ('use') as well as internal ('judgement') conflicts, it shows how, within those meanings, other meanings can conflict (such as

the use of the cup as keepsake and the use of the cup as conduit for a game; the sensation of old coffee and copper on the tongue themselves being more conflicting sensations). Equally it introduces the idea that meaning (as use) *exceeds* specific uses. This should not be misconstrued as saying that meaning is *irreducible* to use, but rather that the meaning that exceeds a certain use comes from a different use that was rarely or never associated with the *object* (as arena or event of functionality) but nevertheless is attached to the object (albeit contingent upon that certain subject, and albeit in dialectical relation to the immediate 'identity' of its meaning-use). This is similar to saying that the identification of an autonomous self is generated through identifying oneself as an object and through other objects, hence, meaning is sought in the relation. However, relations are always subordinated to that which gives rise to the use/meaning (the master relation) and it is these other relations, neither objective nor subjective, that generate neurosis. In regards to a more subjectivist viewpoint, existentialism could be seen as adopting the same insight in relation to the subject; that there is no real master relation between Man and purpose. Freud similarly argues that the master relation between consciousness and pleasure gives way to more complex relations such as the subconscious and sexuality.

Man is constituted by desire and will always act within a primary sphere/stage of neurosis (even if this is the neurosis of nurture from nature) but it is within the individual's neurosis where true power can be attained, that is, the gathering of power and momentum, the fixation, progression, and unfolding of concepts and images that would only be suppressed or vanquished if they were to exist in the exterior world of *projects* and ubiquitous *judgements*. To *realise* that the subject is only the utilisation or conduit of this neurotic conceptual power (that infact the concept *of* the subject and the ego is constituted vicariously through these 'external' desires) is what we need to term

genius, and not the old antiquarian idea of a free-willed, ruminating subject who thinks for 'himself'. There are more important, consequential, debilitating and fatal things afoot that desire wants to achieve by parasitically surging from out of 'the human subject'. What 'it' desires (as a network?) we do not know. Desire desires itself ... = neurosis.

It is ironic that some people see totalization (demarcation), resolution, the exhaustion of various terms/deduction as antithetical to the bifurcating impetus of neurosis. Resolute terms such as 'signification' and 'meaning' are in-fact intensely neurotic. Surely the need to constitute and achieve these terms are undeniably neurotic (we see it nowhere else in the world)! It is because there is no *absolute* support or external legitimation of such terms that neuroses can exist and be desired in the first place. If meaning/signification were 'known' they would lose their meaning/significance in the ubiquitous assimilation of them as 'such-and such' (and hence all un-concentrated/transgressive desire would be lost)[27]. The history of 'meaning' has been the *making* meaningful of the term 'meaning', hence, the constant re-creation of the empty term. Hence, the constant re-creation of meaning is generated by neurosis, and the desire to make meaning *meaningful* to the neurotic who is granting it as such stems from the orthodox definition of neurosis; a meaning which is the outcome of an intensely subjective desire to fix meaning into what *he* or *she* so desires. However, it may be rewarding to speculate whether such concepts as resolution/ totalization/signification are vicariously produced (by impersonal desires?) for another aim: such concepts are needed not only for the self-sustainability of the human race (the projects of politics, society and language to sustain neurosis *itself*) but are desperately needed and utilised by neurosis in order for neurosis to actualise itself; if there were no desire to signify, to *be* significant, then neurosis would loose its hook that connects it to the human, his/her capacity to *act*[28] and his/her lower order practices of value.

26

We still live in a hackneyed ignorant world where meaning and signification are seen as objective, universal and 'given'. Not only are signification and meaning *local* terms, they also return to incoherence and irrationality in the end, and generate from a severe lack of rationality in the world and the subject. Meaning is neurotic and neurosis is irrational. Neurosis is irrational simply on the premise that neurosis came prior to rationality (chronologically) and that the desire to be rational *is* neurotic itself. All meaning and signification should be properly seen as irrational.

This book is in praise of neurosis, but for too long the neurotic vector (repetition of thoughts, desire to follow or fixate thoughts, underlying generative processes beneath the passivity of sense-data) has been expressed under the guise of affirmation and intelligence i.e. long winded or rigorous expositions of method, systems and objectives, all taking place within the repetition of discipline (research) and repetitive rituals (studying/writing). Such 'affirmative' neuroses always hide behind a 'will-to-truth', asceticism or a 'will-to-good' but in-fact the amalgamation of 'the book' and 'the intellectual life' is a document/product of the inhuman parasitic forces, internal and external to thought, which accumulate and actualize themselves *regardless* of the paradigm of the humanist intentional agent of act, language and concepts. Neurosis is in a sense antithetical to the notion that subjects cause thoughts, but neurosis' capacity to always parasitically generate from the 'I' that follows all experience makes us think otherwise. This 'I' is the mainframe for neurotic processes because it is itself neurotic; pulling everything into itself, into consciousness, and is the kernel of power whereby intensity can be actualised into some form or other (through concepts, sensations, actions, visualisations) which can soon construct a 'personal' world-view/pseudo-objectivity.

The sublime encounter, whereby one realises "these are not my thoughts"; whether it is because one is utilising a schema of

language and imaging that was never truly one's own (and is also heavily determining thought 'itself') or whether one realises (in an act of nihilism) that the desires for certainty, to judge, to be identical to oneself through introspection, were never one's own desire, is the moment where transcendence (or the immanence/ embodiment of neurosis) occurs. The affirmation of neurosis is the awareness that within the 'human-world' every object and behaviour is generically a type of valuing/belief (or esoterically a form of neurosis). There may be no 'private language' of the individual that cannot find its source in the external conditions of discourse. However, there is still a neurosis within my head (and not *as yet* represented symbolically within behaviours or projects) which, through the process of obsession (and a strange delight in this cruel process), will have less and less external value, less and less correspondence to any orthodox meaning/use 'in-the-world' apart from its own internal neurosis (a strange type of non-intentional/immoral valuing). The sovereignty of thought lies in its power to be *lonely* (to be this *one* thought, to be this *secret*, to *have not* manifested yet, or to refuse manifestation as a whole/truth). It is perhaps because the external world of projects pervades to such an extent, and that the internal thoughts of Man have always been allowed to bask in secrecy, that there could be said to be such a dichotomy. The irreducibility of thought and matter are harbingers for genuine novelty and revolution, but more importantly (philosophically) they are harbingers of their own self-actualising power, without the constraints of symbolic coding, humanising, valuing or the 'making-into-project'. This is not dissimilar to Nietzsche's affirmation of the great thoughts that leisure and idleness can bring.

All consciousness and life is neurotic. The worlds products are a testimony to the neurotic vector that spurs the repetitions of the process of thought, labour and form; the incredibly slow and frighteningly fast neurotic creation of manifestations/ images, the vague simulation of *value* (project), the festering proliferation of

a form, a concept, the neurosis of time and it's prescription of 'action' (leitmotif?), the neurosis with space and its prescription of colonization, the neurosis of the 'question' that begs some arbitrary answer (theology)? The world mirrors and conforms to the neurosis of thought (Kant?). In many ways the human experience is one of tautology[29].

The "no" (or infinitely refuting/sceptical) paradigm of neurosis (which has become the underdog to the neurotic "yes" of the intellectual) has been either deemed pejorative, degenerate, dangerous, or simply has not had the chance to be seen as what it really is: impersonal[30], inhuman, and infinitely desiring. What is interesting about this "no" is that it is a neurotic no that says no to even the process of neurosis itself (obviously without victory). I call this absolute form of 'nay-saying' *rebellion* in essay two. The whole world yearns, but at present we Men yearn the most (and the loudest) and you will find that the most strident sound in this collection of essays reverberates in the neurotic *possibility* to say "no"; how is it that in the face of incredibly powerful constructs of knowledge/power (Darwinism, determinism, naturalism, idealism, empiricism, vitalism, physicalism, epiphenomenalism, neurology, theology, sociology, psychology etc) or systems of sense/sensibility (love, value, joy, pain, interest, mortality, project etc...) I can still say "no" to them, refute them, and make this "no" a principle of reality, a principle of life? I can even stand face-to-face with ostensibly all-pervasive 'Truths' and deny their sovereignty (not to replace them with another truth, but to realise that truth is only *one* criteria for valuing). There are many practices of *valuing* truths without such values having any affiliation to the concepts, processes and desires that constitute this 'truth' in the first instance[31]. That one can, and, indeed, may dismiss truth, is one possibility for exciting new neuroses. It is Promethean, to say the least, but all systems and epistemologies come from men in confrontation with some prescribed environment: it is a **valuing** of something *over* another, it is a

desire to paper over something, to transcend something, to confront something, even in saying "yes" to something you are saying "no" to its enemies or other possible solutions/values[32]. In this sense, all *knowledge* is part of a wider psychological anthropology, and the rest (its manifestation/legitimisation/proliferation) is left to the auspices of *Power*.

Perhaps I have not taken that next step to assert that my promethean desire outreaches that of Man and Meaning, puncturing the stratosphere, dispersing into constellations or building like a vector unwaveringly toward the sun. What is it that desire will find 'out-there'? Will it be indifferent or incendiary? Will we find that desire neurotically stays-put where it knows it will be further desired (on earth amongst men)? Desire constitutes man, it constitutes meaning (it has effected us the most). It has the capacity to constitute and abide to *identity* (biological sexuality/gender) and to also deviate/transcend it. The desire to play with oneself is the desire to name oneself and to 'be', but it is also the/a desire for a sensation that I do not totally own nor identify myself with.

The times when I inhabit some sort of ascetic desire, to reflect over important 'traditional' philosophical ideas, the overbearing feeling of formulating some impatient pseudo-conclusion to such difficult ideas, in order that I may finally 'say something' and validate myself in the process, always surges through my activities of thinking and comes to the fore in any statement I make (it is easy to mistake what you assume is a *will-to-truth* for a *will-to-power*). I attempt to grapple with this problem in essay one. If anything, I hope the desire towards philosophical asceticism found in parts of this book, along with the profound egoism and obsession with the body, humility and genius found in other parts, registers a textual, hermeneutic gulf, an abyss that language *can* testify to, yet also determines, is *part of* the expression of the human condition. In this sense, language is the antidote to the sickness of language (it is the 'talking cure'). My

awareness of language as a determining constitution of ideas and customs makes this work thoroughly literary and would only ever speculate (irrationally) any philosophical exposition that directly encountered *the Real* of 'reality'. I thoroughly believe that it is the power of naming/designating words such as 'freedom' that wrongly provokes a person into assuming the legitimacy of the language of liberal humanism, whilst ironically making him a slave to this language. Because this book is filled with such 'master signifiers' one is unfortunately provoked by them. One may be correct if they were to spot the severely neurotic and tautological process of this work and see a consequence deep within it: all words create gestations and traumas, and the possibility of redemption is only through further words of infliction. One should ask if signifiers such as freedom, evil, genius, creativity were simply a pernicious product of the circulation of these words in the first place...and nothing more. There is indeed a jester here (or an evil demon) contaminating sensibility and clarity, and 'certainty' is its most pernicious product. However, this jester goes beyond any study of *formal language* and shows us the impossibly authoritative and vulnerable impetus of words (the 'order-word' and the animal call). Between these two poles (between the Masters and Slaves of language) monstrous tricks emerge: subtle *deployment*, timing, motive, volume; non-linguistic and sub-linguistic powers that provide the meat to the bone of words (and sometimes vice versa). The word has *always* been allied to the order, movement, smile, effect – the performance of the saying and the saying of the performance. It is a thoroughly human enterprise in the sense that before (or below) the linguistic operation of sense there has always been a motive: of base-communication, feeling, desire, loneliness etc. What we call the flaws of our humanity actually prevail to be the harbingers of any possibility of constructive sense-making.

Even though I admit that all activity (on the surface) – intellectual or otherwise – is laced with a value (or a prejudice), the

ego in me is not a servant to the possible intellectual and social rewards of my civilization. Sometimes I believe my ego to be constituted in a certain way that makes it only possible for me to 'grasp' and create certain information on the premise that this information will *not* be praised and admired by others. For the most part I invest my time in thoughts that present themselves to be emotionally or egoistically rewarding; thoughts about Power[33] and about Desire (which usually embody themselves as humiliation, obsession and futility) and other thoughts that I assume would be detested, dangerous, brave, nihilistic and provocative, but this is still possibly in bitterness or in a spirit of independence that remains deeply rooted in a desire to be revered as a God (or as a profound Jester/Buffoon/Prophet). To an older generation this may sound contradictory and obscure; "why equate power to humiliation, agency with futility"? If Jesus Christ were not humiliated (and if he were not the conduit for humiliation) his power would be diminished. Humiliation is a feeling that should be equated to the genius; it is a feeling antithetical to the base ignorance of the plebeian. Futility is a feeling that came from the Gods; it comes from the understanding that one is great, that one can transcend themselves, and that one can see the world and its people as hopeless...futile. In this sense, the persosn that sees life as the most futile becomes the man that is wise...and he will keep this futility tied to him like a millstone round his neck.

Every deep thinker is more afraid of being understood than of being misunderstood. The latter perhaps wounds his vanity; but the former wounds his heart, his sympathy, which always says: "Ah, why would you also have as hard a time of it as I have?[34]

And perhaps the older generations aren't familiar with the complete transgression of categorical feelings (based on Christian morality) attained through the transcendence/inversion of Good and Evil, Pleasure and Pain, Joy and Sadness, making them the

same thing; that love hates the Other that violates this, that moments of intense pain and suffering are equal to pleasure and joy (redemption/sado-masochism/eroticism/obsession). Perhaps these states (and the realisation that they can be inverted) were hidden within Christian morality itself?

If I have any sense of Good it is one that came from the New Testament which has nothing to do with society, capitalism or pity, but a Good which is subversive and intimate, all such aspects that, if incarnated once again, with other like-minded apostles, would fall quickly to the punishment of the government, and even those meek religious institutions that sought to serve such apostles. Goodness is sometimes a stubborn, uncompromising nature (after all, these characteristics are found in *belief* too). Do we not find in those figures that carry goodness with a certain stubbornness (grace) an obsession, a neurosis?

What are at the tips/heights of all my pleas in this book? What has unfolded or happened for me to reach ecstasy/despair? These, I feel, are the appropriate questions. For Jean Baudrillard it was the destruction of pre-existing values ('post-modernism') that he took pleasure in, that gave him entropic energy[35]. For Hegel it was the understanding of experience as a constantly developing, holistic and unifying *Idea*. For Georges Bataille it was the experience of *the impossible*[36], or the limits of the possible. For me, I am so fundamentally opposed to our epoch of civilization; the values the subject upholds or is burdened by (a pseudo-status (monetary/social/sexual)), the devaluing of the non-pragmatic, the mocking of the sensitive and the irrational, the making-pragmatic of language, the destruction of the beautiful, the demystification of existence via social and political institutions etc. that every reaction I have within this banal capitalist 'reality' is a firework and a terrorist attack on those very formations of consciousness, and consequently my own integrity (as I am a product of such a contemporaneous

environment).

In one sense *crucifixion* is the sensation whereby an individual questions and transgresses the present consensus, because s/he humiliates himself or herself publicly, and s/he humiliates his lower self that once upheld or complied towards such a consensus. The emergence of philosophical reflection is the effect of a cause, the cause being anything from the desire or influence to think such 'topical' or 'untimely' questions found within a culture, a tradition, a heritage (questioning here usually being intertwined with power, status and the ability to voice concern (remember that one has to have the honour of being *included* within a debate/discourse to be heard) to being an effect of less cultural causes; emergence's of thought, emergencies, material and empirical activations of thought etc. There is the humiliation of the ostensible cause (what violates me and forces me to think?!) and the humiliation of whether the thinker can do justice to what its effects should be. This is described in the first essay (the first firework).

Another sensation (the second firework) is my awareness of the *intensification* of thinking as opposed to merely its representation and result, that is, a sensitivity to the medium of thought (how it feels to think) and less of a regard to what category a particular thought could fit into or function as. Nietzsche taught me that one should not only be aware of the intensification of thinking but also of the differing *climates* of thinking. What does this mean? Just as one can discern the climate of a particular piece of music, can sense the geological conditions of its manifestation, so too can one track the topology of thought (and this is in no way restricted to the topology of earth). Human thought opens itself up to not only the bio-sphere of production (the scene in which all natural sciences and natural philosophies deploy themselves) but to that of the thermosphere and exosphere. To accept that we are inhabitants of the universe and not just of earth makes thought something extra-terrestrial yet terrestrial at the

34

same time ('the uncanny'[37]) and so the 'possible conditions for human experience' has to look a little further than the spatio-temporal presuppositions that ground the ideas of Newton or the Kantian legitimacy of the categories of *the understanding*.

Nietzsche is telling us to set sail for dangerous journeys into the unknown, Quentin Meillassoux is proposing a type of thinking which can 'access the great outdoors'. This is very different to the thinking that has dominated Western philosophy for the last 500 years. Within that period we have seen an intensification of philosophical thinking which has placed itself firmly in a terrain that attempts to weave theological, moral, essentialist, scientific and humanist inclinations together. It does so – respectfully – within a white, middle-class, socially progressive historical paradigm. The topology of this type of thought reached its climax as a mixture between post-Kantian and Hobbesian philosophy; a philosophy rooted by its obsession with 'home', its territory, and its identity as a social class with a certain set of beliefs. Inevitably this thought didn't appear of much interest to philosophers such as Nietzsche. However there is something ironically in-human about the above philosophical enterprise. For a paradigm of philosophy that generally identified itself as philanthropic, moral, humanistic and enlightened, the intensification of its thought can be aptly felt and seen (even understood) as neurotic; instrumentally rational, rigorous, methodical, idealistic. Why? The intensification of thinking had no where to go; it had to stay put as Reason cannot be properly designated outside of the mind and its faculties that produce it. The representations and results of the Enlightenment can be connected to the world of people, revolutions, conquests, society, politics and history, but as characteristics and qualities of thought they remain solipsistic, strangely in-human, promethean, highly conceptual (neurotic). This terrain of thought is very different to the intensification of speculative thought – located in relation to domains *outside* of the mind –

which we see in pre-Socratic thinkers and the contemporary Speculative Realist movement.

Equally, the philosophical exposition of *Being* is given purchase again because of the pre-critical proposition that the subject's relation to the universe cannot be reduced to the phenomena appearing within that subject's existence. It would seem sufficient to speculate that not all relations are *sensible*[38]: a relation may be playing with us without us being conscious of it; duration upon the subject, movements of tectonic plates, gravity, electro-magnetism, moon tides, even the sub-conscious lays dormant from the conscious unless excavated and utilized etc...This is being something without knowing something (and hence this sphere of information cannot be epistemologically contained without transforming it into a reflexive sphere)[39]. To accept that to be something one does not necessarily need to know that thing's being is not an idealist programme (where such lack of awareness is simply the gradual unfolding of our capacity to grasp absolute knowledge or progress as a civilization) but encourages us rather to enlarge our affectivity towards the universe, to enhance speculation and imagination over epistemes that use inductive reasoning all the time, even to create pluralistic dogmas which contain within them the impetus to look outside of our *human all too human* perspective, to include ourselves in rhythms and events that rupture our sense of knowing and experience.

Being can relate to the Milky-Way, far-out entities and astro-nomical voids without such phenomena manifesting themselves within our experience. If something so localizable as *desire* already shows us that it outreaches our intentions, our experience and our identity, then desire's ancestors (and things that desire does not know) must be seen as profound...sublime.

The third intensity (or firework) is the thorough displacement of identity within the twenty-first century which I term *vertigo*. Not only do we live in an epoch where individual consciousness

can be immediately penetrated and mediated by external powers (the media *as* consciousness, the police as juridical consciousness, psychological institutions as subconscious consciousness etc...) we seem to have left any sense of even the *ideal* of the enlightenment subject of agency and have become parasites to the mechanic enslavement of capital ourselves; simulating various avatars that adhere to certain styles, rules, values, processes. The paradox here is that it is still the paradigm of the 'I' (individual choice or agency) that is the target in capitalism even though this 'I' is constituted by an array of desires that come from the capitalist system itself and not any act of free-will or choice by the subject. In this sense capitalism perpetuates my theory of neurosis; it pretends to construct and present an 'I' of the subject but the personalities and desires within this construction have no real location, is no-one's. As Gilles Deleuze has stated, we have become 'desiring machines'; plugged into the libidinal and unconscious economy that capitalism produces, measures and delimits. This is surely an historical development of the subject which can cause rupturing and schizophrenic effects, equally deepening the human condition. The task of literature then, is to capture the immoral intensities of the contemporaneous, similar to how J. M. W. Turner captured his with the paintbrush, *sensually* as it were.

For the main part, this mass-conformism and global mediation is prosaic and unjust. However, elements of this almost prosthetic desire can achieve unconventional, deviant and liberating effects *against* conformism, pragmatism and capitalism. Human obsession fuels itself and can mimic its own momentum, even if such obsession is content-less. The desire to write could be deployed for writings sake as opposed to some instrument used by the human to communicate/uphold some value or other. In brief: the relation we have to the inhuman (or the non-liberal humanist subject), in the methods above, could point to a radical re-mobilization of the subject; subject as artistic

combatant in touch with promethean processes of self-development, as opposed to the destruction of the individual subject to make way for the smooth operational space in which modes of capital function most efficiently (and relentlessly).

It is a dangerous human subject that rears its head from out of the crust of a 'herd-mentality', from out of a technological nihilism/capitalism and the nullifying effects of the academic institution within contemporary society (...but dangerous too are the most philanthropic of more traditional subjects). This contemporary Man, who is beyond *Good and Evil*, and beyond the paternal and maternal (a dependence which colonized older formations of the child-subject (the way they forge relationships and receive ideas of power/status, feelings of dependency etc.)), this Man, who is bored with the prescribed projects that exist in his society, which promise meaning and purpose, what is this Man capable of?! Could s/he make his own meaning... out of the only thing s/he feels is truly sovereign...his *subjectivity*, that is, the place where s/he can say "no"?

It is only fair to let us see what this subject can do (as an anthropological study and as a test of writing). Can writing equal this contemporary subject/can such a subject equal the glorious feats of literature? In a sense they are both working for the same cause, to fuse the subject with the object, a grand fusion that is 'fully myself and fully beyond myself' (Sartre) which results in the *novel* (there is no other medium as intimate as the novel). And this is where we must locate true subjectivities, and locate them in opposition to mass conformism/capitalism. A book's barbed wire is its intimacy and obscurity of content (no ogre may enter). A book's 'inaccessibility' to the less sensitive is its sovereign and liberating potential. However, at times, literature may have to personify *Evil* in order for it to not simply be swallowed and regurgitated back into the info-highway of capital (and in this respect the subject too must become evil...for virtuous reasons).

At worst, this book will show how the subject can become

slave to the various socio-economic, historical, cultural and aesthetic values of his time (lower order neuroses), without even being aware of such, and in-fact can parade such external influences as part of his own innovative sensibility (but this is a legitimate anthropological study in itself). At best, however, it will allow Men to affirm their neurosis as much as their neurosis affirms (and constitutes) them; to use neurosis to make-neurotic new objects and events (new 'knowledge') , to say "no" as much as they can, in order to make their neurosis immune to the primitive neurotic prejudice at the heart of social and political values/laws. There is a pathos of distance (from ourselves and our civilization) in our neurosis, follow it, see what new values emerge.

This is my auto-biography of subjectivity. All that subjectivity is, manifests as an obsession (neurosis) which is aligned to the determination (self-determination) of the natural fulfilment/ evolution of entities, which is vicariously controlled through *desire*. This process is not a logical, clean process but one where desires fight over one another for power (battling for their creation, their appearance in consciousness or their valuing). This business is an impersonal, vicarious process of *assimilation*, and it is a germ which pervades every layer of reality:

Linguistic assimilation: a linguistic process by which a sound becomes similar to an adjacent sound.

Cultural assimilation: the process whereby a minority group gradually adapts to the customs and attitudes of the prevailing culture and customs.

Biological assimilation: the conversion of nutrient into fluid or solid substance of the body, by process of digestion and absorption.

Psychological assimilation: incorporation of new concepts into existing schemes.

One should take this further and see *perception* as assimilative (neurotic)[40]: everywhere we look we see the products of Men (buildings, pavements, vehicles, objects, interiors, environments etc.). All these products have been made under the neurosis of labour (the repetition of the builder, engineer etc.; coming to work each day, and picking up the same materials and actions of creation). The impetus of this neurosis is not only in the making of form but in the desire to accomplish certain tasks in order that one can get paid (value/capital). In the acts of this labour, not only is the subject neurotically fixating form, s/he is also neurotically thinking about the form (what it is that s/he is doing). If perception is made-up partly through the *objects* of our perception (what we see), and these objects are indubitably constituted by neurotic processes, then neurosis lies at the heart of what we call perception. Perception *itself* (even if we attempt to hypostatize this perception as distinct from the objects *of* such perception) could also be seen as neurotic; the fixation of a certain trajectory, person, thought, mood, the need to assimilate sense through endurance and persistence, the neurotic need to drag the 'I' of the subject through every thought and perception we have, the neurotic fixation of a stable neutral and 'given' plane ('reality') where the unfolding of our lives take place, the neurosis of 'time' as linear etc.

In essay four (Incompatible Ballerina) the most obvious (and sensitive) question is: what are the processes, dynamics and environments that create this interplay of neurosis? Not simply to state that it exists but to lay out a topology; the stage that the ballerina dances on (the neurosis of a distinction between 'the real' and 'the symbolic', which in turn constitutes and validates the subject as 'voyeur'). To 'observe' already contains within it the neurosis to fixate whilst ostensibly keeping the 'spectator' in-

tact. The concept of 'presentation' stems from the neurotic need to make something (anything) apparent in order that neurosis can fixate on it. In some forms of neurosis we see the possibility to make apparent (in astonishing detail) an event that never occurred or an event that the subject did not experience: neurosis makes forms appear (some philosophers have called this 'cognition', 'intentionality', 'custom' or 'perception'). The need to *make apparent* contains within it the desire to make manifest *in order* that such manifestation may then seduce (open-ness, prostitution) or distract (preoccupying or occupying the subject from his inertia or futility) with the final result of appropriation (deflowering experience). The *desire* of neurosis has to at least pretend that there is an Other to which this desire can orient itself towards[41], so in presentation we have the preconception of a 'present-er', an Other which is either deemed exotic/new or given the role of titillation (a form of gift exchange – to present is to give something away). Similarly, in perception we also see the neurotic impulse to *fill* what at first seems empty with surplus content (i.e. the inner workings of the mind projected upon some generic space (staring upon a wall, day dreaming, the process of writing and reading, painting etc...)). In this sense perception/neurosis could be aligned to the need to make manifest *temporality itself* (as a sequential process which in turn affirms neurosis/mirrors it)[42]. Why would this be the case you may ask? Because temporality is essentially neurotic itself, and indeed constitutes time from out of itself (essay two discusses this further)[43]. Neurosis may not have needed at first the human concept of time but it needs the affect of location/velocity/speed/temporality. This is essentially what neurosis is – thinking/desiring time, and similar to the fundamentally 'split' subjects of Freud, Lacan and the representationalist account of Kant, the impetus, *will*, or *id* is sufficiently scared of itself in the face of its own reflection by the ego, phenomena or consciousness. The neurotic generation of time brings with it, in

the organisms it produces, a fear of that very time that constitutes it (in human psychology this is termed chronophobia). This fear is imminent and plays the role of orientation and transcendence. If we were to steal this 'transcendence' back from the enlightenment and call it, properly, *horror*, it would not stand moral/traditional philosophy in good stead.

If *Incompatible Ballerina* has any import for *aesthetics* it is the notion that where beauty starts desire ends. Beauty, not to be mistaken as some element of the sublime that causes 'rupturing' effects, is a complex, historically created construct that uses the instrument of death (the antithesis of desire) to mitigate the human's immediate projection of desire into its further desiring world. This mitigating effect (call it repose, atraxia or a state of non-vitalist being) is what I term *beauty*. It is not some metaphysical or innate effect within artwork but a designated art that attempts to create a certain mood, which has a certain history and value (similar to a form of fascism[44]). I find it striking that the inorganic stasis defining the majority of artwork in the history of the visual arts has not laid claim to a type of aesthetic death (or non-being) that it so rightfully deserves, especially as we humans cannot generate this death ourselves; we humans can only observe people's deaths and can never experience or embody death ourselves. At that moment when it becomes our own death, the experience cannot be found as it becomes terminated as soon as it is experienced (the death of the experience of death) and such death, if ephemerally experienced, is only in relation to life and our living self, which thus generates imprecise notions of death such as 'loss'. There should be a revived interest in this inert area of the arts. Perhaps art, being dead already, can afford us some insight.

If we can find the neurotic impetus underneath the conceptualisation of 'perception' *itself*, then imagine what we may find in its *objects*; 'ballerina', 'performer', 'woman'...we find the same neurotic process presented again (and made into characteristics/

traits). The oscillating tautology of the neurotic desire *of* 'perception' and the way this perception shapes objects *as* neurotic/desiring is what pervades in experience and keeps consciousness satisfied, operational and 'sensible' (in the Kantian sense).

Desire desires desire, and will feed on any organism that will sustain and proliferate it. After all, desire made these forms possible in the first place (life)[45] and all that obsession amounts to is the naming and aligning of these desires through a perspective that 'they' can count on, will stimulate us, make us move, make us obsess over, make meaningful, that is, the world that such desires have created for us – the human world. And these desires, finding personality in the simulation of the 'subject' are called neuroses. To follow ones obsession one simply has to keep breathing, but the philosophical task is to accept the power of neurosis and to see how desire's proliferation of itself within the human subject has sustained itself/ carried our civilization. Another more dangerous task is to attempt to transpose *neurosis* into less fixated and less human *desires*. This will one day be the new meaning of philosophy... and it may verge on what we humans call 'insanity'. Not all inhuman desires become human (made neurotic) but all neuroses become human in the end – tragic. Marquis de Sade's obsession with all those 'inhuman' taboo's that, through contradistinction, dialectically created the western moral, intellectual and prudent subject, soon became the very seed of the human. Prometheanism is this process of neurosis in which everything Other is subsumed under identity, and everything identarian is found to be strangely inhuman. Because there no longer appears a stable dialectic preserving the human from the inhuman it is left for neurosis itself to take the wheel in consciousness, and all formations are left to the auspices of neurosis itself.

Something horrific happened when I read Hegel for the second time. It was his theory of the logical structure of

conceptual content and how it navigates the movements of subjects (society, history, culture). What if this conceptual orientation, and hence conceptualisation of the world, was not of our own making, were not even our own concepts? I never asked for the conceptual content of seventy five degrees Fahrenheit to be 'hot', I never asked for the concept of 'object'?! If so, where is conceptual desire going, what does it want with us, how do 'I' 'feel' in relation to the concepts, language, values and perceptions which have been bestowed upon me?

By the little which can thus satisfy the needs of the human spirit we can measure the extent of its loss.[46]

I take the above passage to mean that by the fixity of 'human-all-too-human' neurosis (the 'herd mentality/morality' of our lived 'reality') and our complete satisfied acceptance of this, we can observe how little it takes for us to gain such a 'fruitful' existence, and can perhaps (and not without fright) imagine the vast gulfs of unknown, unlived desires and neuroses that we cower away from in order to preserve such comforting existence. Can we attain a desire which asks more from our little familiar desire (base-neurosis), which allows neurosis to take flight or allows neurosis to work *with* the subject (whilst the subject is aware of it) without the subject fearing this neurosis or anchoring it towards a certain human goal? Can we give identity to neurosis without it being trapped in the fixity of that terribly limited concept 'human'? Can we attempt to measure the Other of desire *inside* neurosis?

Humiliation, Idealism, or what forces us to think from consciousness?

Humiliation is first philosophy in the sense that one must participate as learner or seeker in relation to the 'knowledge' that they so ignorantly desire. The vulnerable process of standing face-to-face and 'open' to 'knowledge' also has a brutish violence to it – "I purport to want to know, I purport to not yet know, but I also purport that I know that this process will lead me to knowledge and that the seduction of the goal of a particular knowledge connects to my equivocal desire, is legitimate, honest, transparent and true.

The construct of knowledge and its method (asceticism) automatically posits the subject as slave to knowledge, slave to the assimilation (order/law) of the particular discourse that this knowledge has found expression in. To read or listen is to have made time for it (labour), to abide by it (law), to accept and assert such as signifying/significant, and finally the construct of knowledge and its method makes us slave to the *ideal* of knowledge i.e. we not only sublimate ourselves in the process of trying to know, we also believe that there is saviour, truth or the real in the very acquisition and exposition of knowledge (there must be some kind of comeuppance for our little struggles). In fact we do not know this: we may have constructed institutions, caricatures, values and rewards for persons that we identify as knowers, their knowledge may have achieved a level of construction whereby we can utilize this construct in esoteric or exoteric situations, but we do not know – outside of utility and desire – where this ostensible knowledge really leads, whether it enters the real.

Hence we are humiliated by the vulnerable act of seeking knowledge (asking for help) as opposed to the sovereign impossibility of 'thinking for oneself', we are humiliated that we even

believe that knowledge will help us, we are humiliated by the 'forced' labour that 'knowledge' seems to require – that forces us to become one of knowledge's workers (but doesn't knowledge also need its knowers)?

It may be helpful to describe the sources of this humiliation as in a sense antithetical. Part of the subject's humiliation could be described as stemming from religion and the other part as stemming from its counterpart, its enemy, the sovereign ego. What I have here termed 'religion' and the 'ego' have not always been seen as antithetical, in-fact why should they be? The ego finds power in the religious order of things, s/he just needs to find his place (or is given his place) within this order. The operation of religion, institutionally and within its texts is the naming and designating of the ego within its political and metaphysical power-relations (the bishops role and status in relation to the Church, Paul's role and status in relation to the operation of Christianity etc.). Isn't the ego a type of theologizing of itself, turning its status into something above and beyond the sum of its parts, its characteristics and its biological constraints? Is not the concept of religion also an extension of the ego, the desire to construct a world where subjects are both the centre of importance (care, love, pity, our saviour Jesus Christ, our God that loves and looks over us etc.) and are also given the possibility to transcend this original structure of signification by sinning, over-ruling Christianity. The Ego and Religions inextricability can cause somewhat contradictory results; the ego enjoys the security of being posited within a larger theological system; the Christian does not need to struggle to keep the authority of his ego in-tact because its reality lies in 'the starry heavens above and the moral law below'. However, the ego reminds us of Descartes 'doubt' (or the doubt of Thomas); s/he asks 'could there be more reality elsewhere?', 'could I accumulate more power somehow?' and 'is my father really alive...is he mocking me?!'. In order for the ego to be truly sovereign it had to kill its maker,

overcome him and take the entire universe for itself; we can see this notion already in the New Testament and also in its demise encapsulated by Nietzsche's proclamation 'God is Dead...who killed him?!'. We could aptly describe this contradictory characteristic of the ego – via the terrains or religion – as dialectical (...as neurotically dialectical).

Does the concept of the ego not depend on the very presupposition that it requires something *outside* of it to give it admission into signification i.e. Jacques Lacan's notion of the subject emerging from out of a symbolically coded society/reality and the need for the subject to identify with this society/reality in order for it to gain selfhood?

Through this trajectory of thought we could say that all designations of any kind depend on both a context and on the Other that co-creates and sanctifies the identification/bond of the designation. A far too crude example would be the designation of an 'I' that is also partially constructed and embedded within a larger social convention of language and a 'logic' of taxonomy/classification of 'things' and their distinctions.

Now, my polemic here, apart from instantiating humiliation as a certain paradigm in which forms of knowledge take shape and are desired, is to explore the double-bind/contradiction of humiliation, to show that humiliation moves both in the direction of the self (ego) and in the direction of the Other (religion). This is not just true of humiliation but of knowledge itself. On the one hand there is a characterisation of knowledge that desires to be truly sceptical of all constructs of pre-existing knowledge i.e. criticality/scepticism. It is sceptical of knowledge's 'foundations', but also (in an extremely philosophical manner) it is sceptical of the knowledge that guarantees perceptions' 'reality'; the ostensible 'gift' or 'myth of the given'. On the other hand, however subconsciously or naturally, there is a humiliation/knowledge that accepts (and perhaps affirms) the relation between a faith in experience and a 'truth-of-the-matter' that causes and reflects

such faith/experience, even in such practices of scepticism (Hume accepted this belief as a sceptic). After all, the gift of the 'I' that thinks, which apparently cannot be refuted, must be seen as a gift that the sceptic must affirm *before* mobilizing his many complaints as to the apparent reality of the external world and the constructs of knowledge and certainty. There is also a sovereign humility within the sceptic when s/he asks "what can I do?", and then there is the humility that touches the Other when s/he asks "what can I do in the presence of life/knowledge"? The first subordinates his faith in a larger all-powerful/teleological life system and prioritizes the scepticism of what s/he thinks is his/her sovereign ego. The latter first asks Life to respond to him, asks Life for a criteria of/for questioning. Regardless of these antithetical modes of thinking, both have a joint sense of futility attached to them.

Already to challenge is to accept so many things, to be critical is to accept the language and vector of criticality. This may not boil down to a question of religious humility or non-religious humility. One could be a sceptic of all philosophical theories of perception, knowledge and truth yet still believe in a God, and vice versa, one can accept a common-sense realist view of the world or accept that perception intrinsically involves belief in both appearances and an apparent teleological structure in the world without being a theist.

There appear two questions that naturally lead from the above insights; firstly – should we construct a distinction between an operation of sense-making which may have built within it a *theological necessity* i.e. to believe in the world, a reality, the self, to believe in operation, to have within local experience a larger intuition of its workings, and then a further operation which creates the same results but through *non-theological* concepts such as neurological visual mapping/receptivity etc, whereby such non-theological operations are a contingent and determinate function and not an unconditional gift? Secondly – would these paradigms of sense-making be different and would they lead to

different aesthetic/moral/philosophical outlooks on thinking and life?

With *humiliation* the 'unconditional' gift is neither the participatory-belief in life/reality nor the gift to intellectually doubt life/reality (scepticism) but is rather the humiliation *itself*. For example I accept a level of humility when I undergo the process of thinking philosophically; I ask the very same above questions – "am I thinking for myself", "what is the criteria and objective for thought and do I trust it?'. These questions – and in-fact my thinking process – is determined by the neurosis of this humility itself and not some external guarantee (i.e there is no proof of a God granting me this thinking, or the utter disproof of the necessity of thinking). The beauty of this mode of humiliating-thinking is that it is both sceptical and aware of external/theological systems of thought. Humiliation is an awareness of something that is playing with your thought whilst you remain unsure whether its content could be said to be real or valuable. The dialectics of this unfolding process of awareness returns us back to our original symbolic construction of the relation between the ego and religion; the ego driven by the humiliation that it has not been endowed with a transparent 'cogito' identity (and is hence highly sceptical of exteriority, external power and is humiliated by its general vulnerability) and then the thinking that embraces the identity of religion – allowing thought to take flight on the breeze of necessary, intentional and teleological thinking that it believes in. It is interesting that such a huge shift in thinking does not come from any external material or historical event but rather comes from the choice of thought itself to decide (I think Descartes was suggesting this 500 years ago).

It is in the fundamental solipsism, scepticism or non-belief in the external world (let us refer to David Hume) that designates the external world as a matter of belief; 'I am *led* to regard the world as something real and durable and as preserving its existence, even when it is no longer present to my perception'

(my italics). It seems here that the more philosophical, atheist and non-common sense realist the philosopher becomes, the more s/he seems to supplement areas outside of his philosophy as pure belief. We see this double-edged humiliation of the ego and religion again here i.e. the humiliation of deprived certainty driving proper scepticism, the humiliation that one believes in the project of certainty in the first place, and finally the humiliation of all 'real' factors that resist or appear external to rationalisation, which leads Hume to regard the world as real.

Perhaps in some way there is that other more 'compromising' line of thought in the works of the German idealists such as Kant and Hegel. Kant secures the ego by maintaining that it is we ourselves who determine the structure of our experience, giving the concept of 'reality' a new purchase in that it exists as a criteria separate (although necessarily connected) from simply what is evaluated in the natural sciences or scientific realism/instrumentalism. One could say that Kant defends the criterion of 'reality' by saying that it is real 'for us' and then re-locating the 'us' as a logical principle that governs space, time, rationality and geometry a priori. But the ego is here still not given complete sovereignty because 'it' did not ask for the a priori judgments that are apparently central to the cognitive faculty of the mind. Again there is a type of comfort or faith in Kant's philosophy whereby we freely accept/affirm both his categorical imperative (which assumes universality) and the a priori structure of mind which gives rise to 'determinate judgments' in which 'the universal (the rule, principle, or law) is given' and the judgment subsumes the particular under it'.

I am humiliated that there is a 'real' that 'grounds' me and my existence (what I would call a religiosity). Most philosophers, conversely, find their own personal location of the real as comforting (Descartes' certainty, his geometrical proofs, Schopenhauer's Will etc.). I am also humiliated that the ego has not conquered knowledge for itself yet (Descartes' doubt and his

attempt to re-think/build the foundations of philosophy). I feel as if there is an attempt to both uphold the ego and affirm the theological 'Oneness' or bedrock of the world-as-it-is at one and the same time in Modern Philosophy.

There is an interesting distinction in the notion that the practice of knowledge/asceticism is physiologically antithetical to the experience of religion i.e. awe, comfort etc. (I have tried to disprove this in the examples above, however I find the dichotomy useful). Its dictum is that in religion, *God will think for you so you don't have to.* This obscure and scientifically unfulfilling theory finds expression in a certain stereotype of the genius, one that brings my two definitions of humility back into consideration. In ancient Rome genius was etymologically linked to genii – the guiding spirit or deity. Here one does not need to be 'clever' to be a genius i.e. one could be a humiliated genius (humiliated by God?). Jesus Christ was a unique conduit for humiliation. We find especially in The Passion so many of those transgressive ideas: that to suffer is to be strong; we find the construct of the 'martyr' etc., all reversals of the usual dialectic between master and slave, weak and strong, guilty and innocent. Jesus Christ is a type of genius who perhaps sets the trajectory for our descriptions of humiliation: he is perpetually humiliated by 'non-believers' that encounter him, he is tortured and ridiculed, he believes in the one God our saviour. The humiliation that retroactively creates genius is in this theological belief that we have discussed, however, the ego finds its seat right at the end of The Passion. Apart from the incarnation of the son of God being an individual 'normal' man (giving the ego some promise here) it is finally in the words "Eli, Eli, lama sabachthani?" that is, "My God, My God, why hast Thou forsaken Me?" which affirms a very real humiliation (to be deceived/neglected), but again it is the aura of the sceptical sovereign ego we have talked about. Deep within Christ's soul (his ego perhaps) is a retaliation, it is the beginnings of a real

philosophy i.e. "I have been neglected and therefore I MUST think for myself, I MUST think-out of this mess". It is possible to accept that there was no neglect or Other that neglected you in the first place. What forces thought to think within this context? Is it still the vector of humiliation? To be humiliated by that which one does not know and so to attempt to know, to be humiliated by the status of knowledge in society (that people are 'cleverer' than you and so achieve a level of power or grace in which you desire for yourself)? Is there not a strange self-assimilating quality in the discourses of knowledge itself, removed from the interlocutors, that seduces one into illusions of certainty and mastery (simply in the mere following or application of a method)?

What became humiliating for Christ was belief. He believed and he believed. Of course there is that slight humiliation within every thought whereby we understand that the thought is not solely ours, we understand that the impetus to think it is in some ways irreducible to the cogito or willing subject that apparently causes this thought in the first place. Especially for Christ we understand that every thought and action was in some ways a homage or acting-out of God's will. However at the end his belief did not come through for him, his belief did not create a reality that was identical to his desires ("My God, My God, why hast Thou forsaken Me") and so he died hating belief and hating the knowledge that he continually swept aside in order to give room for his belief (the sacred ties of custom and education, the alternative, orthodox religious institutions of the time etc.). There is no way to live after hating these two things. An impossible task of philosophy would be to think within this bereft mode of thought.

Even in Einstein we see a form of humiliation which is inextricably linked to a form of religiosity when he states things like "when the solution is simple, God is answering" or "the most beautiful experience we can have is the mysterious. It is the fundamental emotion which stands at the cradle of all true art

and science". There is both a need to think for oneself, yet a need to accept and embrace some unknown form of mystery at the same time. There is a trajectory where these statements could contradict one another (however both still contain humility). That genius is slave to the power of mystery, is a religious manoeuvre, religion as the reification of non-knowledge. It stops us in guiding a thinking beyond mystery (or totalizing mystery into knowledge). Even though Immanuel Kant is famous for putting knowledge back into its proper place (within the limitations of Reason/sensibility: the transcendental aesthetic) Kant is victim to a fideism. In his construction of the 'thing-in-itself' (which is absolutely unknowable) we can also find a place therefore, for speculation of this 'unknowable', an endeavour outside of the limits of reason he so adamantly constructed. Let us look at Kant's description of the Sublime; we are at once confronted with something of a sublime nature (of epic proportions, or of natural authority), and reason 'holds' this dizzying sublime, allows us to think and experience it without knowing its essence. Reason cannot penetrate the sublime but only sublimate it. Its very failure to do so creates the ostensibly positive feeling of awe (awe generating from the humiliation of the Sublime?). The rationalisation of the sublime, as we have stated, is also not of our own doing (in a sovereign sense) i.e. its capacity is just there already, I did nothing to will it into existence, so there is a believing in it and, in a Heideggerian sense, a 'thanking-for' it.

One could argue that any intellectual-theological thought is a thought already driven by a limiting desire. Its thought believes in a One, a Real, a Truth or a God which acts as the *source* of this thinking. This process is cyclical in that the process of thinking is a gift which was inaugurated and originally came from this source (i.e. God), and cyclical also in the sense that thought cannot out-think the source (for example Christian thought cannot out-think the principles of Christianity; it must abide by

the ostensible laws and customs or it becomes non-Christian thought and hence doesn't believe in the concept of this divine origin anymore and hence the strategy of the thought that comes out of this paradigm). According to the prior theological criteria it would not even be considered 'thought' anymore as it denies its theological identity. Equally, theological thought is not to think but to use thought as a contact to what it is more interested in (what it is more allegiant to) which is this origin that gave thought thought in the first place (and Man life). For example, for all of Descartes' scepticism he stops short when he believes that he has discerned a 'real connection' with God ('ideas as being inscribed on the mind by God').

The humility that drives Descartes' philosophy is that – in the face of God and his absolute Truth – he cannot as of yet 'connect' to him, he cannot 'prove' his existence by means of the rationalistic method dominant at the time. So this humility drives his method and aim. Of course there is a humility not just in the techniques of science, mathematics and philosophy of his time (their failure to grasp God), but a humility in himself – almost an apologia to God. The former humility of the then present state of knowledge is a humility linked to the ego. Descartes must doubt all prior epistemologies, all people (this is personified in the deceiving devil that tricks Descartes) and this is truly a sovereign return to the ego-thinking that produces results. We are discerning here the very 'ethics' of thought, its very locomotion, its desire.

Dostoevsky – what forced his thought? Was it a *conflict* of thought (or its application to reality) that spurred him on to 'really' think (or to think with dignity)? Did he think for example: "why is it that we are meant and compelled to love thy neighbour yet I see my neighbours begging, homeless, being hurt by others (other neighbours)"? There is a Christian moral tradition (belief) in Dostoevsky which forces him to reconcile or create an alternative solution from out of this conflict (this sounds a bit like Hegel's dialectics). Dostoevsky is one of my par exemplars of this

double humility I speak of; he is humiliated by the ostensible purity of Christian ideals yet he is also introspectively propelled by the power of sovereign humility enough to proclaim himself at times irrational, anarchistic, a beetle-man, someone who hates everyone else, is disgusted with himself and is fundamentally worthless. However, this worthlessness is always in the face of some worth; one must fathom worth to know/believe what is less than it, and hence this is a religious attitude.

This conflicting situation of thought reminds us of a theory of the impetus of thought, a thought based on survival, tool-thinking, conflict and adaptation i.e. natural sciences/ Darwinism. A thought, which, has its origin in some 'lower' stratification below thought: striving, adapting, mutating etc. Can we not yet be Promethean enough to say "how humiliating for us"? How does thought feel about determination? Is liberal, critical, 'indeter-minate' thought not itself a determinate operation that is not without a use found within those theories of consciousness within the natural sciences?

And what of the thought that really does 'come forth' from out of nowhere, an event in an essentially infinite and novel world that calls forth the subject and creates a 'singularity': a singularity which the 'subject' swears allegiance to (Alain Badiou)? Is there not some humiliation in asserting one's fidelity to such an event? (I am in no way saying that humility is a pejorative characteristic).

But what of the consequences of 'events' and what of the consequences of all objects/appearances, mental representations, judgments onto this 'subject' which is humbly humiliated? (I know I am describing a metaphysical subject unbridled by those consequences but its real anxiety pervades everyday experience). This does not bring up the question of freedom, as the humanist, metaphysical concept is redundant in most respects (we are perhaps immanent to and with one or plural realities), so it rather explores the powers of conditioning/determination/ seduction and our learnt reflexes/cognition. How are we to

escape the neurosis of affect, representation, signification, time etc.? These empirical neuroses are what I believe force thought – perhaps not even force thought but double it as participation with these neuroses. Like a dark side of Heidegger (which exists) there is a subconscious/determined reality of equipment that locks us into locomotion, and an obnoxiousness of appearances and objects, the very excessiveness of imagery where time manifests itself as memory within the human, that makes us slave to a 'world' that many of us are too sensitive for. Humiliation is a thought *itself*, and when we feel humiliated enough to find thought again, in purer pastures ostensibly outside of this humiliation, we return and double the inaugural thorn of humiliation back onto itself. The problem is that people think that with the more 'knowledge' we acquire the less humiliated we get (the less humiliation occurs within thought). Even after a type of theological humiliation fades away (the humiliation that we do not have a teleological purpose or Father) other humiliations will arise.

Are we humiliated enough to prescribe what we want, or think thought should be for ourselves or for the physiology/ sympathy of thought itself?

If it is that life forces thought, then does that mean that any thought that hinders life, its growth, its conservation, will appear redundant? Could there be a thought that appears fugitive within the demands of this life-force that supports it? Isn't it always life that seems to escape thought, passes it by too quickly, forgets about it? Do we even know that life wants to let thought live? Do we even know that life is the veritable vitalist spring that thought thinks it is? This is in a sense the same question we have been asking in this essay: why does thought believe in itself similarly to those philosophers we have mentioned that equate experience to some fundamental correlative belief in its existence (its external guarantee)? Thought's essential un-belief of itself would be its very own aneurysm and indeed the aneurysm of

philosophy. Every thought that remains, after thought's un-belief, is neurosis, because, after this disbelief, thought will deny any transcendental system governing it, its projects, its relation to a 'world-view' or a 'reality', hence we would merely have mental-perceptual images, repetitions, movements, dynamics and processes of capture, apprehension and seduction that are properly and aptly neurotic.

Yet perhaps this aneurysm has already happened in one sense: humiliation is the awareness that thought perhaps does not believe in itself but simply is validated perpetually by an impersonal present that consciousness has to think in and through. That there appears a 'reality' which affirms the reality of thought every second does not warrant that thought believes in itself, and it doesn't warrant the objectivity of this former 'reality' either. The consequence then is that thought is too busy assimilating (grounding itself as a consistent operating reality) that there is absolutely no room for any intellectual, semantic, theological belief within thought about its own existence. This also means that there is no belief in a process of autonomous questioning outside of the repetitive reality that thought is undergoing constantly. The assimilation of reality's consistency and coherence in thought will always be more powerful, natural and immediate, and will never allow thought to develop itself unconditioned by this assimilation. Questioning cannot be fully real because part of this process of questioning must question itself and hence its own reality. Most importantly though, if we believe in thought's capacity to absolutely question, then in order for it to legitimately question this larger assimilated 'reality' (the reality of experience) it must be to some extent separate from it or at least not reducible to it. What gives reality to the question is the secondary assimilation of it into a larger assimilated reality; the content of the question then becomes empty, tauto-logically real (doubled and made/assimilated as real), there will be nothing in the question that questions reality because the

question has given up on itself and has laid claim to the assimilation of this larger operational reality. If questioning (and its innate need for process) were real, then we would have to assume that its vector worked in harmony with the assimilation of reality, but then questioning would always be secondary and 'grounded'/coherent within this reality, and hence the status of questioning itself is conditioned, determined, damaged and limited. The more powerful the question the less occupancy it will have within the assimilation of 'reality'. Equally, the more familiar something appears the less thought has been given admittance and the more integral this familiarity becomes within the assimilation of 'reality'.

Conversely, that thinking may have the ability to think through its own vector, its own reality or unreality (the reality of the thoughts themselves) is an extremely ambitious position to hold, and perhaps if the assimilation of thinking were to overcome the assimilation of reality that tends to constrain and locate it, we may end up having a real thinking that could be said to be humiliated with the static repetition of present instances, which pulls thought's reality along with it. Perhaps we could have a thinking against the cancellation of thoughts and their empty reproduction within reality, or on a slightly menacing note, perhaps real questioning cannot exist within the assimilation of reality (the prosaic questioning of things in relation/ adequateness to reality and the locating of things *in* reality) and instead all we can hope for is a moment of instantaneous thinking that terminates itself at the very moment it is guided into a reality and is assimilated as 'such-and-such', or a thinking that still holds integrity even in the face of immediate termination – aneurysmal philosophy.

Rebellion:
or what Man can do with desire

Immanence

Not only do *beings*[47] find themselves already 'conditioned' by a set of necessary[48] determinations (the actions and reactions of chemicals in various other compromised environments) which therefore give rise to a specific *personality* or *characteristic* of such a being, in the more complex processes of *Beings* (human beings) we mirror this very same necessity *conceptually*[49] and *phenomenologically*[50] as it were. Within every experience, assumption, 'image of thought'[51], human certainty, value, opinion/prejudice a similar *vector* secretly attaches itself to the underbelly of these 'perspectives', and shapes *Being* into a narrative, a project, a means to an end. What is this purposive vector that shifts its destination or hesitates every time I question its ability to navigate? Is it part of the same vector that directs the flower to the sun and fulfils its beautiful blossom?[52] In a sense yes, but in the human's self-positing it negates its own unwavering development and transcends its prior orientation (the natural) by relating to pluralistic circumstances: the production of *errors* or relations to other *beings* as well as the theatre of being (life). The conditions for all beings seem to be prescribed by/in systems and patterns of variability and invariability within matter itself. Because environmental conditions lie within matter itself (and vice-versa), the organism and its environment are in-fact co-dependent and fundamentally from the same one substance (monism). In this sense, there is no essential causal relationship between an environment and its entities because both influence each other and are ruled by an oscillatory development between them (symbiosis/constant conjunction). Epistemologically cause and effect is valid and pragmatic, ontologically however it appears too crude and irrational. Even Humeian 'ideas' such as resem-

blance and contiguity will never give us a deeper, contextual, realist or holistic intuition of the world. This is not to say that there is no temporality/duration that works upon things, but that an entity isn't ruled by time any more than such time is ruled and expressed by and through its objects. One may agree with this symbiotic, co-creative approach in regards to the human and its environment but others may argue that the notion of 'presence' is the most influential factor in the creation of life-forms. If an entity isn't there to be present within an environment, then there would be no catalyst or object that would manifest life. The flaw in this assumption is that some people wrongly associate presence with the constitution of entities/objects and *conscious* objects (what is present is what shows itself to be present) because they are more immediately empirical, but the 'presence' of a various manifestation usually denies the presence of something else happening or conditioning such a manifestation at the same time. Why would you grant presence to the ringing of a bell over the presence of the earth itself, and why would you confer the presence of a wave crashing into *you* more than any other wave in the sea at that particular moment? We also begin to see that the notion of presence is one that is in relation to the 'subject' and so it involves the notion of proximity as well as temporality. Equally, *life* is found just as much in the enabling conditions of life as well as in the organism itself. One finds it hard to associate presence with environmental conditions unless such conditions manifest themselves in proximity to us (some people assume that environmental conditions have presence only insofar as being expressed through the objects that *present* various transformations)[53]. Did Aristotle not make this mistake when he stated that 'matter exists for the sake of receiving its form' and associating form as object and matter as some ephemeral illusory substance that lacks any characteristic? The truth is that all matter is already formed in some way and is touched/figured by its own presence within a system and environment. What would matter 'look' like if it

weren't figured by form at all?! Is there not an idealism in this form of 'neutral' materialism? We are denied the possibility to conflate matter and form as the same active/present substance, and we are denied the possibility to conflate the ever-trans-forming forms of our thoughts with the forever extending electric impulses that surge through the brain and soil and relate every-thing back to the One. To reiterate: not only is life co-dependent on environmental conditions, the entities that manifest from such conditions will equally transform these conditions again, and these 'conditions' themselves are already a type of entity/organism. 'Environmental conditions' should not be seen as some pre-existent bare arena, but are actually already made-up of these micro-relations between the manifestation of particles in relation to other particles, and ergo, the reconfiguration of these relations via its presence within that relation. Also we have found that 'presence' is itself a relational concept insofar as it demands both an entity to be 'aware' of such presence (to be temporally consti-tuted) and an entity to *not* be fully aware of all presence (omnipresence), or else it would not inhibit the experience of succession/duration, and from the other side of the relation something must be present *upon* something for there to be presence at all (whether in – as I have already mentioned – the *awareness* of presence in consciousness, or by the constituting production of presence through the subject/entity (ies) (the possi-bility to transform from one possible outcome/action to the next). Time is expressed through humans and entities. Humans and entities produce and present the constituting process of time. For time and space to 'exist' (and to exist in unison) the notion of *presencing* is inevitable and necessary. Space has presence within time (present's time) and time constitutes, drives and manifests itself as a constant presencing of itself (a constant reconfiguration of its properties). If there is anything ontological it is the absolute[54] status of the *reaction*; the oscillation between an atom that *presence's* itself (as it must do because it is part of space and

time (even if it is merely an atom of time)) and the holistic and constituting effect that this will have on itself and its environment. At this stage please note that this notion of *presencing* should not be misconstrued as *presenting* because a lot of this presencing cannot be seen by the human eye. Presenting can only be seen in proximity to a subject – by being close to its various manifestations (through experience) and by it being visual (not super-micro or super-macro). Presencing is everywhere all the time, and its refusal to be tailored to human schemas of knowledge (idealism/empiricism/cause and effect/past-present-future/linear-cyclical) allows for various meta-'physical' accounts of the subject (examples being Nietzsche's notion of 'eternal recurrence', Bergson's 'pure memory' and Hegel's 'deep present').

Time and space will never be able to be solely located in *one* of these arenas (the human/biological organism or 'the external world') and in-fact the presupposition and linguistic proposition is a fallacious/ transcendental one. Yet a pluralism of temporalities do occur within the same general environment: the intensification of life expressed through the mayfly, the intensification of light in relation to the rate of photosynthesis in a plant i.e. not only does the symbiotic relation between entity, environment, duration and presence constitute specific expressions of these 'prior' qualities (organisms), but also these very organisms will shape this environment along with *a unique sense of time* that will be ordered and mobilised and will set a precedent to the following activities of their race/species. We are strange instruments of the materiality of time and space[55]. All the most complex of entities will hold this temporality and spatiality for all time, and it is found in our capacity of presencing whereby we construct our reality. Our reality is fundamentally based on what we think of as present: proximity of our thoughts to a material body, the presence of manifestations and ergo communication between these present manifestations, and also the presencing of scientific discourse which gives us a type of consistent

framework for orienting ourselves (presencing of 'cause and effect' and the *presencing* of manifestations which are *presented* through analysis). In this sense presence is *immanence*[56].

Manifestations of the past always have to pass through the presencing of the subject to be acknowledged as such (memories) and the presencing of memories will always be subject to a further history inextricable from time, yet sometimes undiscovered by the thinking subjects themselves. We live in a sort of simulation of perpetual presents which constructs socio-historical *being*. The realist might say in relation to this that time is being supplanted by the perpetual presencing of being. The idealist or correlationist may say that for time to *be* at all it has to manifest as ever-changing presents. But why do these perpetual manifestations of presence (becoming) have to be limited to the human purview? Time's constitutions of objects (and an object's actualization of its time) exist and are present through different *modes* (of being) whilst still remaining in the same presence/present (ontological univocity). Even before the existence of *human* beings, this presencing was felt throughout the land, between rocks and minerals, between every inorganic and organic object that constitute presence (and vice versa). What differentiates us from all other organic and non-organic life-forms and their conditions that manifest themselves is *not* the presencing of their manifestation, but the appearance that this manifestation takes as a posteriori to its own reality and actualisation, in formation with its own possibility of existence (self-consciousness). The phenomenologically necessary structure of presence does not mean that all objects and their activities are idealistically aligned to our senses (or that our *being* makes things present), but on the contrary, that we are but one entity within the presence of life, and we are limited to seeing some of those presences and not seeing others, depending on whether the presencing of those entities share the same spatio-temporal remit (proximity to us, a size that is apparent to us, within a spatio-temporal framework

that we can cognitize and experience). 'Presencing' is not a specifically human phenomenon or conceptual zenith; rocks do it, waves do it, elements do it.

Proximity is key in the deconstruction of the anthropocentric, transcendentalist account of 'reality'. Reality, as one world or nature, seems legitimate in relation to our *proximity* (an object that further holds within it the objects of being). However, as soon as one inverts proximity into distance, one realises that the earth could be a speck within a larger 'reality'. Such an infinitesimally small speck (or 'large atom') that its status as an object and operation within a larger structure (of reality) could be seen to be as insignificant as the way we view a dust particle within our own image of reality. Hence, the criteria for human (empirical) reality is held within local objects and their relations (proximity as 'near-ness' in relation to us and proximity as size in relation to us) and not some transcendentally real or objective sphere that we have decided to correspond to the limited workings of the human mind. Immanuel Kant is aware of this and attempts to speculate the 'conditions of possibility' for us to experience 'reality' through human experience and rationality alone. As a consequence we are rewarded an apparently comforting tautology: the world 'out-there' , which we think/posit, is a product of the kind of thoughts we naturally acquire as rational human beings. Running throughout all these theories – repressed in the background – is a presence – neither explicitly empirical nor conceptual – that reaches out and connects to a world outside of these constraints.

The Consequence of Creativity

If this metaphysically formulated view is even slightly correct, then this *relation* that I speak of, which constitutes life, is constantly and relentlessly *creative*[57]. Even if we go beyond the solely physical account of this natural creativity and look into the way humans schematise their environment, adopt the capacity

for language and communication etc., we see the possibility to make variable a set of invariable rules (as linguist's such as Noam Chomsky proposes). However, if we make *everything* creative we conflate creativity with life (and vice versa), and if we consider everything to be creative we also empty the word creative out of any normative content. What does it mean to say that an earthquake is creative, a mass-suicide, a snowflake? If everything is creative then *nothing* is creative[58]. I believe creativity presupposes both agency in the reconfiguration and production of the world, and a form of *negating* various prescribed circumstances in order that one may create alternative manifestations. The irony in my stance here is that *this* formation of creativity is *against* the natural purposiveness of say Aristotle's *final cause* or Hegel's dialectically unfolding teleology, because it upholds that creativity must be distinct from this loose mystical form of determinism, that creativity's instinct is in its straying away from the notion of a natural development or a self-fulfilment of its properties. My creativity is one full of error, 'non-natural-ness', and perhaps for creative reasons we should integrate this desire for the error and the refusal of the natural order to be *sin*. And if creativity doesn't seem to come from the 'natural', then this sin rightly places itself within the supernatural and *transcendence* pervades again (in Christian form)? The inaugural thorn that inspires human creativity comes from a tormenting question: how can nature be both purposive and free at the same time? How can creativity reach its full potential within a nature that is ostensibly both uniform in its laws and adequation to empirical observation? Even if we conflate these two terms (purposiveness and freedom) or confer that nature contains error and deviation just as much as orientation and conformity, we still cannot help from rebelling. It is "a rage against life...as it is" (Georges Bataille). This is my Promethean inclination, and it is to our own detriment that this particular 'transcendental' version of creativity is yet another vector of desire (a specifically human

one?), a making singular and stubborn of the plural and impersonal possibilities of life. One might ask if we should take this thesis further and proclaim that all *virtuous* human creativity should stem from an initial form of rebellion? Equally it is not too hard to make an analogy between my desire for creativity (as a specific form of human agency and negation) and that form of creativity which the Enlightenment left behind (individual creativity/genius) mixed with that strange Russian/proto-nihilist/anarchist/existential desire for negation, rebellion and destruction seen in twentieth century literature on *the individual*.

Desire

In the twenty-first century (and for all centuries prior to this) the relationship between entity and environment has changed through the advent of different thoughts and rituals. The human being can superimpose a multiplicity of designs upon its world through concepts, perception and formation, and regardless of the argument that there is an essential nature within us, the human can excel within these constructed designs to such an extent that it will soon find itself alien or ignorant towards the more 'naturalist' relations to its environment. Influential systems of thought accumulate and disperse, changing our 'first nature' into 'a second nature' (and perhaps third)[59]. There is a collective heartbeat, but instead of a physical/social body, it beats within a metropolitan body of desires, mediations, skipping and connecting synapses, creating conjunctive and disjunctive syntheses. It is all unreal if we accord the notion of reality to either concrete experience (reality based on sense perception and the material order) or our connection to universals/absolute reality (Plato/Hegel). The twenty-first century seems to be neither of these but rather *simulations*; of an order that is said to exist, laws that are said to be in place (social, civil, moral, ethical, political, and architectural) and perceptions that appear edited, super-enhanced and fettered with hidden political, sexual, moral,

social and consumerist agendas. One no longer *encounters* rules due to deviance, transgression or simply nonchalance, but rather assumes them, even expects them.

Where do we locate *desire* within this simulated context? It would seem that all desires are historically formulated. The desires of the twenty-first century (in its ironic prudence) seem to terminate at the point where they are recognized and consumed: sexual, social and monetary status is recognised through achieving such superficial aims, and desire usually acts as locomotion driving states of 'un-accomplishment' to states of 'accomplishment' or sadness to happiness. It is a prudent desire because it is dismissed at the very moment when it is realised (both in consumption but also in the subject's reflection of his or her own desire); the film spectator is happy to feast on his/her own desire in relation to the exposed actors only when s/he cannot be caught in this very act (separated by a screen, within the darkness of the cinema); the nymphomaniac is destined and perhaps content with his or her sexual impetus, but generally only within a private sphere, and with his/her own body. Equally pornography only attains a 'sensible' desire as it is produced under certain restrictions within the context of 'entertainment' (depending on various other elements such as music, lighting, choreography etc.). The 'everyday' reality of kissing is exempt from most pornography, seen as being too 'intimate' compared to the physical 'depiction' of the act of sex. We seem to equate one that revels in ones own desire as arrogant, narcissistic and hedonistic. We seem to equate desire to weakness (as we are propelled by something against our 'will'). A thorough repression of desire has taken over through the institutionalization/extir-pation of madness/the mentally ill from society and through the proliferation of a work-place mentality which insinuates that a practice of desire/expression is antithetical from its main policies and ideology.

The desires of the twenty-first century in a sense cover-over,

restrict and *restrain* the real liberating desires that they originally prophesised (in the name of social Puritanism, which is obviously historically constructed through the values of Christianity). These desires themselves seem to be constituted by the non-subjective agencies of cultural and economic corporations, and hence such desires are not human. We transcribe these desires *as our own*, yet we do not own them and we do not even desire them. If we want to save desire, then we cannot accord it to that purposive movement towards some goal or other (mere locomotion), especially as such movements are usually the effects of some larger determinate structure, which is constructed external to ourselves. Similar to Descartes' deceitful 'evil demon', such 'desire' may have been 'tapped' or simulated by some untrustworthy corporation or group of power. What principle of reality can we find here? Desire is here used as a means to an end (consumption of objects of capital that fulfils the pleasure of the subject and sustains/enhances capitalism's reign); it is used as an exterior determinate structure that attempts to sever itself from the human in order to catch it from a distance. However, when desire is conceptualised and affirmed as 'subjectively' or transcendentally constituted, what happens? Desire that cannot be fulfilled, that arises out of a subjective space that hasn't been colonised by the entertainment machines of desire and distraction is a desire which desires desire *itself*, a desire to drive oneself to oblivion, a desire which is a completely uncompromised sexual fascination, fanatically religious desires, a 'will-to-truth' of the rigorous philosopher or academic etc. Are we saying that desire desires the most inside of a human? Perhaps. Are we saying that desire within the subject has no boundaries when we know that it does in our society? Perhaps. Are we saying that the making subjective of constructed desires (our identification with desire) gives us some agency? Perhaps. The process of humanizing desires (neurosis) always seems more threatening than the impersonal tools of desire we find within capitalism (we are

scared of the obsessive man and not the obsessions themselves...there is no such thing as an obsession itself). 'Desire' in capitalism is really *seduction*: a product brings us closer and hopes that we will add it to our desiring world. The problem is where does seduction end and desire begin? So many of capitalism's products are already embedded in the discourse of desire, they were made as chess pieces to a game of pre-existing desire, they were perhaps made with desire in mind.

Perhaps we are simply exemplifying the possibility to *name* desires (to identify with desires) and are therefore disregarding the milieus that construct the various games of desire and the tactics involved in *playing its game*.

Nietzsche looked to the Greeks for exemplary formations of desire (we already see the dominance of their desire and their knowledge of the games that constitute such desires within their plays/tragedies and their philosophers), but today's desire is linked to a wider history and oriented towards an alien future: idleness, anxiety, complete compliance, immersion, austerity, miniature objects and products such as toys (technological or otherwise), the desire for décor, fashion, machines, non-sensation (numbness/distraction), mentally and physically *disabled desire*, all under the auspices of an encapsulated social desire (a desire that formulates rules, etiquette, inclusion and exclusion)[60]. We are not condemning the contemporary games that pervade in our epoch (capitalism, society, politics, gender, creativity, love etc...and their inter-connectedness) nor those 'private' games that stem from the same sub-structure (individual moments of reverie, miniature hobbies and routines that involve some further miniature context of desire). The critical question is whether there is a line (moral, aesthetic, political) between those practices/games of desire that we believe we intentionally participate in (for our own pleasure/virtue) and those 'other' practices/games that we unintentionally participate in, that we believe to be oppressive and infringe/violate our

desired status as liberal humanistic subjects.

Perhaps the key to true desire is to accept that in order for us to respect the sovereignty of desire (on its own terms) we must not be able to obtain it. Desire is a *process* and not a means to an end. Therefore, the social and cultural processes and systems that capture and monopolize desire (as consumption, as entertainment, etc...) vanquish true desire as soon as they are mobilised.

In the first instance, desire could seem to be produced by external objects (the object causes the effect of desire upon the subject) however, for this object to be desired, it must already have been prescribed within the human world of meaning, language and society (which creates status, power, notions of the exotic etc...). Even the notion of an object is a human concept, which is not without an undercurrent of desire. The concept of object allows the possibility of both appropriation and objectification (both processes of desire). Capitalism's biggest secret is that it does not wholly create desire but only leeches off the subject's generative desiring capacity. If we humans knew this there would be trouble. Capitalism presents us with one answer, one product at the 'end' of a desiring path, a residual futile approximation of the sovereign power of human desire. Hence, desire itself becomes conformist, is mass-produced and streamlined, repeated and normalised. Along with this pernicious process, the contradiction of capitalist desire is uncovered: desire, being 'beyond good and evil', is capable of bypassing morals (desire works on its own terms, regardless of prescribed rules), yet capitalism (and society at large) seems to attempt to demarcate the boundaries of these desires and allocate them as either 'bad' or 'good' depending on the processes that are carried out by this desire and their end results. Capitalism cannot manage desire, so at the expense of its possible implosion and failure, capitalism has to nullify desire so as to control it, thereby decimating the human's true sense of desire. Most of us cannot

remember a time and a desire preceding this event. However, desire's fervent impetus is oozing itself out of late-capitalism as a consequence of this nullification. It came out of the twentieth century in the form of 'anxiety', 'perversion', 'illness', 'insanity', 'crime', the controlled distribution of 'intoxication' within alcohol, the sedated distribution of 'hilarity' found in comedy productions, even the content of some of these capitalist images and slogans themselves had hidden deep within them a kind of madness, a type of giddy consumption and nihilism. I am in no way saying that desire is subjectively constituted, it is a game that needs relations, *but* a subject can make new games, and an encounter with new games of desire can also create new subjects[61]. Similar to the abhorrence of repression within psychoanalysis, these 'oozing' residual, ill desires occur because capitalism gave us something that it thought we would be content with (a product), yet our desire outstretches it, and those manufacturing companies have to now feed us another pill so that we do not get some type of desire withdrawal effect. This withdrawal (or simply this acknowledgement that our desire hasn't been gratified) is repressed in today's society, yet it comes out in confusing bouts that contain more intensified desire than can be measured (neurosis and anarchism).

The truth of desire has a rebellious aspect. It is fundamentally rebellious because desire has a way of individuating, and even constructing, subjects. The desire located in the Trojan War starts in the most intense of places – the individuals Helen, Paris and Menelaus. The spring of desire in Antony (Cleopatra) manifests itself in a rebellious form against Octavian, and essentially the entire Roman government. In this sense, desire is a form of micro-fascism in that its manifestation is uncompromisingly individual (even though its essence may perhaps be social, biological, universal). Desire wants more (hence it rebels against its former realisation of desire) and commonly feels counter-rational or counter-intuitive (hence it rebels against its own

subject) and finally alludes to a place *outside* of the subject (and hence rebels against the identity of a subject and the supposed origin of this human desire).

At present there appear, in a simplified way, two forms of rebellion. Firstly, there appears to be the rebellion against the old concepts of determinism and the limits of our physicalism, resulting in libertarianism and idealism (to name but two). Secondly (even though I have not witnessed it yet) there appears a form of rebellion that does not seem to care about such humanist/philosophical concerns as determinism and physicalism and instead is simply concerned with existing social orders and their deployments of power (inclusion/exclusion) which can be encapsulated by the term *politics*. However, these two forms are inseparable. Our concepts of politics are based on philosophical formulations of agency, individualism, egalitarianism, freedom, morals, ethics and reason, and moreover such concepts are posited and acted out within an already prescribed political arena with limits, rules and set values[62]. The revelation that desire both constitutes the subject and is constituted by the subject is a Power that flies in the face of all those traditional philosophies that seek to maintain a dichotomy between thought and materiality, body and mind, external conditions and internal processes etc.

Owing to the fact that today's political unrest is in a state of slumber, and that 'the proletariat' is considered redundant (in that it appears both un-cultured and generally recognised as a term that was thrown on the scrap-heap of history a long time ago), perhaps it is worth utilising this *first* form of rebellion through the tools of the metaphysician and the naturalist to coax out the rebellious impetus in subjectivity (as a desiring subject). In a sense, the 'ivity' of subjectivity is desire (and/or the possibility of inhabiting desire). Only through the vistas of biological mechanism/hard determinism, the futility of linguistic correspondences towards reality, the walls of the body and its relation

to sociality, the austerity of the hard sciences, the control and punishment of political regimes and the conformity of global capitalism can we at least remind ourselves of what our dangerous rebellious potential *was*. Perhaps we can find that *philosophical* desire, to break out of all pre-conceived models of the human, once again (philosophy being an act of rebellion itself).

How I understand the philosopher – as a terrible explosive, endangering everything...my concept of the philosopher is worlds removed from any concept that would include even a Kant, not to speak of academic "ruminants" and other professors of philosophy...[63]

As we humans view the light of a burning star that has already burnt itself out years ago, we can once again find our own incendiary rebellious impetus using the emanating light that still lingers and provokes. But what happens if we saw ourselves as pure rebellion (such is a burning star)? We would rebel against ourselves until all polemics were burnt out...this would be freedom. We would rebel against the concept of rebellion *itself*. And this is what we must do. And to one day ask for more boundaries, more objects and more obstacles, in order to consume in an antagonistic rage – would this not be heaven? Perhaps it is to the cosmos that Man should turn?

Being

At the stage where the human has the capacity to posit itself, it does so, burdened (or connected to) the materiality and desire of its 'former' self (natural being that is a necessary outcome, contingent, and strives towards the conservation and development of itself). The content of human consciousness is therefore a picture (perspective) of this 'natural being' and is necessarily limited, specified and given expression through its

materiality. If the flower could think, its thoughts would be 'flower-thoughts'. In other words; the content of thought is like a painting, in the sense that the content and appearance of the painting is naturally a product of paint *itself* and not some universal language that can be understood and posited by every entity in the world[64].

In this sense there is an originary and unique determination of Being within a material entity before this being identifies itself (however consciously or unconsciously) *as* a being. Simply stated: there is a material identity which precedes and conditions conceptual identity.

What is important here is that Being is not an attribute that some entity or other acquires (or adds on to itself) but is something intrinsic to the bio-sphere of life (even within inorganic matter)[65]: presencing as being. It is the *nomination* of *Being as identity* which is in a sense a supplementation of being that auto produces the 'subject'. There is no need to call an entity a subject constantly. A subject manifests itself at times when one is conscious of itself as an entity that is being *subjected to* something or another, or when one is aware that they are 'subjectifying' (Foucault/Deleuze) a process as internal to one's identity i.e. turning pain in relation to external stimuli into a fear of pain and a subject under the threat of pain.

Most beings that become aware of their own presencing structure (as an entity) whether consciously or not, seem to use this 'consciousness' as immanent to and continuous with its self-actualisation or development as a material object. One might argue that the distinction between conscious operation (in the organism) and material operation (in the environment) is non-existent. If this is the case then the strangest deployment of Being can be seen in the human-positing of its *being* in consciousness, as a consciousness that can waver between 'blindly' accepting a furthering of that being's characteristic through the activities that consciousness gives it, or reflecting on its own organism that is

under the conditions of Being and consciousness. The latter reflection in humans seems to strive off a meta-semantic process whereby it consciously attempts to sever itself from what constitutes it as a 'subject' or organism as opposed to affirming it. That is, it thinks itself as a subject outside of the immediate and immanent world of stimuli that it is within. It even attempts to forge a gap between itself and its environment in order to think itself adequately/rationally. In a different sense, the entity attempts to think itself as *identity* as opposed to thinking itself as immanent to the relations that construct such identity (the latter being a Spinozist approach). Perhaps one even tries to think themselves as a subject without object (and thought without being). One can spot this wavering problem in the term 'utility' (which Hegel does) whereby utility could suggest a larger system of utility (life) whereby an existent entity is simply part-of and a furthering-of that process of utility (which would denounce the absolute)[66], yet the term also portrays a type of dichotomy between what is utilizable and non-utilizable, or what is open to utilization and barred from utilization. In Hegelian language *utility* pre-supposes *entity* (there is no utility if there is no*thing* to be utilized), hence consciousness is a furthering of the organism's utility whilst concurrently substantiating its thing-hood through this utility.

It appears that consciousness ('access' or 'self-consciousness') can only be posited *in the last instance* and is hence chronological[67] and mediated. In the last instance we perpetually find ourselves thrown back onto a *surface*, determined to seek out questions-of-depth upon a shallow language that utilises meta-principles such as metaphor and generality to seek truth *outside of* the 'subject's' immanent existence. Heidegger realised this in his later work when he became horrified with the two-fold reduction of experience into an object's present representation to the mind and the subject's present desire to grasp its object.

However, Beings *other than* us and the more or less compatible

and continuous conditions of the material world hold infinite and alien encounters which provoke, enrich and antagonise human thoughts and its projects. Equally, the 'thinking-content' that is characterised by the material conditions and utilities of the human, when positing itself, is a content which is nevertheless content-less[68] i.e. – consciousness. Furthermore, one should give specificity to the many beings of nature, but not in a limiting sense: to limit any Being to the immediate context in which it finds itself in, and the modes of expression linked to its body/genetic structure, is to ignore the fact that Being must be related to other beings and even entities in the universe that appear inorganic, microcosmic, macrocosmic and exist outside of the stratosphere. One may argue that this speculative or transcendental element of Being does not effect the natural conditions that characterise something as 'such and such', but what of the scientist? Does his/her interest in the world outside and beyond him/herself not constitute him/her as a specific being – a 'scientist-being'? We can say this about any being that aligns itself to a set of values which do not appear immediately 'present-at-hand' or imminent to phenomenal consciousness? Infact every being constitutes itself speculatively to things that are 'outside of themselves' and this can be readily seen as a characteristic of their Being[69].

The formation of the proto-human brain might be genetically prescribed through the constant nurturing by the mother, the biological conditions that permit such nurture, and by the community that enrols the brain's consciousness as 'such and such', but its relation to *Being* is unpredictable when confronted with experience, and appears only as *resistant experience* due to the protection and comfort which these prior factors have deployed.

Don't get me wrong, the production of biological organisms *are* (they have being), but they are not reducible to 'bare' organic material processes because patterns of symbiosis and collective

movement are vital to the destinies of material processes (the formation of life), and such formations are *connected* to vistas outside of the organic and the stratosphere, and are equally generated in the formation of sense and non-sense (symbolic behaviour).

A human does not have to know or affiliate with Being in order to *Be*. Being will always be more[70] than what society, environment and language will present itself as (or make manifest). To give potentiality to *Being* one must accept the ephemeral ridicule of 'being a metaphysician' or 'a transcendentalist' when one is actually refusing the claim that *Being* must present itself completely within the criteria that it has come to inhabit/enforce (conceptual, sensible, rational, empirical, linguistic, objective, social, historical). This refusal is all the more important at present, in that Being has been reduced to this remit within our epoch and has become pejoratively instrumental to the carrying out of tasks (pragmatism, capitalism).

Between the vast potentiality and sublimity of *Being* (whether in the infinite vistas of experience, the feeling of life or the revelations of thought) we seemingly act these intensities out (we naturally exaggerate them) on a platform made up of space and time. Can Being exert itself anywhere other than this realm of space-time, indeed, can it be said to be anything fundamentally distinct from these realms? My being has a relation to the universe (ad infinitum?) and some of these relations I cannot comprehend nor show in the realms of conventional/empirically correlational space-time. I also have a relation to rocks and 'atoms', dust, blood-cells, sound-waves, various physical decay rates and amoebas where my making manifest these beings sometimes betrays their presence in and to me. Perhaps I expose my own infinity and my connections to the inorganic dangerously within the troposphere of biological, oxygenated life, similar to how obligate anaerobes (micro-organisms that do not require oxygen) exist dangerously within normal atmospheric

concentrations of oxygen. How does one relate to a world if that relation, when intensified, can kill you? How can we remain so thoroughly embedded and so thoroughly exotic to the world?

Many would suggest that I am wrong however, and will not hesitate to inform me that a prior universalizing concept of space and time are within all the concepts and images human minds have, they 'ground' them. Some will say that my thoughts are only moments that are instantiated through our shared, learnt assimilation of language which will refer to my experiences via my brain ("I am at this moment hungry", "I feel cold"). Social behaviourist theory will tell me that we learn how to feel and infer emotions through the external behaviours of other human beings in a variety of situations. In this case we could all be performers: I run into the town, take all my clothes off, and sob. The content of this act is merely the act and what it *represents*. There is a tautology where the representation of feeling *is* the feeling (extensity *as* intensity).

What this anti-idealist, realist, naturalist and physicalist disenchantment of *Being* produces is an overwhelming sense of the body (embodiment theory), the flesh (biology), the brain (neurology), but also perhaps a vulnerability and naivety towards the body itself as object: we begin to see in notions such as the 'master and slave' relation the physical domination of one man over another, and the appropriation of consciousness from the 'for itself' of an individual to the 'for someone else' of say a leader or organisation. We also begin to interpret the subject (body) as site of humiliation, whether this is in the New Testament (predominantly in *The Passion*) or in its modern re-appraisal in Existentialism (the subject as authentic individual against the impersonal forces of capitalism and social consensus). Any relation to frameworks such as the 'cogito', the private 'inner language' of the subject, the subject's relation to infinity, God, the life of the mystic, has been left undiscovered, and the humiliation of the body and its relation to systems of power and discipline

remains. As well as this being extremely reductionist it is also, as Nietzsche stated, 'human all too human'[71].

It is to my belief that the terms 'lost' and 'lonely' emerge from out of this objectification and humiliation of the subject as negative and reactive themes. The above terms manifest generally as Man's alienation from other Men (his society/home) and Man's poetic impossibility to think his relation to being, knowledge, truth, nature, and his/her own ideals and values *outside* of the very constructs of these terms and what they have come to denote *within* his/her society, history, language and culture. What if we were to think about the above terms generating from *ex-nihilo*? This is surely a sublime feat. What if we humans were the only true bearers of this lost and loneliness, whereby our strange nomination and characterisation of these terms only existed within our culture and disposition (thus being truly lost and lonely *within* us)? What if we were to see these terms as a provocation? Could we *un-think* the terms of being lost and lonely (equally rethinking the position and status of the 'subject' in relation to these terms), or could we rethink these terms as illusory, semantic and political master-signifiers that have come to define our disposition as a species and hence could be traversed (in Nietzschean fashion) with a further re-definition of 'Man' and his relation to the universe? Can we reorient the lost and the lonely away from the solitude of the body and mind, a loneliness which has buried itself into the human reflex and manifests as the absurd idealism of the potential threat of *bad faith*,[72] or the ostensible loneliness of the 'internal' world of the human projected onto the 'external' world? Furthermore, perhaps the possibility to think 'loneliness' is a transcendental or conceptual feat whereby we have learnt to discriminate between the limits of our knowledge and something Other, which is different from us, beyond knowledge, alone from us, and even above (meta?) our designation of what loneliness is? Is it possible to think a loneliness which precedes experience and knowledge

(this originary loneliness creating thought itself i.e. a loneliness that manifests as one person's separate thought in relation to the next person)? Is it possible to think the lost as not being a specific relation to me, perhaps not being exhausted by any relations or any entities? The lost as *absolute*?

Could we speculate (perhaps dogmatically) that the lost and the lonely come from a more primitive, material basis? For example, when I spoke of the human positing his/her existence (self-consciousness), I spoke of it as a reflexivity that is shaped and finds expression through its *nature* i.e. its entity, its characteristics and ostensibly its limitations. Perhaps the feeling/concept of loneliness too comes from the pre-human, even pre-living material occurrence that distinguishes X from Y; that X it is *not* Y. Is to *not be* X to be lonely and lost *from* X? Amongst many things this could presuppose a pluralistic *substance theory*, a theory where objects lie side by side never truly (or directly) interacting with each other, and also, the loneliness of substances from their attributes[73].

The 'lost' and 'lonely' which we find in western theology, Renaissance – Enlightenment – Modernist literature, all psychology, and Romantic-Impressionist-Modern art is, in a sense, a *weak*, dependant and romantic representation of these terms. It is a humanist conception of the terms (and by that I mean Christian, anthropocentric, naturalistic). It desires a fundamental *Other* which will overlook, judge and justify our human actions (generic human justice). Its requirement is that the human relation to the world is more important than any other relation to the world; in this sense it views the human relation to death (mortality) as a highly emotive and pejorative process (again there is a type of narcissistic 'woe-is-me' self-inflicted characterisation of the subject which is affiliated to the reduction of Being to the body and finitude). As I will elucidate in the next essay (Vertigo), the construction of language and the integration of language into all areas of lived experience produces ostensibly

originary distinctions such as 'self' and 'other', 'subject' and 'object' (which gives rise to the alienation and humility of the subject) and, in a sense, occupies all concepts which do not have the elasticity and emotive force to traverse such fixed correspondences to words. The determinism that words seem to have on the conscious subject (and not vice-versa) places the subject within a system of syntax that contextually and relatively creates meaning: meaning as both denotive (" x means y") and meaning as the linguistic instantiation of inner feelings such as guilt or love ("I feel x"). Language not only creates conceptual – and hence phenomenological – distinctions, it also attempts to convert/relate itself to everything; all objects[74], dispositions, events, sense-making, sensibility etc., thus determining a 'lost' and a 'lonely' that is always lost and lonely *in relation* to something else (similar to how a word and its significance is always actualised in its relation to another word or a larger whole). One might ask what is so lost and lonely about this sort of *construction of* the lost and the lonely through words, *shared* language – socio-historical being.

Vertigo:
the lost and the lonely

I. Obsession

For me, there seems to be two forms of being utterly lost and alone in the world, which peculiarly cancel each other out: a lost that traverses any notion or identity of the 'found', and a loneliness which traverses any origins to a cognitive, emotive, theological, paternal or maternal *Other*[75]. A destruction of the terms lost and lonely, which although attaining a power that cancels their meaning *for us* (the object/subject that is lost and lonely), does not vanquish the somewhat contradictory truth of the external plausibility of lost and lonely *states* that pre-exist identity, home, nature or world. The question here could be posed as whether the words 'lost' and 'lonely' with all their denotations and connotations can help us in describing character-istics of things outside/external to these concepts/nominations (or help us in determining a non-conceptual 'lost' and 'loneliness'). For example, separation of matter[76] within the universe (or *as* universe) is very real, but we do not equate it with the semantics of human separation (from some thing or other) even though matter attains its identity/entity as separate *from* other material entities/processes, the determinations of an 'object' or the separation that is found within the transformative processes/reactions between chemical substances[77]. Material difference has always been a differential force regardless of the capacity human consciousness has for differentiation (taxonomy and phenome-nology ('that which appears'). Re-orienting the notion of external lost and lonely states in this way (as 'objective' separation or the separation intrinsic to 'objects') might be valuable, but one could also make 'subjective' material (matter) in order to imbue it with the terms lost and lonely that we often associate it with (subjec-tivity as material affect within 'experience'). Nature *as* subject is

subject to various determinations of its own actualisation, and what if this nature-as-subject was unaware of itself *as* a subject (identity), or unaware of its consciousness (as consciousness is a form of objectification which it cannot fully invest in as it is necessarily a subject which precedes such objectification)[78]? Would it not then be cogent to suggest that all such 'materialist' or 'monistic' metaphysical insights, if correct, would indeed create and pre-suppose these ostensible human conceptual terms (lost and lonely) as secondary, hermeneutic nominations of this original schism[79], and not vice versa (or at least that they share the same fundamental identity)?[80]

If one, in a sense, transcendentally cancels identity, then one also cancels non-identity (as nothing can be *identified as* non-identity). What we would have is complete immanent ambivalence. Other things may not be able to perform this technique and are therefore locked into and bridled with feeling lost and lonely, or feeling nothing at all. The meta-question here could be whether one could be lost and lonely within the obliteration of these terms (without identifying themselves within these terms), but this would once again postulate the validity of these terms outside of our own purview, comprehension and use. However, one does not relapse into a pre-Kantian dogmatism (where one makes the naïve premise that one can think a loneliness and loss that precedes and is external to *our own* thought), if one can locate this 'lost' and 'lonely' as existing *within* the centre of thought itself. It would allow us to navigate a thought from the void into unknown vistas, conditioning the possibility to question without a prescribed answer, forcing us to induce and deduce with our reasoning: loneliness prescribing the 'I' that thinks, the 'I' where all thoughts manifest and are justified. In many ways it is loneliness which conditions thought (to be *a* thought)[81].

On the other hand, this cancellation of the lost and the lonely by the 'subject' could be seen as a 'realist' inclination that refutes

the notion of opposites and the subject (the noun which is upheld in predicate logic) as opposed to an idealist or materialist inclination, whereby it does not serve as much to point to some form of absolute loneliness in which we are constituted by, but to state that there is no thought that lies outside of our own (outside of thought is an external mind-independent reality) is to purport that any definition of 'loneliness', 'place', 'Man', and even 'object' would be a grave idealist assumption. Hence we are lost and lonely in a universe where the 'lost' and 'lonely' do not exist (apart from in that small section of conscious beings). Hence some may come to the conclusion that we are *not* lost, or that we are tautologically lost and lonely within the very self-generation and designation of these concepts/nominations without the terms actually 'existing' in realist fashion.

In an almost Promethean[82] operation of realization, the dialectic[83] is surpassed by positing such as a fictitious logic, under-qualified for the act of surveying existence. Familiar experience seems at once based on conceptual presuppositions (which are largely products of what we could call linguistic and social 'progress'): ideas about self act quickly to become futile and unresolved (a means to some egoistic or holistic end), instruments that attempt to achieve some bedrock of knowledge (or 'certainty') seem mediated by some unfortunate and persistent human shadow or some idealistic 'view from nowhere'. Equally, the familiarity of experience seems interwoven with the body (embodying experience). Everything around us has been built with the concept and experience of the human behind it: a desk in proximity to the span of a writers activity in proportion to a stack of papers, a door in proportion to the size of our bodies, our navigation in proportion to walls, floors and ceilings, and outside, the width of roads in proportion to two cars, all 'space', all 'instruments', all objects *ad infinitum*.

The familiarity of experience also grounds itself (and expresses itself) in behaviours (social behaviourism) which only

point to a relative, anthropocentric history/ontology without bedrock, a history of the 'behaviours' of thought, and not of thought's behaviour (or non-human behaviour that bifurcates that of physical behaviour). One cannot question themselves and their Being without reinforcing those almost tautological frameworks such as the 'questioning subject' conditioned by language, the 'rational' framework enforcing such a question and its exposition, the sensibility that confronts the world and asks such a question (conditioned by the senses we have been endowed with), the somewhat crude behavioural reflex that reinforces every thought or feeling within a set-system of signs, and the stench of *human* valuing and meaning which propels us to ask such questions. All this as tautological exploration conforming within that enduring Humeian custom that induces uniformity and natural laws from the world through being accustomed to the perpetual appearance of constant conjunctions within experience (calling this habit) regardless of any external/realist or rational guarantee. What place does thought even have within this ostensible uniformity?

The 'banal realism' of experience (which sets experience into conformed, uniform instants of a purposive whole) starts to unravel itself, liquefy itself, and some miscellaneous entity or fissure begins to parade the streets of both our inner and outer lives as a bizarre 'thing'[84]:

> *"Realism gives me the impression of a mistake. Violence alone escapes the feeling of poverty of those realistic experiences. Only death and desire have the force that oppresses, that takes one's breath away. Only the extremism of desire and death enable one to attain truth"*[85].

We could pretend that this horrifying 'real' thing that hides behind 'banal reality' is the horror of the impersonal 'external world' rearing its ugly head at us, like those moments in David

Lynch films where we are suddenly directed away from a suburban decadent narrative towards a nest of ants smothering over one another, but really it is the madness of interpretation/experience that creates horror. Georges Bataille's vision of death and desire as the ruling forces of existence stems from a biological and environmental movement (a type of dark materialism) but finds its horror in the conflict with the human individual (through self-consciousness and sensibility). 'Man' has constructed from all his customs, nature and nurture a type of zenith that hovers over him diaphanously as a strange alchemy between 'meaning' and 'value'. It is this perpetual valuing of things (and ourselves) that has got us into existential fevers (similar to the illness that the Christian constructs of good, evil and morality played on us which has been diagnosed through the natural, scientific and psychological breakthroughs of the last 200 years)[86].

Horror is not in the world as a distinct form, but rather manifests as a *sensible relation*. In animal life, even plant life, we see reflexes of the organism that cower away from certain relations over others (by a principle of pleasure). If we were to look for horror in the distinct object, the object unfettered by its environment and relations, or the object 'in-itself', we would not find horror there. To say that something horrific is caused via some *external* violation is to perform a contradiction, as cause is co-dependent (or constantly conjoined) to an effect/object/subject. A 'subject' must have the capacity to be effected by a 'cause'. That horror exists in the *relation* that is the unshakeable stench that haunts us, because we are solipsistically stuck within it, even constituted by it. Without experience (human or otherwise) what would the words 'horror', 'pain' and 'fear' mean, and what could they point to? Horror is an intensity left for the specificity of experience (its zenith being human experience). If we were not diaphanously *obsessed* with experience then we would not care for the encounters that

confront and challenge it, and because experience drags along with it the notion of an 'I' we can't help but be territorial when this experience is violated. I do not experience the shedding of a skin cell, I do not experience the disintegration of a star; I experience a principle of 'pleasure' and 'pain', and to me these sensual poles are both ambiguous and horrifying. We are horrified by this horror because it acts both as our access to pain and yet individuates us as certain territorialized creatures which have the capacity to avoid and navigate through pain because of this access. In a sense, the horror of certain conditions, actions, environments and entities which are generated by our *relations* to them (and vice versa) cause us to form an idea of *loneliness* based on the limits (spatially, morally, biologically, chemically, physically) that generate our narrow states of pleasure. We would like to be alone from pain but contradictorily this would be at the expense of being lonely (to have no relations to an external world/be without subjectivity), because pain territorializes us *as* 'subjects' (there is no subject that exists without pain (the body or 'I' that is constituted by the indexicality of pain/stigma) as well as de-territorializing us from other subjects/objects.

Obsession, as such, is the new 'substance ontology'. Not constituted by impressions, ideas (Hume) or atoms (Democritus), nor generated by the humans 'intentionality' towards some object or other that would suggest a role of agency played by the human in this process (Husserl). It is a persistency neither constituted by authenticity/concern/'mineness' (*Jemeingkeit*) – such as Heidegger's Being –, nor the cogito of Descartes, but rather a neurotic vector which correlates a will-to-survive with a will-to-live based on an alien obsession with itself (within *our* self). In every entity there is this neurotic vector that modifies itself and gives it character. It is this structure that allows us to believe in 'subjects', but not of those humanistic/theological 'subjects' we see from Descartes or Kant[87]. 'It' (neurosis) manifests through the amalgamation of information (concept/image) which proliferates *itself* within the

fallacy of a 'subject', hiding the pools of micro-fascisms of power which scatter or gather parasitically both within and without the subject. We can allocate this as the 'survival of the fittest' or to adaptation theories instantiated by Darwin, in the neurotic fixity of the subject, its schema, its 'human all too human' customs, the deep psychotic repetitions found in trauma, dreams, orthodox or unorthodox processes of signification, the apparently 'objective' neutral studies in perception where colours and forms neurotically relate to 'wholes' or neurotically 'organise' themselves to be further neurotically 'identified' (repeated) and interpreted (a further springboard for neurotic constructions)[88]. Even in language, the neurotic need for stable correspondence of words to objects and behaviours (for further obsessing over) and the desire to construct a linguistic obsession with oneself and its identity via discourse, monologue and soliloquy (does this even deserve the status of 'communication'?) pervades throughout.

Inside the 'private' life of the mind, calculated, regular experience is slowly drained out, and what is left is the plug hole of an obsession. Obsession has its objects, but sometimes 'it' obsesses over the non-material and non-intentional momentum of obsession *itself*. The obsession *is* a personality (the self). It is fixated, much like the traditional notion of a fixed substantial subject which exists independently from its passing qualities (this obsession can be multi-faceted but always carries itself along through the slipstream of its own obsessive vector). This obsession can be silent, can seem passive and expansive. It can seem majestic (the self-motivating waves of joy, energy and power). It can equally manifest as a sort of burden (solipsism/self-consciousness). It can be erratic, dissonant or obstructive (the obsession of a recurring scene, image, object or woman). It can be intellectual or proto-existential: an obsession with *the question* (one does not know what to do, has no external guarantee for some action, moral, or other guiding principle). Man is obsessed by himself but has no real content, intrinsic or otherwise, but

simply interpretations. The substance of Man is his/her obsession. It is character-building without any immediate content (one does not know what the obsession is of/about). Man is much like a blade; cutting into existence, stabbing experience.

Orthodox experience is surpassed by a promethean realisation; neurosis constitutes human experience, and neurosis chooses what it wishes to be neurotic about: no longer does the positivity of solid Cartesian doubt[89] reinforce itself through doubting its own very doubt (i.e. affirming that doubt is undoubtedly real). Instead, the doubting of doubt doubts the validity of *itself*, realises that it was never really doubt, never radically so. To doubt is to deploy a construct called 'doubt', and like any construct, it has been constructed. The need came from the obsession, and the obsession itself is more real than the ostensible ground in which it came from (rational doubt). Rationalism is an obsession, but such obsession is not rational because obsession pre-ceded such a doctrine. What is this obsession with certainty and identity? Is it an obsession based on fear?[90]

II. Words[91]

The language that the critical subject uses to expound his/her doubt is already *prescribed* within him/her, his/her culture, and his/her civilization. Not only is this historical framework for thinking (language) ignorantly acknowledged as 'originary', it is also *believed-in* (is this not already a form of dogmatism)? Hence 'doubt' becomes belief, and these two historically antithetical terms become conflated. The sceptic *par excellence* is the Man that believes[92]; "a form of belief always over a form of truth" the sceptic says.

Some unknown rebellion should occur within Man when he realises that this babbling doubt finds itself always already mediated by a language of the Maternal and Paternal (or of *The Law*) i.e. it is not *his* doubt. However, can doubt ever really be

sovereign to an 'autonomous' individual, considering that such doubt finds its impetus in the collective world of values and language? It would however be naïve to assume some holistic historical framework of language in which the subject is *victim* to. Language is not some form of deity, it can be found as an event within the world, immanent to it. If Man wants to be part of the inaugural impetus of language, as opposed to being victim to it (determining thought), all s/he can proudly present us with is that primitive homeland of his: Men wondering across each other, in linguistically fertile soil, crying, begging, uttering some spasmodic murmur; hoping that communication would somehow arise from a devastatingly human *lack* and *need*. Why was language forced out through the hot spit of our lips mixed with tears? Not because of some civil inclination towards discourse but because the woman, in childbirth, bellowed, because the child, covered in sand and dirt suffocated before sense fell upon the lips of his/her screams. Anything that commences after this messy event ('primitive'[93] language) is simply a product of fallacious perseverance (for example; knowledge, truth, rationality, society). In brief: language comes from the subject's obsession with its continual existence (even though it does not know why it is obsessed with this), and language is a form of saying "no" to all forms of violation (pain) and "yes" to the distractions and repetitions of play/joy. These sounds/words are the result of external forces playing upon the subject. However, the sound itself comes from the subject and finds its character there, as opposed to say the sound of waves crashing, which is the result of external forces and their reverberation (the difference between active and passive sounds). The human's sound is active/semantic/individuated (it cannot help but be a proclamation). The waves' sound is passive/impersonal. Because of this, language has to be seen from the standpoint of the human, his/her threshold of pain and his/her capacity to bellow, and this has to be instantiated *before* the 'creative',

'systematic logic' (Chomsky) of language pervades.

The principle of this type of 'primitive' language is that it is based on the individual subject and his/her relation to the external world qua the 'I' that follows all experience. *This* form of language construction safeguards subjectivity and free-will, it affirms that language comes about through the subject's capacity to feel and to allocate freely whatever s/he sees as a threat, pleasure or 'such and such' through the designation of words. We could say, in opposition to this, that language comes about through the same circumstances that govern all natural bodies and 'laws', that it is a system which simply extends the rational design of the world and is inevitable. We could also say (in the same vein) that in order for language to be sufficient it must relate to a meaningful systematic whole: the manner in which words are composed in relation to a sentence, and a sentence composed in relation to a further whole. The consequence of this notion, as I have stated, is that it makes the subject vulnerable to a system of language which prescribes the subject and makes it slave to the variable options of that system[94], and further, it simply ignores the possibility that the origin of language could come about through pain constructing the subject. Surely the capacity to feel precedes language. Even now, if pain is not immediately corresponded to the impetus of the need to speak, it is indeed still obsessed with the 'I' that pain has constructed; "look at me, here I am" or "I can hear you, where are you?"

Even if the externalised, structural 'philosophy of language' is triumphant, the possibility that I can say *no* to it and actively create my own meaning/language that does not correspond to the politics and utilitarian pragmatism of social language/ discourse shows to me a great mark of subjective agency and a great triumph of art: the creation of sub-styles of language, styles of content, the creation of local vernaculars. Philosophy itself can be seen as the construction of a language that is opposed to the mass-dissemination of political ideals (even though there have

been many that have used it for the contrary).

The linguistic capacity we call 'questioning' is fundamentally one that has to drag its own horrendous guilt along with it, that is, the guilt that we are here today 'questioning' as a result/consequence of those other less fortunate humans that never mastered the language of safety and inclusion ("please save me!", "my mother is below the rubble!", "watch out for the monsters!"). Modern Man that speaks is the providential Man, but a providence that has been shaped by insensitivity, by a looking away at the linguistically excluded, by a Darwinian uninformed evolution, whereby the Man that can speak is the Man at the top of a pile of Jewish bodies in a concentration camp who has reached the hole in the ceiling (the light, goodness and truth of Plato's Sun).

Within the sensible relation of pain (the subject that feels violated and the object of violation), pain has already been communicated without the desires for rational understanding or even any real exchange. I say "ouch" to an encounter and thereby unconsciously communicate this "ouch" to the object of violation, to myself, and to a hypothetical being who I almost ask; "why did you make me feel this pain"[95]?

If one is to equal the original *fatal* spell of language; the cry of help, the saying "I feel" to pain (the expression of pain unconsciously outwards but without the hypostasizing of some other entity that could hear or feel our pain), then one should be transforming it, saying that which must be said, even if one cannot! In this sense, a type of primitive ethics, morality and Christianity exists at the heart of communication i.e. help (if not *help*, then thunderous joy; to speak, to thank, and to laugh). As Nietzsche once said, one learns quickly that there is an excess in the world, one must quickly give it away/share it. If one cannot sufficiently articulate and communicate this excess to one's self and others, let alone use language to affirm the free-will of the subject, then one will drown (in hermeneutics).

The substantial *questioning* subject is both ontological *and* anthropocentric (as the early Heidegger stated) but that doesn't mean that anthropocentrism was the catalyst for this ontological questioning i.e. thinking *being* doesn't necessarily have to start from the *historical* paradigm of the human individual, fettered with values[96], an 'image of thought'[97], a certain perspective, receiving *being* merely through the senses that always accompanies this 'I' of the individual subject. *Being is everywhere*. The *nature of being*, instead of finding meaning and identity within personal and collective human 'projects', may have found itself less confident to start with, filled with the awe of the infinitesimal rather than the finite intentions we are seemingly encumbered with. Descartes once said that he was immediately open to the idea of the infinite within consciousness rather than the finite. I sympathise with this. Sometimes a heavy rationalism (which at first appears overtly anthropocentric) rises above the relativism of language and touches upon a strange inhuman absolute. For example, Descartes' idea of infinity cannot be reduced to language[98] and therefore to human understanding. Equally, his principle that Man is essentially a thinking (hence non-material) thing seems to be strangely in-human in our present epoch of 'embodiment', phenomenology, materialism, objectivity etc. In effect, all thought which cannot be set to a language, and hence a system of intentional objects, can only either verify some indubitable non-linguistic identity (*cogito ergo sum*), point towards a sublime non-human ether, or act as an 'unrealisable' limit within consciousness that "defines itself and suffers the absence of that totality as a 'lack' of its own being"[99].

Questioning without language is awe. Questioning with language seems to produce the opposite effect: institutions of knowledge and rationality. However, there are those powerful dirty men that write with the belief that language *itself* has no legs to stand on, no absolute frame of reference[100]. The world is not full of immutable objects to which words could accurately corre-

spond to. The human being has no empirically descriptive and hence scientifically objective emotional state which the categorical function of words could adequately (or absolutely) refer to and represent. Is it not in-fact *words* that accidentally betray their system of signification and bring such irreducible anomalies into question (like Descartes' use of the word 'infinity' or Bataille's use of the word 'silence', which betrays its very essence)? There are even those nymphomaniacal thinkers who believe that words naturally reflect sexual desires and lusts, similar to that architect Jean-Jacques Lequeu who mirrored the natural beauty of genital form through his own architectural creations. There are even some who think that language was constructed for the sole purpose of advancing procreative probability.

The child, exhausted and naive, wants to be heard, but already something else within him/her desires a language for oneself![101] But the language of identity will always as its postulate secretly desire a commensurate language of the *two*: a grammar of reality that will validate or mirror this language, an entity which has to be identified *with* or *to* for the unity of comprehension to take place (or the realisation that it *is* an entity in the first place), a language that will trick the brain into thinking that it has a personality, desires and fears...that is...a *name*[102]. I always imagine a moment where one day a man will look down upon his body, or perhaps see his face in a passing reflection, and scream.

Because of today's high levels of subjective (and hence linguistic) conformism, to speak is to accept that what you have uttered has already been said (is in-fact a superficial, tautological response to a question *pre-scribed* by your society)[103]. A space that has been cleared for the saying of something pre-supposes the saying of it, already inhabits meaning, already rests on the shores of sense. Thought holds within it a strange character of thinking determined by language, and language has within it a strange compulsion to communicate and hence reduce thought to use/function. Everywhere in the human world, in every arena,

building, city etc., all that can be heard is the communicative aspect, and everything else is error, noise, obstruction. We have become data banks with antenna's picking up information on the basis of what is deemed valuable (the political/social consensus... and the assimilative force of language *itself*)! One has learnt to call themselves (and think themselves) an *'I'* only through the possibility of a *them* and a *language*. This could be extremely beautiful, loving and symbiotic, or terribly claustrophobic, dirty, polluted, weak, depending on which way you look at it.

This 'two' that *identity* discretely produces is not necessarily the 'other' of society (the social constitution of the subject) or the social determination of language upon the individual (the linguistic formation of the subject) but fundamentally the separation between Being and Words. The war between Being and Words is relentless. *Being* still tries to grasp words like hammers, sets them forth like ships and gives them life/being. *Words* still orient *Being's* moves and customs, still cover up and omit various non-linguistic blunders (the instinct and grit of biological life-forms, or the experience of lived duration/ sensation). In mainstream social life and discourse *Words* have definitely colonized: we have a civilization determined by (made up of) the same language and communication that actually is a tautology. If we think linguistically, and our language conveys our thoughts, then we are stuck in a vicious circle, where thought is not extrapolated or transformed but reflected back upon its own language, returned to itself and thus determined. To assume all communication (including thinking) under the remit of language and continuity is to not say *anything* other than this (it is a re-doubling and not an exchange). **One cannot 'say' anything outside of this exchange of sayings**[104]. Linguistic communication[105], like capitalism, is solely legitimated because of the mere fact that it works, by its efficiency, and this should be worrying.

The objectification of *being* through language (whether

through allocating the subject as an object or describing other things as objects) creates a uniformity and continuity which perniciously restricts and dis-inhibits the human to experience moments of intoxication, awe, joy[106] and what I will term *vertigo*. The hammer, reduced to a tool, and hence a certain restrictive 'world' and efficiency, cannot feel the humility of its own insight; that it is presupposed now, that it can never feel out of place (which is its reality). Its potential to forge relations with new situations and objects has been restricted and conditioned to several tasks. Thought has been made into this very same tool (instrumental thought). At the very beginning thought was forced to *speak* for *itself* (which is an impossibility that language has tried to amend/cover over for centuries).

Our tautological use of language has conferred language a power *external* to ourselves, which has the capacity to determine thought, its practical projects, and even the subject's psychological constitution. Forget about sticks and stones, words will always hurt people, because words designate and allocate areas of the body and 'soul' to act and react. Words coordinate the general behaviours of the human animal. If only people could see this! But this is only the surface of it i.e. our understanding of it.

The rationalisation of psychology uncovered the psyche as a socially constructed entity that plays slave to various linguistic and semiotic signifiers: the illusion of some tragic principle of significance that we seem to be bound by i.e. the *need* produced through maternal and paternal relations actualized at an early age. What are these significant alarm bells? I have fresh wind and soil right here, which has nothing to do with such thoughts…I will run across that and see where I get to. Structural psychology tells us that what we love, desire and fear are all stereotypical and archetypical constructs. The truth is that human beings will perpetually mess this theory up, make it more complicated, more singular, and more human. A subconscious without words is a much healthier one. If you can 'use' words then go ahead, but if

you are overly influenced by them you should take caution.

Descartes' famous cognitive-linguistic doubt – 'I think therefore I am' – spurred a civilization of neurotics, speaking to themselves in the name of universal progress. What we have here is a subjectivist doctrine under the laws of a pseudo-objective language. To take away the language would be to take away the distinction and classification of the world and the self. When one is truly alone one knows that they are also 'lost for words'. Words won't comfort, they were never really 'there' in the first place, just simulations, metaphors, displacements of something that never existed[107]. Or vice versa, the words were very real, but the objects and behaviours that these words were meant to refer to always seemed inadequate, never gave anything back. One will never find words *in* objects, and in this way, one will never learn what love, morality, beauty, and awe *is*. It isn't any*thing*.[108]

The Vertiginous Man cannot discern *difference*[109], his/her disgust of language (what s/he sees as the apperception of limitation/the designation of false means and ends) will not let him/her know. S/he is alone, without language and without the anxiety/alienation of opposites. S/he is 'primitive' in the sense that s/he has not utilized the 'material' necessity of language within his/her given society that spurs a civilization to ostensible progress (as in Marxism). S/he is gifted however because his/her emotions and sensibility have not been pushed down or made decadent by language (which, remember,form class structures and forms of inclusion/ exclusion). In short, s/he is not embarrassed or humiliated by his/her sensitivity and sense of importance (with heightened sensitivity comes a feeling of importance, meaning, will-to-power)[110].

The vertiginous person *cancels* the *lost* and the *lonely* through the abandonment of language/knowledge within society and makes life possible – liveable for him/her. If s/he were to believe in language and knowledge (and why should s/he?!) s/he would

then encounter what Camus called nausea and what Tolstoy (along with Bataille) had called torment[111], an existential quandary or will-to-truth emerges within the subject that resists explanation: "who am I, what must I do, where am I going, where have I come from, how do I carry on"? The vertiginous Man sees these semantic preoccupations as hackneyed, limited and formulaic, not to mention fallacious. S/he may respond: "I will never know who I am, I mustn't do anything, I must perhaps necessarily do nothing, I am going nowhere...am I somewhere to 'be' in the first place"? Or s/he may refuse to enter the register of language which prescribes such questions and behaviours. The 'question' has always been a germ of language that does not actually exist in the world, and its vectorial counterpart (the 'answer') is equally fallacious and makes duration something to be answered for.

The problem with believing in the deployment of a word which corresponds to an object, value or truth, is that one must identify its opposite too (as the opposite or 'non' is part of the word's identity – in contra-distinction). The classification of language works just as much through the production of differences (by equivalence) as through the production of identities. The consequence of *attempting* to *not* be lost is the *awareness* of being alone. Descartes was certainly not lost standing on his subjectivist foundations, but he was alone because the price he had to pay for ascertaining truth was the realization (or inferral) that this was deduced *from* God 'out-there', and equally in a world consisting of *two* properties, which severed the human 'subjected' *to* reality from the objects 'subsisting in themselves' regardless of human activity. One can imagine the sense of alienation the sensitive person would feel if faced with this Cartesianism: s/he would feeel as if he had to forfeit the phenomena/qualia of his experience for the 'indubitable' truths of the real mechanical workings of objects within the world. His/her very sensitivity/sensibility would be a lie. Or Immanuel Kant: the

consequence of not being lost in his grandiose systems and faculties (?!) was that one was always inhabiting a *representation-alist* account of existence, always on the 'other side of the absolute', mediating existence and not 'Being' it, separated from the caesura between appearances of things and things 'in-themselves'.

The intellectual and psychological urge to name the *Real*, the objective world of the Sciences, or the true nature of reality in philosophy has also had its insidious consequences. Immediately one can recognise (and admire) Carl Jung as a combatant against this insidious *Real*. In his work we see a psychological focus on the subject to generate forms of myth-making which function in order to accommodate one's personal desires, fears and alien-ation within an already determined social reality (or on the contrary, an impersonal *Bare Life*[112]). One may ask why one should name this 'monistic' reality in the first place. Equally, the consequence of naming the Real in philosophy has been the renewal of a form of loneliness. The philosopher begs the question "where do we locate the *Real*?", and automatically we retire to our separate camps. Do we locate the real in experience (this *Real* being peculiarly anthropocentric and empirically limited)? Do we locate this *Real* in Matter (the real flux of material process or the atomism of Democritus)? Do we lock ourselves up inside the cage of language, proclaiming that all such 'locations' and 'realities' are consequences of our own inaccurate use of words and our misunderstanding of the role language plays? Do we locate the *Real* in the *Idea* (after all, what other medium do we have to make any conceptual judgements about the world)? The vertiginous person gets travel-sick at the thought, starts again from *nowhere*, or subtracts him/herself from this notion of *somewhere*. S/he is a sceptic who is even sceptical of his own scepticism – the vertiginous Man.

What is this strange reversal that occurs? That to be mutually alone and lost, one could undermine the very definition of

mutuality – its origins being anthropomorphic and presupposed by unity – making such impersonal, pluralistic and vertiginous instead.

But rest assured, most people are not sensitive enough to feel this vertigo, and if they were, they could surely never be abhorrent and weak enough to enjoy this light cancellation of certainty through a practice of 'living'? Surely they would enact *a rage against life as it is?*[113]

III. The 'Lost' and the 'Lonely'

Let us look at some superficial definitions and situations of being lost and being alone. Let us note that Man's confidence in relating human conditions with physical and social behaviours – which amounts to the same thing as believing a word to correspond directly to an object – gets him/her in all sorts of problems. For example, who maintained that 'loneliness' and being 'lost' could ever amount to anything significant in spatial terms?

In spatial terms, to be lost in the world one does not need to be alone: a tribe of hunters are lost in Appalachia, but they are surely not alone as they have each other. Most modern families do not attain this intimate sense of collectivity and symbiosis. In-fact, I would go so far as to say that this Appalachian tribe, if they were to use the concept of loneliness, it would be in order to reify and demarcate their clamour of brotherhood against the extended void in which they journey across. Loneliness for them is a *style* not a philosophical conundrum, threat, or vertigo. The notion or affect of loneliness is never contemplated by itself (*alone*). Their notion of loneliness originates as a 'lack', that is the absence of companionship. It is those that are haunted by a concept of loneliness before companionship who are truly alone (or those who realise that companionship is not enough to keep loneliness at bay).

This 'companionship' is a temporary antidote to loneliness. It is an antidote in the sense that one must put themselves into its

situation, one must be distracted by it, seduced by camaraderie. Beyond, or after this antidote, the ambivalent *hope* of society (simply put: the reason or excuse they give themselves *not* to kill themselves) is worn off. No one ever gave me a *reason* not to kill myself. Suicide is often mistaken as illogical but it is indeed the very opposite. The desire to live cannot be verified by Reason – life is therefore irrational;

> "God is necessary, and therefore must exist…But I know that he does not and cannot exist…Don't you understand that a man with these thoughts cannot go on living?"[114]

I think that modern hope is simply the denial of asking serious questions concerning the criteria for existence. There is still the lingering metaphysical fallacy that entrusts, after all, a value *to* value[115], but the transcendental or rational grounding has disappeared. There *was* a moral ground for existence, even if we simply use the Christian commandment "Love your neighbour as thyself" (Mark 12:31) or the Levinasian[116] commandment towards the *Other*; "love thy neighbour *more* than oneself", but this cannot be seriously practiced after numerous insensitive interventions such as the Holodomer, the holocaust and the Khmer Rouge regime, amongst others.

There is a strange hope in the primary nature of biology: the automatic responses the organic body has to foreign bodies, its self-survivalist economies, the peculiar preservation of itself etc. After accepting Darwinism, one does not need to impose the moral, philosophical question 'why' the organism does what it does but 'how'. Answer, years of adaptation, rearing and survival. In-fact, the how is the why. This answer is not sufficient for the Christian, the liberal humanist or the metaphysician.

It is glorious to see this *first* nature transfigure into *second* nature, that is how the subject complies toward this impersonal Darwinism. Man constitutes teleonomic principles: from the

reproduction of the species (found in play, social integration etc...) to the basic function of the eye 'capturing' images of the world. There is not a single uncharted space that doesn't reek of teleonomy, pragmatism and survival: the arts are as bad as the peacock's feathers (sexual selection is natural selection). Oh, how complex nature's selfish survival plays itself out through us, in unconscious drives! How such nature surfaces as the psychological need to keep the quasi-objective model of the subject intact, how this registers in the symbolic level through fear of one's own death, the biological transfiguration of heat and food into energy, the will-to-live, even civility seems to me to be some banal process of conditioning. Man plays with the limits of this pragmatic determinism. In this sense s/he is the limit of evolution (in both a pejorative and dignified sense). S/he will provoke the entire world including him/herself. He will fuck as much as he can, gorge on everything, prod that which suggests being left alone (even his own wounds he will poke). When a person asks serious questions about existence, or pushes frivolity too far, s/he simply makes a mess out of the natural order and process of things, s/he shunts its rhythm. Unfortunately there are no great secrets to humanity. Only the human *him/herself* can reminisce over childish fertile things ephemerally. At the end there is only *futility*.

Futility is perhaps a little Christian boy, a bit like a little boy who gets bullied, a bit like a little creature that gets put into a box full of other creatures and eventually is eaten to death. Perhaps the enigmatic residue of futility, that strange remainder of human life facing demise is pure irrationality: Dionysus, tragedy, human things that throughout the epic eternal history of the universe only humans would understand. Funny how from a larger perspective the once unfathomable, unpredictable emotional outcomes of human beings were always the things that *we* knew best, which are most understood.

The squalor and movement of shared activity (labour/ritual/

song/language) seems to keep any void or tragic questioning at bay...for the meantime. Throughout the entire history of civilization the specimen of Man will always thrive best and most securely in the company and shelter of others. This too is Darwinian (and Marxist); the capacity to think and to doubt has always been a dangerous exercise, a project for *oneself*; but one must think for oneself! Whether this thinking is mobilized in Socrates' questioning, Descartes' 'doubt', Sartre's 'bad faith' or Dostoevsky's solipsism, it is always stylised as a *weakness* (or something that gets them killed!). It is weak in the face of the optimistic, ignorant, hedonistic masses. Darwinism, positivism (any purposive project) would be renounced if all Men were to find vertigo in themselves[117].

> "*Even if man were nothing but a piano key, even if this were proved to him by natural science and mathematics, even then he would not become reasonable, but would purposely do something perverse out of sheer ingratitude, simply to have his own way...then, after all, perhaps only by his curse will he attain his object, that is, really convince himself that he is a man and not a piano key! If you say that all, too, can be calculated and tabulated...then man would purposely go mad in order to be rid of reason and have this own way.*"[118]

The survival of the fittest in politics and society equates to the power of the collective, the dominant, and the reign of the powerful. However, we know that civilization is not fit, and it does not seem to harbour any real power (of transformation, innovation, truth). We also know that the power of the collective is only ammunition in the hands of the true power: the power of the minority, that is the affluent.

Was it at that moment when Dostoevsky's thought became incongruent with that of the living – or survival (his nihilism) – that his thought became truly strong? Again, was it when

Nietzsche strove to equate his thinking with the vital power of life – that is life beyond subjective living and survival – that his thought outstretched that of the social and became strong? Let us not forget that Nietzsche's analogy of the 'strong' and the 'weak' was never an aristocratic one. Nietzsche's strong was the differential element in Man against the herd mentality of the masses of 'the Same', and in this schema *error* becomes productive, the variability of selection, and no longer some degenerate, determinate, entropic phenomenon.

Both Darwin and Nietzsche knew that the vital impetus of human life resided in its differential genetic element, its capacity to modify and transform itself. For Nietzsche this mutation/modification sprung from an *Ideal* and for Darwin it sprung from a necessity. But how could the daily routine of Man find comfort in this differential origin (or non-origin i.e. *difference*). Man's ego is directly against any fundamental schism or transformation of the subject; even in love it quivers. It is safe to say that amongst all the clamour of men who superficially want to 'change themselves' or 'open themselves up to new things' they secretly want to stay put – as "a piano key"[119].

There are others, like myself, who exclaim: "if one cannot justify saving the social then one must abhor it". In the future there may become a war amongst Men, between two ostensibly opposing fundamental principles: one side harbours an inclination towards the social, the other an inclination towards the authentic, the novel, the expression. These two principles are antithetical modes of living and valuing. The winner will be the result of either good or bad art, of fulfilling or unfulfilling living. The criteria and consequences for both sides are yet to be fully grasped. The first Men can never be truly democratic because social methods must be utilitarian if they are to remain social. The second Men can never truly be democratic because – regardless of free expression – the process of judgement and taste (which is inextricable from the impetus of expression) is necessarily fascist.

Anyway, the stranded world of the huntsmen is a being lost that can be found, and a loneliness that articulates itself through the absence of home. They are simply *misplaced*. I describe a being lost which isn't necessarily (or merely) spatial; it is a being lost after the colonialism and modern urban/technological development of Western Europe and beyond: the person that is lost *temporally*; lost in another time of ethical practices, lost in a feeling of virtue or nobility, lost in the smell of ancient ivory, lost in the tragedy of life. Or perhaps a person lost within the infinite gaps between time points themselves; lost in a part of Zeno's arrow, lost in a time not as yet colonised or synthesised by the theorising and scientific formulations of time, perhaps a person still preoccupied with the concept of eternity...? Perhaps even a being lost which is truly philosophical: the *nothingness* which persistently accompanies consciousness and transcends its situation within a given environment/ context[120], that part of consciousness which allows a person to be free even when s/he is ready to be hung, that nothingness which propels people to *choose* what they are free or not free from, that part of consciousness which is truly Cartesian in that it 'intuits' that its existence precedes language and social intercourse, and even the primary identification of the self.

This is perhaps a being lost which necessitates loneliness. But still, this is too humanistic/romantic. A thorough sense of being lost, of what I term *vertigo*, is a being lost that has no presuppositions to it; it is not lost *in relation* to what can be found, its vertigo is not equivalent to anything else because it cannot *find* anything in its vertigo. Its only pseudo-equivalence is its relation to the *identity* of being lost: to *be* lost is to find what lost is, to have vertigo is to be the *being* in *being* lost. However, this is merely an epiphenomenal identity, an alien but sovereign identity[121]. But even this *being*, this apperception of a thin veil around its whirring vertigo can get lost sometimes. The *event* of suffering, pleasure and awe can be found on this paradoxical

threshold between identity and non-identity, where the imper-
sonal void of consciousness and its history ascends into identity
in a rush of pain unknowing. Or where, on feeling sensation,
some disappearance or disconnection grounding it peters out and
returns into the great outdoors of non-perception[122]. Man does
not stop being lost by designating him/herself as lost ('being'
lost). The locating of being lost does not abolish its lost-ness but
simply demarcates a linguistic and semantic point in relation to
the absolute unknown. In-fact one is lost *within* this very desig-
nation of being lost (similar to Wittgenstein's thesis on the limits
of meaning/experience in relation to those logical propositions
that correlate to 'facts' about the world) i.e. one is lost within the
constraints of the socio-linguistic construction of the variable
denotations of being 'lost'.

To be lost is not to be a lost tribe. To be lost is to be *one*. To be
lost is to have lost the mimetic faculty needed for behavioural
imitation and social etiquette.

Equally, there is a superficial 'loneliness' that stops Men from
being lost. Most people *feel* alone in the world, but their
loneliness is a stupid, fruitless one. One is lonely because they
miss someone or thing, hence their loneliness can be switched on
and off (determined by the disappearance and appearance of
certain objects). One would feel less humiliated if they were to
stop lamenting the ostensible object of loss and attempt to think
loss itself (as generative of meaning). Or, alternatively, refuse to
confer value onto petty qualities such as the presence of some
thing or other, its proximity (its empirical consummation into the
remit of meaning). Other weak people only feel loneliness
through being victimised by the effects of despotic practices of
living (capitalism/society/culture): the limitation/oppression of
expression, a distancing from real subjective experience, a
distancing from their visceral mortality, and a head full of
embryonic concepts that have been imposed upon them. Their
fight for the human condition (in its hackneyed philanthropic

form) is always an antagonism against some form of power or other, but these people assume that non-oppression would miraculously end the mystery/suffering of consciousness! Unless they can truly change the experience of consciousness in its temporal condition directly, I think not.

> *"The true philosophy of history...consists in the insight that, in spite of all the...endless changes (of historical circumstance) and their chaos and confusion, we yet always have before us only the same, identical, unchangeable essence, acting in the same way today as it did yesterday and always."*[123]
>
> Arthur Schopenhauer

Schopenhauer is here saying that concepts of freedom may change, political operations may progress or make way for new ones, but consciousness can only be redefined and never recreated (this connects to his metaphysical insights on noumena and the Will).

These philanthropists I spoke of – before this Schopenhauerean excellence – feel alone but are not lost in themselves. They are part and parcel of the unwavering decisiveness of the mechanic enslavement of capital i.e. they will be fine if they remain in stupor, upholding some ego-centric value – ignorance is bliss. I say to these people: "dig deeper before you perform your daily dramatic antagonisms, stop being so topical, so cultured, so socially reared – learn from the mystic...go further back (or forward)...don't be slaves to the present! Expression doesn't necessitate content!"[124] Confusion and suffering does not come from the historical and social situations that Man exists in and must confront, but rather, comes from consciousness *itself* and its irreducibility/incomprehensibility to such processes of conditioning.

This is how I defend the superiority of Schopenhauer's dictum 'consciousness is suffering': one closes their eyes but still

their consciousness is active (excessive even)... this is neurosis, within and external to human reflection. It is the opposite of those dogmas that superimpose 'tranquillity' onto hysterical neurosis through the instrument of 'meditation'. Let us refer back to my notion of constructing identity through the recurrence of pain. The entity becomes a subject (let us say 'the criminal' subject) through discipline and punishment directed towards his/her specific material body. Not only is the subject constructed/ individuated as personal site of pain, the criminal subject is individuated *conceptually* too: now a being of guilt, of 'bad consciousness', s/he is told that the true subject is *not* one akin to his/her current disposition. Schopenhauer's great insight is not primarily that 'consciousness is suffering' but that 'suffering is consciousness'; the identity of the subject needs to latch itself onto a constant individuating process, and this process is the awareness of a constant, almost diaphanous pain. To equate consciousness with pain is to equate consciousness with (and more importantly as) identity. This triadic logic (pain-consciousness-identity) is what makes Schopenhauer much more dangerous than those other German Idealists of his time.

The paradoxical production of a vertigo, which fastens, prolif-erates, and constitutes itself as an identity (found in the sincere experience of *being* lost) is inverted in the notion of loneliness. Instead of the dénouement of vertigo culminating in identity, there is instead a sense in loneliness where this identity is outside of oneself: un-reachable. In loneliness we have a primal awareness of the *other* before the self-identification of this other as 'lacking' or 'gone'. Loneliness needs to know what it is lonely about, where the originating trauma came from. Before this, loneliness was not a concept, was not a problem: it therefore never existed. To be lonely is to be in relation to other entities. In this sense, to be alone is to never entirely, *absolutely*, be alone. It needs relations, it needs relatives. It is dialectical in the same way that the 'concept' of freedom is: freedom finds itself through a

process of induction whereby it contemplates itself through various encounters with limitations, boundaries, restrictions.

But when one realises that this inter-subjectivity of the self (the self that is lonely and the *other* that causes or deems such loneliness) is in-fact a false projection with no origins, that is a simulation of loneliness that continually generates meaning and not its opposite, then one has successfully crossed over to the other side. One cannot be lonely anymore because one refuses to believe in folk-psychological tropes: the significant other, the maternal, the paternal, the childhood index, God, the pathos of mortality etc. Even subject/object distinctions collapse, language stops confirming consciousness...*a new type of breathing* comes about. Loneliness stops being humanistic and starts being powerful in a different way. The self is not an *effect* of some fundamental *lack* but the only true *cause* of an affirmative loneliness that *only* exists in the self. Perhaps one is not lost either anymore. This is what I mean when I speak of the lonely and the lost converging and cancelling each other out. It is the cancellation of any point of approximation, any type of real decision. Because there is no such thing as a being 'lost' or 'loneliness' that exists outside of consciousness, the terms become full, impregnated, excessive...positive. In a sense, because we are the only true bearers of loneliness, we in-fact are its parents, its friend in loneliness. This diaphanous relation, of *being with and for loneliness*, has been either simply disregarded or turned into a vicarious connection with a God.

Yet surely the words 'being lost' and 'lonely' usurp an archaic sense of the terms which have not been exhausted by human knowledge and events, which feel as if they existed prior to the designation of the words that denote such terms. The need to denote the sense of being lost and the lonely within being-in-the-world – this must have come from somewhere, some deep wound. Surely we could never have made up this entire ordeal ourselves for our own punishment?! Just as self-consciousness

separates (or 'negates') itself from the world by grasping itself as an object (or as a definitive subject), so too do words separate our holistic or immanent feeling of existence from the linguistically constructed 'separate' objects, moods and activities that words denote: to take the term 'lost' one must see it immediately as an abstract term severed from other states or moods. Then one must, from a distance, attach the meaning of being lost to a certain feeling or situation. This is the passage of sense, of association, of classification, of knowledge – but it is fallacious in some sense.

There may not be a being lost and loneliness that exists outside of consciousness, but should the human sensitivity towards these states, and the human possibility to destroy their supposed origins in an almost promethean manner grant us the power to call this being lost and loneliness ours? The lost and the lonely certainly exist within the animal kingdom. After all, their territory is the 'wilderness', and making one's home the wild is to make being lost and lonely an abode and an operation. Animals are more promethean than us in the sense that they have made the ostensible 'effect' of loneliness (irrational deter-mination without origins upon the subject) into the only true 'cause', making themselves beings that come from (have their origins in) being lost and the lonely. Indeed, in this operation they have stopped themselves from being lost and lonely by conflating the subject with its environment. It has taken us only until recently to almost consider doing the same. Instead we have been dreaming of a divine, human realm beyond finitude, an immaterial pure realm beyond material change, or a plateau of human perfection as opposed to inhuman imperfection. This type of desire is in-fact an extremely lonely and lost one; not only do we live within an infinitesimally small and unique planet in the middle of an impersonal void, but as humans on this small planet we intend to dream up even more remote, autonomous realms that do not even exist. Could we not say that the places where things do not exist are the loneliest and most

lost of places (dreams, simulations, imagination)?

The greatest philosophers of the western world believed in a lonely and a being lost that *preceded* human experience. Schopenhauer spoke of an unchangeable substrate that was alone (albeit in a matter of degree and not kind) from the perception of phenomena within our world (conscious represen- tation). Plato obviously spoke of a realm of absolute ideal forms, separate from the residual simulations of these perfect forms that occur within lived experience, and Kant spoke of a realm funda- mentally unknowable and hence alone from our innate categories of the mind and our sense perception (the noumenal world). Does it not strike us as odd that such 'rationalist' feats come with an almost childish pre-conception of loneliness that defines the human intellectual enterprise? Is there not, even to this day, a loneliness that we dogmatically project onto external objects, which becomes a fundamental 'necessary' knowledge: the loneliness of the external world is a loneliness of objects (separation) which affirms the objects reality *as* object (ostensibly devoid of semantics/intention). Is this not a contradiction whereby we attempt to speak of a theory of separation coherent with science, taxonomy, classification etc., whilst simultaneously attempting to make these terms (and their sense in relation to phenomena) non-semantic? Furthermore, it is a separation of *objects in relation to us* that gives the determinations of an object a residual spectre of semantic separation, isolation etc. Outside of the relation *to* or *for* us, would 'objects' even be separate or distinct? But am I not here making those same claims that the above metaphysicians made, giving unity to a metaphysical image of being whilst simultaneously breaking up this unity through the construction of various 'phenomena' and the isolation of interpretation?

In a transcendental sense, do we not believe that separation/ loneliness produces objects *without the objects consent*? Is there not some strange discreet sympathy or pity on objects? We have

already been warned of reducing the subject into a mere impersonal object (Hegel's master/slave dialectic, Sartre's 'bad faith', Marx's proletariat etc.), and the connotations/definitions of *objects* are (deviously) dialectically opposed and counter-created through our idealistic construction of the *subject* (in relation to theology, politics, art etc.). Could we go so far as to say that we humans imagine the object to have been *effected* by the illusion of loneliness/separation but are dubious to whether the 'object' has of yet affirmed this quality *as its own*? This act is an odd projection of what we do even to ourselves; we can say that the loneliness of the internal world (subjective consciousness) is a loneliness that is identified as 'subjective', which then affirms the reality of loneliness as subject to the conditions of our own judgement. Hence, this judgement, conditioned by loneliness is thus being conferred onto objects. Perceptual anthropomorphisation we could call this, where anthropomorphisation turns out to be a prescription of human loneliness as opposed to any 'human-like' descriptive traits.

If a whole community of people were truly and devastatingly lost they would not be alone, because they are not alone in this conviction. This being lost is confirmed amongst each person, given carnal spirit. Can this be sanctified as being truly lost if these people make their home the desert of the lost? No. One must walk away and start again after this false sense of being lost. Every step towards validation is a step away from vertigo. Equally, loneliness cannot come about in twos or more, this is why Noah felt no guilt in sending animals into his ark two by two.

Even though this new vertigo is necessarily non-dialectical (abolishing the pre-requisites for being lost and being lonely) it *maintains* itself through the mental/conceptual dialectic of an old identity and new transformations of identity/non-identity, that is *being* lost and *being* lonely in conjunction with the *lost-ness* of being, and the *loneliness* of being. This is its abhorrence, because

it knows that this dialectic doesn't really exist – what exists is the *process* that occurs between two un-knowable origins. Primarily, the origin of Man (ontology) is the irrational, the un-necessary and the un-conditioned nature of the universe. Because of this first origin, nothing subsequent to it can attain any form of real knowledge/reason (whether manifest in a human or a higher being) because its entire validity is contingent upon an uncondi-tioned and hence aleatoric *event*. The second 'origin' is the state *from* such an origin towards further spontaneity, change, the future, the absurd. Because we have no grounding of 'what' we are and where we came from, we have no *total* license to mobilise, censor, dilute or change what might *follow* from this first origin[125]. The future (in a wider sense than just the historical, habitual or rotational time of the earth) is *absolutely* aleatoric, spontaneous and at-least fundamentally un-predictable. If these origins are un-knowable, a rational/logical or empirical dialectic can never be said to exist because tradi-tional dialectics *solve* the oppositions between concepts, and the two origins that I outline above cannot be solved/totalizable. Equally, any form of sufficient or logical dialectic is a fallacy because the very opposition or ambivalence between things like 'lost' and 'found', or 'subject' and 'object' are *not* stable forms or concepts (they are forever mutating to fit various registers of linguistic or practical utility) and hence cannot be legitimately pursued or said to ever even exist.

The vertiginous person gets to go a little further down the rabbit hole if s/he knows that the 'rational' world, inhabited by his present civilization, is still continuing to fix points of thought, continuing its rotor of labour in a comforting folly. The vertiginous person gets to displace his/her whirring non-identity reassuringly upon the rhythms of language and society before jumping into the vertigo of new thoughts. The vertiginous person sedates his/her disorientated 'subjectivity' by enacting objectivity. S/he only has to inhabit the modern world to sooth

his/her chaos: the television ignores authentic individual experience and plays something already coded, already constructed, simulated to fit *everybody*, *universally* and *objectively*. For a holiday, the vertiginous person can jump into a set language, imitate certain social behaviours, and simply respond to the objects of stimuli immediately around him/her. If s/he does not accidentally deploy self-consciousness, s/he wins every time. There is a simple trick to this smooth operation: one must do some light research. For example: if one sees a certain brand or logo, one must assume some promise of happiness and quality from it (?). If the level of the voices of other human beings rises around you, best emulate them just in case. One is expected to spend the money one earns labouring on objects in the hope that they will titillate some desire which will momentarily displace their vacuity and compensate for real needs and desires. Do we not simply *borrow* money off franchises if the money that we receive goes back into capital by consumption? Oh...sorry... yes...one needs to work...involuntarily...to stay alive it would seem...but really they mean to live comfortably i.e. without feeling themselves live. I imagine death would be too problematic in this scenario?

But I see you need more convincing. I believe that every opinion is a prejudice, but perhaps I can utter something or other to make this disappearance of certainty more lucid.

IV. The Vertiginous Subject: a character building exercise (or vertiginous virtue)

It is not the works, but the belief which is here decisive and deter-mines the self and determines the order of rank to – employ once more an old religious formula with a new and deeper meaning – it is some fundamental certainty which a noble soul has about itself, something which is not to be sought, is not to be found, and perhaps, also, is not to be lost – The noble soul has reverence for itself[126].

There is a vertigo of the subject, "not to be lost" but "also not to be found". There is a chaos in it. One is brought up into the world, at first almost completely inebriated by the alcohol of the maternal womb. Too drunk to worry about indescribable bursts of pain one might call *feelings*, or the migraine inducing awareness of a *self*, a totality of parts constituting a *One*. Oh, how everything seems to come back to this one! Every sensation never applicable to anything else, anyone else!

When one is finally *conceived*, as a body and as a thought (consciousness) ...and as a *name*, one is still continually inebriated, but this time by words and other beings. These beings, these *others,* are the incarnations of certain models/archetypes of how one should behave, in other words, how a be*ing* should *be*. One helplessly learns from, looks up to, and emulates these other beings, as if life were some breeding ground for imitation.

I imagine that the first trauma that one must have, before the initial disgust at these creatures, is the awareness of the complete suppression of any chaos... no vertigo.

Every new born in the world persistently tries to tell us, crying, screaming, kicking, covered in their own alien yet intimate materiality (snot, shit, tears) that this conscious experience is absolute hell. They feel as if like a popped blister: forever open and sensitive to the whirring stimuli of a chemical world. We adults find this inaugural torment overwhelmingly endearing and adorable. At the point where the child settles, is nurtured, I like to imagine that this temporary absence of chaos (this serenity) is marked with an utterance peculiarly human: "pity", the child would say to him/herself, as if chaos could have been home...once. The memory of his/her pain, so confusing at the time, yet so illuminating, is reconciled at this moment with his/her strength when s/he, in repose, modestly laments it.

Written on their faces, and glistening in the incandescence of their eyes, was a mantra that assumed human pain to be something which securely kept them away from predators (once

we reach the field of pain we must go no further and turn back). If this is so, then the awareness of pain is peculiarly regarded as the gift that preserves life, which stops us from wondering out of the village and into the woods. If we weren't so bent on escaping pain, under the moniker of 'threat', we would begin to see pain and suffering as the zenith of life encompassed in experience (the cleverest know that they desire it even). I wonder if the symbiotic pain of conception for the mother and the child is the inauguration of this pernicious definition of pain – as *threat*. The child, after such pain, of being pulled out into a world that was, at first alien to him/her, will now do anything to avoid going *anywhere* because of this threat of pain! S/he will even avoid death which is the route *out* of pain! The mother, her love indexed by this inaugural pain of conception, now understands *what* she must protect her child from: after the pain of conception comes the holding of the baby, stroking, nurturing and protecting, the comfort of exhaustion …this is of no coincidence.

These odd, predictable and weak beings, which I am in the company of in an austere hospital with rusty pipes behind the walls and clean clothes in front of people's bodies…who said that Dante's inferno was fiction?

This vertigo of the self seems to be easily written off as psychological amongst those weak critics. Fools! It is what I speak of that *creates* psychology, not vice-versa! You do not answer something by diagnosing it! You cannot even liberate it that way!

Human civilization can be generally defined as the building up of opinions regarding the nature of human reality and its hierarchy of utilisation (expenditure). Vertigo is the resonance of failure that echoes residually after each of these presumptions made by Man.

The following has something of that echo, as well as the sound of my own stupidity:

that the world is flat, that the world is round, that it moves or doesn't move, that objects are conditioned by laws of force, that objects have their own causes...four (Aristotle)? Or two (Descartes)? That human thought is a cause by its own right. That human thought is a process influenced by exterior and prior inclinations: conscious, unconscious or subconscious... but what is this subconscious? And where does 'it' want to go – to drive itself to death? To return to the inorganic? Freud! Father! God!?

Do we have an innate moral capacity? Are we 'naturally' driven by the 'good'...? 'What' is 'good'? What I see, is such what it is? What are these microscopes telling me? Bohr?! Kripp?! Darwin?!...and these words I utter, how intimate are they with me? Are they me? Where does this questioning even come from? I never asked for it!

And all these held in the arms of a statue of an angel;

Infinity? Finitude? Spinoza? Kant? Bruno? Cantor? Time 'and' space...what?! Absolute...relative, pluralistic... monistic, nominalistic ...

However painful this vertigo may be, for me and for a few others, I cannot pretend that it is not merely child play (vertigo *makes it* child play). Does anyone become sad when one recognizes that all serious endeavours in the name of their discipline, in the name of the father, in the name of inquiry, is mere 'child play'? And like the toppling of building blocks caused by an exhausted child, so too the building blocks of our intellectual history fall.

After a moment's silence amongst a group of people, huddled now, together in a circle, with head scratching, cigarette smoke, that odd mixture of utter seriousness and naiveté, the strongest person, if s/he existed, would try and do 'something'. "Push that

which wants to fall" s/he would exclaim. "We must face the flow of life"! No other loon on this planet would dance to destruction as s/he would. To see that at the heart of any moment, indexed within it, is always its disappearance. "What do I seek out now?" asks this small dying rare creature.

Any strong person knows that s/he has already had too much. If Man has danced towards the moon, has heard music carry, drop and lift his heart, s/he hath seen and heard too much. These things express the angel of presence and disappearance. Within these forms is always a signalling and catharsis of death. Some people have been lucky enough, bizarre enough to have experienced these deaths. The sensation of a sun that slowly sinks into that night where all things are black, and returns, fiery and with wrath, as if it were the Second Coming. Those tragic Hellenic forms of theatre: the audience are perhaps made Gods through the intensification of life, anguish and death that they observe, over and over again – the immortal crowds of Greek tragic theatre. I sometimes desire to die from a sudden aneurism, to watch my own existence disappear *in front of my eyes*...I applaud it even! What an unusually modern embarrassment that one is not even brave enough to equal one's own death. We are all too weak to die. In-fact, we are so humiliated by death that we cannot even celebrate it anymore; it is no longer a truly literary or aesthetic feature.

But whether one takes life 'on', as they say, with a dance or with a steady commitment, both have a sort of stoic *compliance* toward the world. It is as if, failing to deviate from our own mortality, our own scope as animals, we invert this failure into reification. A friend once told me that we all become equal in death. Others have told me that what I see as nature, outside the walls of the city, is also the nature of Man. I refuse all these naturalistic slogans. Ask the worker in the slaughterhouse. S/he has seen so many deaths that they become like mathematics; the hammering into the organic 'stuffness' of the brain becomes

merely an oscillatory binary of 'on' or 'off'. Something utterly new happens. Something totally absent of sentimentality occurs; **there is no more loss**. The slaughterhouse worker, through his/her labour, has found a type of *idleness*; the value we give to life, through its perpetual destruction, becomes *valueless*. This was never the case before: death used to be seen as a meaningful fate, which retroactively propelled Man to create authentic acts in the face of his/her mortality, which helped constitute his/her own finite expression (even if only led by one's fear and anxiety of it... ONE MUST DO SOMETHING!!). The simple event of death produces and gives meaning to lives that would otherwise be perpetually stuck in a static world whereby there would be no difference between self and other, life and death, meaning and non-meaning. No difference is indifference. Regardless of the *life* that is existentially bound to death, death *itself* was seen to be a holy plateau, a mark of bravery. All soldiers on the battlefield have the solace that if they do not live through their battle, at least they will reside in the most dramatic and virtuous of all terminals – death. If people are prepared to *risk their life for something*, then they will be disappointed with anything less than either that *something* being carried out or *death*.

For the slaughterhouse worker death becomes a banal game – one gets giddy from it. The quantitative destruction of life mires the qualitative capacity of life, not so dissimilar from the quantitative proliferation of information and the image in modernity, which liquidized and eventually shattered the real experiential quality of life. And what of these new historians? They on the other hand have no taste for the day-to-day triviality of death, none of the squalor. The historian savours the *event*, the slow arduous destruction of a civilization that traverses all the sweating members within it. The new historian is a type of ungodly god.

I am inclined to say that Theodore Adorno was wrong when he proclaimed that philosophy (that is the Enlightenment

project) had died with the inauguration of the Jewish concentration camp. Such a profound amount of killing, such astute disavowal of Jewish life, the denial of any mutual equality, the denial of any rights, *must* have paved the way for some new impersonal power. Something *beyond Good and Evil* must have come about, something so incongruous from pity, it would have indeed inhabited a different realm altogether.

It would have been heroic to have been vertiginous back in the days when meaning was felt viscerally by Man, when the dust of the death of God hadn't quite settled.

In this vertigo of the self we always had the comfort of the vertigo of life, the whirring of feelings, the contingency of life, the changing of the elements, the rotation of the earth. We are still so ingrained by this way of life even though it does not exist for us anymore. Once upon a time it would not have been such a strange and complex idea to re-enact private anguish on a public stage. The idea and the vision which it implies being Greek. We have lost too much of our humanity to sympathise with such tropes. In contemporary times we have heard about and seen so much suffering that we are almost looking for some new universe to come out from underneath it. The dictum of the day should be as follows: *There is nothing that awfully interesting about Death* (yet perhaps on a large scale, where there becomes something totally inhumane and impersonal about it).[127]

In the Promethean days of vertiginous pathos, the vertigo of man was diagnosed and treated as either insane or artistic, that is, *Outside*[128] of the social consensus.

The artist is simply he who has mastered the distribution of his vertigo (his insanity) into controlled splurges of heated chaos. Of course, because we know that every person has this vertigo, the defining of such as 'insane' is only a sociological definition, an institutionalization, with the weak hope of oppressing such vertigo and renewing the classical model of Man. The problem with this classical model is that it is precisely that: a model. And

further, a literal model: some ardent bent to make the brain akin to the statuesque form of Greek figures, with classical features, symmetry, balance and posture.

In-fact we should see this vertigo as being healthier than 'sanity'[129], but the great economy, with its generation of mass-produced value, through the mass conformism of the subject as an object, with its own terms and conditions of human activity and leisure, has seen that such vertigo is not fit for civilization.

The consequence of the oppression of people's vertigo has, from time-to-time, ascended back up into crowds of faces and has outwardly directed its oppression into events of torture, war, sexual liberation, suicide, philosophy, art, poetry, activities resulting in hyperthermia etc...

Let us agree with Nietzsche that this is the oppression of the Dionysian by the Apollonian. And even if the Apollonian paves the way for the psychologically 'deeper' self, it is a psychology of apparently rationalized desire, and such a 'self' brings along with it all the manufactured objects of its 'mature' and 'yearning' libido (the commodities of capital). What happened to the desire that outstretched and obliterated the use-value of the commodity...Dionysian desire?!

Yes, I am a victim of a certain stage of vertigo. When one has vertigo they can do two things: they can deploy a Dionysian rage against life as it is (this is an embodied rage which displaces the pain of the mind into the body...the dance[130]) or they can move on, exhausted, and indifferent. The former is the nihilism of modernity, the latter is the nihilism of post-modernity. But the stage of vertigo that I belong to is now nearing its end; Nietzsche saw a metaphysical stasis devouring life, a technological nihilism coming, he saw a strange post-human un-reason vanquishing. Nothing to do but pull back the reins, mobilize a negation or affirmation of this situation, transform thoughts, transform values, transform subjectivities...but always hoping to do so before they were sold to the nearest impersonal bidder (modern

industrialization, capitalism). Love, tragedy and spirit were always there in his project. Amongst other things, his Vitalism made him a Dionysian Dancer. The 'nudity' of Georges Bataille, the exigency of Michel Foucault, Lyotard's appeal to be Pagan...all these forms of exigency will always be that romantic form of nihilism which we see earlier in figures like Dostoevsky and Camus.

What comes later is a different type of instrumental vertigo, one that uses indifference targeted towards the self and indifference as a weapon against reality, values and signifiers, to deploy critique on everything, but without the pre-requisite of creating a more emancipatory practice of living and thinking (I've always wished to be this way but I myself am too sentimental).

Examples of this sturdier, parasitic vertigo can be found in Derrida's concept of 'deconstruction'. Every assumption, identification or concept has its own complex history, full of further interpretations and so forth. How can we mobilize the concept of the Subject before we deconstruct how the term or word has been used? As an unchanging substance, as the ego of the cogito, as the social subject etc...? Here, vertigo has found the distance of critique, and all it needs to do is be slow and consistent, picking away at the grounds of what was. This later vertigo loses its Dionysian streak to the point where Derrida's vertiginous method calls itself an extended form of 'rationalism'.

For the rest of us, we will remain schizophrenic and trembling.

The mental institution is still the location where the vertigo in Man loses its battle against the all-pervading dominant social reality that we have been told to accept. These vertiginous people must learn to pretend, or learn to let this evil image of reality go. I say this, however, with great admiration. I always saw myself as being fit for such a place, for several years I have never seemed to be able to get past the embodiment of my own consciousness. I have been, as some may say, held back by my desire to stay a little

longer with this fundamental incarnation of thought, vision, sense of the infinite... sense of the infinitesimal. It is as if I have always wanted to hover over its threshold, as if it were the key to everything, as if I were to find something there. Everything else was chattering voices, baboons bounding towards something or other, following eagerly the effect of their unknown cause, as if they weren't aware of their own predictability in the process: in short – tantalized by the hovering carrot in front of them[131].

It was inevitable that the artistry of the vertigo, even the rounding up of it into mental institutions, would soon become facile, become *institutionalized*. Where can a vertiginous being go to get some kicks around these parts?

Now, like anything, the vertigo's ammunition must be focused upon and channelled if it is to be actualized, identified (turned into something with form). It would in-fact be more accurate to explain the identity of vertigo as over-thinking: the chaos of Being's vertigo is intellectual, it is not a defect but an affect of *Being*; more relevant and innate than the affects of people shopping, watching TV or talking about normative topics, with a set of normative predictable exhortations and outcomes set within an axiom of a certain language, which as a postulate, will set a certain mode or grammar of thought.

But as I stated at the very beginning, this vertigo cancels itself out, peculiarly through the realization that it is *alone*. It is in-fact this arbitrary mechanistic world of bodies, interactions, language and routine (where no thought is ever given its own permission to take flight) where the best vertigo is soothed ('sedated' if you like).

It has not happened by chance that the masses which inhabit our streets, tidy our roads, govern our state, share our food and entertain us have replaced the officials that have unwaveringly secured the goal of the human being as primarily sane, useful and insatiably ready to consume. I am afraid that you too are now the representative of what this discreet army have put into

place. You now represent the values of the working/middle-class: weak, no Dionysian streak, preservational, conservative of values (yet you do not embody them yourself)[132], upholding the value of being 'sane' (I imagine that whoever abides by the sick formula of sanity in its most overt form gets a bonus...they must get something for their suffering). We all have our 'projects', our un-amended values that we refuse to revise, as if staying alive in and of itself could harbour any importance.

But gone are the days of *collective* vertigo (what we have quickly come to call the Dark Ages). There was never any way it could have lasted (or on the contrary, it was never strong enough to destroy the world... *itself*)!

What we post-modern or contemporary vertiginous beings have now is a chair to sit in, a study, a quiet walk through our town, to observe (and only observe). What we have realised is that we may viciously write and rant, exorcise some of the most powerful forces that are taking place today, and then rest within the stupor of the masses. The comforting repetition of 'chit-chat', the arbitrary forms they seem to bring out from somewhere: a standing lamp, a pair of trainers, a mirror, an object like all other objects. It is the repetition of routine and the repetition of our own anguish and self-hatred of each other and ourselves. That is, the repetition of jealousy, the repetition of desire[133].

I wonder if this acute practice of secret vertigo that I speak of, within one's own home, and the general pleasure in the obser-vation of the masses, is the pleasure that Montaigne or the late Nietzsche had in their day. I think so. There is nothing wrong with the aristocracy of thought if the proletariat upholds stupidity *ad infinitum*.

So, this relation, where being lost (in vertigo) encounters being alone (outside of the herd) has some *grace* to it. It is almost as if with the mass clearing of Hiroshima underway *before* its bombing, the internal combustion of chaos can now securely implode. And now a new type of breathing comes about,

becomes 'managed' by the hospitalized exteriority and makes life liveable. The ability to live is a primitive quality. It is not hard. But when one has this vertigo, s/he needs to have a rotating object above his/her bed (society) to keep him/her calm in the night of the whirring that spurs us on; "and if thou gaze long into an abyss, the abyss will also gaze into thee"[134]. But are we *allowed* to have such lives?

In a struggle to be kept a good secret, I become a refugee between two worlds that I refuse to apply myself to: I refuse to let the vertigo take me, and I certainly refuse to live the modest, primitive psychological life of the somnambulist proletariat.

The vertiginous Man can only stay alive, it would seem, if s/he maintains his disgust for all humanity. But s/he cannot relinquish it publicly. Of course, the artifice of living these two lives is questionable, but it is no longer a dishonesty that should be pronounced *weak*!

The vertiginous person would have been wiped out by now if s/he remained annoyingly honest, virtuous, noble etc. There is a reason why we do not have the brave, suicidal idols of Socrates, Jesus Christ, Giordano Bruno – they do not fit into our modern nuanced adaptation to our surroundings (they were not Darwinian enough).

This vertigo, being precisely that (a perpetual un-grounding), needs the ostensible ground of its environment, its people, its presuppositions. It needs to consume these little nests of fixity. Dependent on the products that generic Man creates for a sense of his/her own stability, the vertiginous Man consumes, and this will momentarily relieve him/her of descending into his/her own void. S/he needs the fashionability of materials, signs, feelings, words; s/he is, as Levi-Strauss predicted, a *bricoleur*[135].

Of course, there are those vertiginous Men that grow weary of the affirmative indifferent practice of bricolage, and feel the need to produce their *own* ground. As Schelling proclaimed:

The philosophical demand born of critique necessarily leads me beyond all the limits of knowledge, in a region where I do not find an already secured ground, but must produce it myself, in order to remain firmly on my feet.[136]

This *production* or *action* that Schelling speaks of, what an antagonism! It is the attempt at a *causa sui* principle of thought and Being. It is as if he were trying to uphold the very agency of the subject that he was repudiating theoretically: to *produce* something with an *action*, but without the idealism of the relativism between space and time – the spatialization of time. How can thought be produced without the subordination of production to the common misconceptions of space and time within experience? How do *I* produce something *without* recourse to that aspect of Being that limits itself to personality and subjectivity? How do I reify absolute being by naming its true path non-being (the annihilation of subjectivity into infinite extension?)

I too find the subordination of the universe to thought closeminded, but to give it the emperor's clothes of 'non-being' gives no pernicious credit to the vertigo of consciousness.

Man is not at the top of the food chain – millions of bacteria infiltrate and infest the organism of his/her body that remains unnoticed. We too, like bacteria, swarm and feed on any paltry dabbled world we can get our teeth and claws into. This is how we make home, how we make signs to each other and how we synthesise the feast in-front of our eyes. A stone's throw away from *terra firma*, outside earth, is a void which is unthinkable[137]. If we have any relation to an absolute, it is precisely because we hid or ran away from it that we are alive today, and we should thank God that the earth feeds upon the sun, that it mustered itself into an unthinkable cosmological equilibrium. That it flaunted, begged and sold itself for its place amongst the already dead stars.

Let us talk more about this relationship between vertigo and

loneliness. If some, indeed most, metaphysical philosophers like to speak of an unconditioned entity like God, Mind or Soul in relation to the constitution of life or an incorporeal substance such as the 'in-itself' of Kant, then *I* would like to speak of the metaphysics of loneliness, a transcendental, originary loneliness. I have always thought that if there was anything unconditioned, unobtainable by the senses or outside the remit of cause and effect, its effect on the human species would be that of incomprehensible loneliness as opposed to some entity that presents itself to the realm of consciousness such as logic, reason, truth, the totality of opposites etc. This transcendental loneliness may be incarnated in us as *lack* (touched upon by Lacan), *limit* (touched upon by Kant), *'wall'* (touched upon by Bataille) or the *absurd* (touched upon by Nietzsche and Camus). The subtle footwork of philosophy has always been – as I see it – the balancing of this absurd expanse of *vertigo* with an intellectual pursuit as truthful to this absurdity as possible[138]. Inevitably, out of this pursuit comes correspondence, community, sociality – civilization, and what is left of the absurd becomes a distant siren's call from outside the castle of 'human-all-too-human' custom and values. However, it might still be the case that it can be found hidden within the very rationality that we exercise upon the world: *the labyrinth of reason.*

But if the prevailing mathematics and sciences of our time have won the battle against humanism, and have made value, truth, morals and beliefs redundant in the face of what is scientifically 'real' and altogether alien from the residual incandescence of a peculiar chemical and biological urge, then psychology has since captured the flag, because there is no way that Man will willingly go insane based on the radically incongruent premises of reality denoted in quantum mechanics, neurology and the natural sciences. There will be a psychological consequence in Man, greater than anything before it, if psychology is pushed aside as merely an illusory (non-real)

mental state (folk psychology) in the face of Eliminative Materialism and the ostensible legitimacy of scientific realism.

Psychology, in its alleged falsity, only then becomes a psychological truth, or a true psychological condition. A definition of the promethean turn could be seen as a hatred towards all forms of 'reality', 'truth', 'power' and 'legitimacy' that has not been conferred by human judgement within the world of human social and cultural desires. We have already seen how Dostoevsky smashed his head repeatedly against a wall in response to the scientific image of man. The worst is either yet to come, or, will be hidden from society as a threat to the uniformity of social conscience and consciousness.

Let us philosophers walk the tightrope between loosing ourselves in the absurd and distracting ourselves with the language and discourse of hackneyed values. Nietzsche knew that the zenith of the then present capacity of upper-most bravery found itself in stupidity. This is why he sometimes called himself "dynamite", "wise" but always simultaneously a "buffoon". This stupidity is differing in its power. One must be stupid enough to endure existence – this stupidity could be ignorance (this is a base, *weak* stupidity) – but stupidity could also be the creation of the most fictitious logistical systems of artifice and illusion: philosophy/culture/art (this is a noble, *strong* stupidity). However, there is another type of stupidity exclusive to heroes of the heart: *brave* stupidity. The bravest event of Nietzsche was to leap off the tightrope, as Caligula once did as well as Strindberg, into 'insanity'. This type of stupidity finds itself more in the heart (or soul) than anywhere else:

I feel such a pain in my soul – a pain which frightens me. My soul is ill. My soul, not my mind. The doctors do not understand my illness...Everybody who reads these lines will suffer...My body is not ill, it is my soul that is ill.[139]

The moment Man's vertigo can identify its loneliness *empirically* is the moment s/he becomes a safe person. If s/he can just get past the incomprehensible insatiability of absolute loneliness and identify loneliness with him/herself, even in the ego. Even mark his/her loneliness against that of his/her neighbour or the masses. All modern loneliness seems to occur without any real archaic sense of the word. The fight that many prior brave people had to endure in order to receive the medal of their very own promethean loneliness appears no more. Modern loneliness appears to be dialectical: one must distinguish themselves *from* the crowd. To be lonely is to stand alone from *others*. One cannot know loneliness by themselves, the whole world must help us towards that conclusion. In this way, we are safe from any harm that vertigo can do now.

Historically, this has been very different[140]. Arthur Schopenhauer could never eradicate loneliness – one's private inner sense of time could never legitimately reach out to other forms, because these forms, far from being other or 'out there', were in turn made by this structure of inner time *itself*. Time is –

Not merely a form a priori of our knowing, but...the foundation or ground-bass thereof; it is the primary woof for the fabric of the whole world that manifests itself to us...it is the archetype of everything.[141]

For Schopenhauer, there was either the impersonal, unknowable squalor of the material world or the specific duration of the human species (life as suffering)[142] that could only point to its own self-image. We have a dualism here, but the duality is a difference in *degree* and not in *kind*, that is it is still the same 'one' world. Man cannot reach the full reality of the world but only its fleeting attributes and 'phenomena', which are inferred by the reasoning subject through the *internal* processing of space, time, and causality. The Metaphysic that constitutes this primary

opening-up of time, and subsequently space and causality, is located within the *Will* of the individual (the metaphysical substance of the universe), but this preceding metaphysical *Will* could only be apprehended *after* this *Will* was inferred through 'secondary' qualities such as the senses (which assume space and time within their utilization). This 'catch twenty-two' indexes Schopenhauer's absolute loneliness like a trauma. Schopenhauer could never get to (or intuit) the spirit or *Will* of this Time. Whenever he attempted to do so he would be bombarded with time's secondary forms such as space, image, phenomena etc...

He was a man alone, with a private time of the soul (or of his inner-most self-consciousness) that he could only allude to, that could never be conflated into knowledge.

> *Our self-consciousness has not space as its form, but only time; therefore our thinking does not, like our perceiving take place in three dimensions, but merely in one.*[143]

Schopenhauer's decision was to go more 'inside' or 'within' this *Will* of his, rather than discover the impersonal, inhuman base external world (the world of the sciences). This 'going-in' was his point of entry into the vertigo.

The post-modern secure vertiginous person looks out upon a world already fashioned by consciousness. S/he knows that the disgust s/he harbours for the others around him/her is intrinsically disgust for him/herself (this *bad faith* is stuck in him/her like a thorn).

S/he too *dwells*. S/he too already inhabits space and time; like his/her fellow passengers, s/he too makes it his/her home. S/he even makes this space sacred and private sometimes.

And what does s/he find within these spaces? I cannot do a Schelling here and *produce* some form of enquiry, some transparent investigation, without taking a view from *somewhere*. I'm afraid that what we may find is *gaps*.

There used to be those great myths of animals that from sheer exhaustion and necessity spluttered out an exclamation, an utterance, a cry. And from those cries came a psychology of touch and a language of designation and communication (language was never meant to encompass all areas of life and its expression as it does now)!

Unfortunately we cannot see this thread at work anymore – that, or it has become disenchanted somehow. Now the vertiginous person gazes upon the ruins of the attempt at beautiful communication. In place of where the old heart attempted to prosper, a collection of logical truths, a rich tapestry of syntax and rationality is found. There is no harm in producing a pattern, but imposing a false coherency that will confuse a person and limit his/her potential to the strictly logical, now that is oppression/fascism.

And if the vertiginous Man can live in today's world, it is not only through the sedation of his/her feverous mind via the presuming mechanistic masses, it is also because the tapestry of logic, custom, syntax, and reason save him/her from falling into him/herself: as Nietzsche once said; "without accepting the fictions of logic...Man could not live"[144]

And so, vertiginous Man wanders, dancing on this "fictitious logic". S/he is alone precisely because s/he sees that every grain of sand and every mound of soil has been churned into a comforting logic of some kind. S/he is alone because s/he sees the crowds of other humans with the comfort of this logic in their hearts, with the logic of capital designating them powers that are not of the archaic order (the archaic powers such as strength, bravery, love, authenticity), but only of the truly modern power of *indifference*: indifference to the power of life, indifference to others, indifferent to any *higher* calling. It is a *weak* power of indifference – they are conditioned by ostensible values such as money, false understanding, sameness, the value of 'leisure', without seeing their dialectical conditioning by 'work'. They are

not indifferent to themselves, they are hedonists – but little quivering mouse hedonists, never Roman hedonists. The emotive indifference of romantic nihilism is in many ways more heroic and in this sense less nihilistic than the adolescent desire to remain unchanged and untouched by experience and the rawness of consciousness which we see in today's human.

The vertiginous Man whispers to him/herself – "I am alone because everybody else seems to be not". A loneliness that has to turn into indifference or it would manifest as rage: "a rage against life as it is". It would be a rage not dissimilar from that of the protagonist in Planet of the Apes: a human, inhabiting an earth full of apes that have replaced the sentience and sapience of Man, this human seeing his monument of Man's identity *in his own image* (the statue of liberty), his gods, buried beneath the rubble of *a new era*. The worst enemy is the immaterial enemy of time. **Man collapses, smashing fists into ground, sobbing.**

I wonder if before the fabrication of God as correspondence, personality, father there was not a single lonely being in the forest of experimentation? Giddy vertiginous schizophrenics with no grasp of a static location to enable the possibility of being lost, with no sense of self which would enable them to feel lonely. The pre-Socratic Man looking up towards the cosmos, does s/he not have a lonely bone in his body?

"It is all for me" s/he would shout and abound in joy. But by counting these phenomena as objects that construct Man's identity, his/her world, s/he forfeits life and sets him/herself up for superficial loneliness (gives into a base form of loneliness). By owning the delights of the world, the consequence will be their gradual disappearance, flux, demise…his/her loss and lament. By identifying his/her desires and thoughts with a body, s/he begins the perennial fear of one's own death (the human condition). What a fit of panic this young astronomer would get if he could truly look out onto his/her cosmological family and see there millions of burning cousins, sparkles of space dust, ashes of

burning stars: the flickerings of an agitated void predicated by destruction and deletion. If anything, s/he should find company in the relentless disappearance of identity floating out there in the black. What then happens when Man realises that what s/he designates as his/her home, his/her identity, and his/her being, is actually the opposite: that it is not the persistent presence of something or another but the infinite disintegration of the world that rings true in his/her soul? When will Man realise that meaning is predicated by time's passing, the pre-requisite for loss and value?

Will Man ever realise that every form of holding-to-be-true, every value and every object is simply a period of lament? When *this* becomes home, Man could never be lonely with such an array of baroque destruction seeping around and through him/her. For the vertiginous Man then, s/he cannot attempt to *construct* theories (like Descartes thematic axiom of the builder of new *foundations*), but instead *subtracts* him/herself from the world. What a nihilistic oscillation this becomes, between the perpetual activity of life and the passive disdain of the vertiginous subject – a bifurcation of some kind, or a buffering. These *gaps* that Kant talks of right at the beginning of his enterprise, where we find ourselves already on the opposite side of the absolute, this is the acute awareness of the vertiginous Man (this 'absolute' itself being a product of indirect knowledge or a human projection of our own lack of identity). This infinite approximation of an escapable present and an escapable distancing of oneself as object, this is the gap that must be measured. And what precedes this reality lamented, what precedes the lament itself, other than the void that makes history and myth possible?

This epoch will be defined by a new age of anxiety, posed in the question: how (or why?!) is it that subjectivity is constituted by infinity and the impersonal? And it is here where the vertiginous Man teaches us a crucial lesson: that one cannot deny this

vertigo by opposing it to the fallacy of a self-substantial identity (the traditional human subject) – one *is* this vertigo. Freud's *uncanny* becomes the new topology of the human subject: at once familiar yet unknown. All this time, reifying and distancing ourselves from the conspiracy of the *alien*, stopping ourselves from the giddy realization that we were the aliens all along. Attack of the five foot homo-sapiens!

If one is afraid to fall within vertigo, then one is already afraid (and ashamed) of the stubbornness of their identity that petrifies one into fear (…is this identity aware of your possible rebellion)? If so, this divided and antagonistic subject hasn't turned out to be the loyal subject you were upholding in the first place. In Nietzsche's words:

> *To be ashamed of ones immorality is a step on the ladder at the end of which one is ashamed also of ones morality.*[145]

Incompatible Ballerina:
a meditation on desire, meaning and beauty

Have you ever been to the ballet? As spectators we are thrown into a *motion*, at once embodied by and symbolised through the gestures of a ballerina. Is she the passive container of a prescribed symbolic language, is she merely the instrument that once connected or dropped within the active circuit produces the desired (or necessary) results, or is she *adding, working, doing, dancing now*? She is always *what* we should be looking at, although she is constantly attempting to show us something else, something other, something more. What she is trying to tell us if we were to ever ask more of her pernicious beauty can only be two things.

I

She is primarily telling us that the domain she has saved and preserved for us as the *symbolic* is really a *mirage*. She mutters to herself with her head down: "just because a symbol has the capacity to refer us to something, this does not mean that the symbol legitimates this 'something's' existence". She continues...: "in-fact, the symbol's power to seduce, functions on the very premise of the *non-existence* of what it is referring to, that is its *abstract* quality". She smiles because she is symbolizing the concept of the symbol... *ad infinitum*. The ballerina loves the flight of the symbol; she knows that it leads to nowhere. She tries to keep that oscillating flight, of one assumed passage of meaning to the next within her bosom, within her dance, locked in a zip-tight bag, trapped within her own presence like a centrifugal wheel[146].

There is an inherent nihilism in this act[147] whereby the ballerina's presupposition is one of indifference. She is proclaiming that the mythical narrative that she is playing-out

(let us say the story of *Swan Lake*) is no more 'real', 'meaningful', or 'universal' than any other moment of existence[148]. In light of this, she has come to the conclusion that if there are no varying degrees of significance or meaning in the world (each event being merely the mirage of an aspiration that never shows itself to us concretely), then one would do best to place meaning blindly within the perpetual 'present'[149], or in *becoming*, as Friedrich Nietzsche used to say[150]. In this way she makes us love the ballerina, her dance (which seems to be the same thing), and *nothing* more[151].

What she gives to the spectator is a new revelation: that desire, seduction and beauty are always paths (or vectors) whereby we move from ourselves and our understanding towards our projection (or displacement) of a further desire; a desire towards *meaning* for example[152]. However, it is perhaps the fact that we do not even know ourselves before this desire takes hold that gives desire its infinite capacity. The idea that perhaps desire constitutes the Self (through its limits and vivaciousness, as opposed to vice versa) is yet to be fully acknowledged in the mind of the contemporary liberal-humanist denizen. Has the ballerina not always known this post-modern formula?

This type of *projection* of meaning, however is always experienced as *lack* because meaning has, as its pre-requisite, the further concept of *resolution*[153] (which is simply not compatible with the real world of chance, plurality, contingency and flux). In life nothing can be resolved. When something 'means' something we are saying that all its further possible meanings (or relations) are terminated, because one has found the meaning that *they* want from it. This meaning is a type of finalisation: it resolves or fulfils a need, a quality that one feels they must identify oneself with. The object of meaning resonates lack precisely because one knows that, if they were utterly fulfilled by the object they would not need to continue searching, desiring, or being seduced by it. This is very similar to how aspiration is generated in relation to a

very real lack or disdain within the forever present situation of the human; the slipstream of un-fulfilment will keep Men aspiring. One begins to feel trapped in this lacuna of desire. The ballerina however affirms it, and this is why she is a peculiarly contemporary phenomenon[154].

What else, what *otherness* could she be pointing to outside of this desire? Nothing. In order for any thing Other or separate/external to be shown, felt and heard they too must inhabit the same characteristics of the symbol. The ballerina will transcribe whatever she experiences into ballet herself, further helping the appropriation of the symbol.

One may ask if Man's 'will-to-live' originates from a strange extrapolation we perform, whereby we assume some peculiar legitimacy of meaning, either 'innate' or 'out-there', in fear of encountering perhaps the most simple truth: that man could easily destroy the pretences of 'meaning' and find non-meaning behind the former's façade. One would see existence sprawl itself out, bare, nude. This is a situation Man cannot bear for some reason[155].

Does the ballerina's contribution – that there is an *oscillation* between carnal form and the impetus that titillates it (or an oscillation between our object of desire and desires desire), which is simply on a relay loop, constantly building and building in momentum, becoming more and more reified – have anything to do with psychology?

Psychology seems to be a game of signifiers. Freud's dream analysis is the hermeneutic/textual search for *symbols* (symbols being both figures and acts). There are *sources* or catalysts within the psycho-analytic/diagnostic work of people like Freud and Jung. Jung's archetypes for example are precisely the opposite of the ballerina's oscillation of a desire which never shows itself. The ballerina would not accept the mystical humanism of 'innate', 'originary' hidden forms – she would see the politics of *desire for* such, and the construction of the platform that would

have to announce this form as 'originary'. The ballerina's real expression of meaning and trauma is a *processual*, one which *never* signifies in a totalizable fashion, which hides behind the banal, hackneyed symbols of a culture of popularized assumptions about the human condition. That is, it hides behind the false structures of last century's decadent assumption of what desire is and does, that desire is found and constituted in *narrative*, that desire works solely on the pretences of cause and effect, that the object of desire has to be understood in order to be desired. Desire is so much more fatal and threatening than the institutions that rear it and nullify it. That one even *knows* that they are under siege by desire or the auspices of desire is something that must be done away with in the twenty-first century. Desire is constant, desire constitutes the subject, and it is just up for debate whether the object wins in its titillation of desire or whether the subject wins in claiming desire[156]. Equally, it needs to be considered whether the Other that the subject desires is really itself (cultural/ideological desire masquerading as exterior objects thaat the subject has the 'freedom' to identify oneself with or not), or whether the desiring capacity leads us into *difference*, real Otherness, and ruptures of identity.

Desire is only *partially* found when desire reaches what it *thought* it was attempting to find (its signifier, its mother, its own demise, shell beach[157]). Ballistic-balletic oscillatory desire in a sense wants to destroy this meek resolution, is humiliated by itself, and either dances *over* such desire (retaining the self and the body once again) or wanders past it indifferently like sometimes how a school child instead of entering his or her school in the morning, walks past it and does something else.

Or it is when Man understands that his/her desire is stronger than what s/he thought caused it: Wittgenstein is driven to write the '*Tractatus*' but he is not satisfied, desire makes him create his '*Philosophical Investigations*'. Or desire can be less rigorous and more idealistic – remember that desire peculiarly found in the

animism of the most enlightened philosophers, and more conventionally in the Fideism of theologians: the projection of something more, an excess, a recognition and validation of meaning in an otherwise arbitrary and mechanical world. Perhaps, in a less schizophrenic and conformist era this oscillatory desire that I speak of was called *humanism*. Humanism is just another trajectory of desire: an historical desire. The question is how much the desire *in* humanism is ours/'human' (could there be an irrational/inhuman impetus behind its dissemination, or could it reflect a deeper *ressentiment* within the contemporary human)? Could our desire for humanism stem from the impersonal stimuli of capitalism that ironically promotes such desire, or those hackneyed moral, social and theological contracts and institutions that once endorsed it as an answer to a specific historical situation? Could our desire for humanism stem from a fear to embrace the consequences of hugely differing individuals, their values, their Promethean-ism, their nihilism?

Bourgeois Western liberal humanists' think that desire is something animalistic, barbaric and irrational, but it is such desire that created the deepest ostensible sensibility which we often attribute to that specific section of society. It would be interesting to *deny* desire like Arthur Schopenhauer – to resent it. What did Schopenhauer find when he discounted desire as having a place within the human rational world? Why are people so afraid to take a look?! Even to this day there is a strange regressive, philanthropic surreptitiousness, whereby the proliferation of social and cultural activity is used to cover up the simple real void between the biologically determined animal (man) and the psychological impulses that lead him to wander into error without a clue *ad infinitum*. Art, society, norms, values, politics etc. are all names of the same process: the repetition, liquidation and 'legitimation' of some of the odd results that have taken place in Man after these deeper antagonisms have

occurred within him/her.

The revolution of the ballerina is the musical equivalent of the dark revolution in psychology (the usurpation of the untamed subconscious/unconscious) in the early-twentieth century (against social and logical positivism, scientism and metaphysics) and the revolution of Nietzsche's philosophy at the same time (against rationalism). In each of these cases, even if they try to refuse it, they say the same thing, whether they dance, write or theorise the conclusion: *Desire isn't completely commensurable with Meaning*[158] (and hence cannot attain complete semantic, semiotic and linguistic representation). The bifurcations of desire exceed meaning or rationalisation, its aggravation resulting in neurosis, psychosis, psychological trauma. There is equally the realisation of a sublime desire (the subconscious, the 'Sturm und Drang'[159], the vitalism of Bergson and Deleuze, the radical notion of Hyper Chaos found in Quentin Meillassoux) that is reduced to the 'human all too human' instrumentalisation of desire into the remit of moral, social civility/activity. There is that moment in ballet where *musical* desire (if it ever was desirable)[160] became visual, and that strange bifurcation occurs when the ballerina becomes objectified whilst simultaneously de-totalizing any musical score by bringing the music back into the realm of the finite human and his/her localised distribution/production of desires (which are generated by the irrationalism of neurosis/desire and manifest from the lack of the human to perceive his or her desire, which dismisses or cannot fathom any teleological, purposive or total system i.e. objectivity). Equally, the ballerina's desire cannot be schematised because her desire does not correspond properly to a truth or an object (representation or correspondence theory) and she lives (!), she carries on, breaking all present constructs of meaning and resolution, aligning herself to new desires and situations that the passive contained 'score', 'painting' or 'composition' could never (being already coded) enter into.

What type of sadness emerges when the human realises that instead of pointing to some quality 'out-there' or some transcendental law-giver who commensurates meaning with Man (making meaning-*full*), there is instead simply the *becoming* pragmatic of meaning as uniformity in culture? I will repeat myself out of necessity: we are in the process of a mass social and political determination of meaning in which authentic acts of making meaningful and the possibility to start again *outside* of meaning is becoming harder and harder. Meaning is discretely (and sometimes obnoxiously) used as a kind of ideological seabed, in which capitalist/mass-conformist advertisements, images of success, and forceful prods to buy and do 'such and such' bob along-on and are used to legitimize their essentially meaningless projects and schemes. In-fact, what is more imminently catastrophic is the awareness that these despotic meanings, when unbridled from their power as certain operations (capitalism, dogma etc) or as figuring in a certain identity, person or collective, *still remain* as strange, residual, semantic determinations even after their inauguration and historical effect. What are we to do with the rubble of all these supplanted, failed or obscure meanings? What are we to do when these desires that resided are picked up *again* or assumed as natural (similar to how the brain permits a neuron to pass an electrical or chemical signal to another cell via the movement of the *synapse*)? Does desire not need to perpetually and immanently produce itself in order for these older pools of meaning to attain new, active relations? How do we stop each and every stimulus of constructed meaning from having foundations within the archaeology of the mind? What I am saying here isn't some modernist awakening and realisation – meaning has always been the despotic capturing of *desire* (desire as ambivalent, myriad, transgressive) and desire has always *hidden within* the human need to supplant desire *itself* in order to operate as a political tool. We find this double edged desire (hidden in both

directions) within the secret of literature. Literature desires to traverse meaning *as* use (through subversive techniques such as rhetoric, persuasion, exploitation, sophistry, humour, poetry, rhyme, verse etc.) preferring the criteria of subjective sensibility contra the techniques of 'objective' correspondence such as scientism and essentialism (classification, logic, taxonomy). However, it wants to do this *within* the remit of a wider meaning/ signification, and further, within a localised context that will legitimate it *as* significant (language/grammar). We writers always want to capture desire under meaning, similar to how a fisherman wishes to catch his fish. In a sense literature almost wants to reify the extension of words, the infinite displacement of metaphor, which in its labyrinth assumes poetic significance from out of the ambivalence of Mankind.[161] However it can only do this if we contend that this ambivalence is intrinsically meaningful. If it is not, then the meaning that arises out of literature's metaphorical suspension[162] comes from an error: a reification of the error, even a reification of a false non-meaning[163]. The non-meaning is false because it has always already been prescribed as meaningful – non-meaning masquerading as a type of meaningful irreducibility of the human condition or its determinations. Now, is desire to be irrational (poetic) actually within the auspices of rationalism (i.e. to expound its irrationality is actually a procedure that is rational through and through; to rationalise the significance of this irrationality and create institutions/frameworks for its judging), or has there always been a strange irrationality in rationality/discourse itself, whereby this irrational characteristic could be utilised as either a limit to the rational or a quality that preceded it and is more adequately originary to Mankind and hence his expression?

Man suffers; the impersonal organism in which s/he has the strange task of conducting life, strives to grow, accumulate power and survive. This odd need comes out like bas-relief in the world of human experience – it deploys to unimaginable lengths the

need to stay alive through myth, belief, value, meaning, custom, fear, ignorance etc.

What can any spectator do, any lover of art seek, under the whir of such realization? S/he tells him/herself this:

"I do not know thy source, I do not know what it seeks, but indeed I feel... so I will affirm my experience, in this moment. I will confer meaning upon this ballerina...after all, she must be part of this feeling I am indeed feeling".

Man gives up on meaning – probably quite rightly so – and affirms him/herself and the objects s/he encounters as sufficient. This is in-fact *all* there is to it. It is the *use* between these objects and subjects that generates meaning (and here I completely side with Wittgenstein), and not some external object/representation of meaning or internal mental state. However, the truth of this use is not necessarily positive. If older legions of meaning can be defined as the constant *negation of* the scientific, empirical, social, political use of meaning (how something signifies something literally or through association), instead claiming that their meaning transcends these 'uses' and is legitimate *because* of its negation of this sort (i.e. theology, mysticism, sensibility), then we contemporaries have conversely ingrained meaning into use for the efficiency of pleasure (or *jouissance*).

Use is what happens to meaning when untangled from the auspices or ambiguity of desire. Use is what is left of the object after desire has been oppressed (finalized) by the object's ostensible meaning (conferred by us). Desire usually never gets a look in regarding the object, as the object is always already placed within an economic order whereby its meaning (use) has already been prescribed and predestined. Thus real desire seems at first glance to be vanquished, and only a shallow desire (the desire of the *use* of the object) remains. However, desire *within* the use of meaning impregnates this *use* and makes it excessive and hence

non-useful (yet still remains strangely meaningful). For example, the original use of the beer mat has been fetishized into a desiring object beyond its use: the desirability of collection (archive/ colonialism); desired as an object that will vicariously provide the subject with status among other beer mat enthusiasts; a desired object that further vicariously desires a community of beer-mat collectors and their various esoteric activities; the desir- ability of seduction i.e. the travels these people take to find these beer mats; the desirability of propriety etc. The myriad construction of uses mirrors the infinity of desire, and these uses themselves spawn further, more esoteric desires. Perhaps use is but a platform for desire (working with desire), yet we should be aware that 'use' *itself* can attract the desire of the subject: how many objects have we encountered that we have suddenly desired without that desire entering our lives before that encounter? We assume that this 'use' of the new object is what we have been waiting for all along. How many promotions of various products/hobbies/activities have we been sent (an activity holding within it a certain use/game), and how many people have joined such activities because they hold a use in their life (exercise, distraction, well-being, social integration etc.) before the initial desire to do any of these things came about. Capitalism 'reminds' (re-mind's) us of what we desire.

There is a residue that pervades within the 'constructivist theory of meaning': the historico-social processes that influence and construct meaning (as dogma or as correspondence to actual states) seem to conflict with one another (i.e. belief contra scien- tific observation, or one construction of historical meaning contra another earlier or later construction). Hence, the construction of meaning not only proliferates itself as an antagonism within these historical constructs, but also unfetters itself from these processes that construct meaning and lay themselves bare within a ground of reality (as the ashes of older half-made meanings)? Heidegger made the mistake of seeing this ground as

'primordial' and inherently meaningful (through his notion of 'world disclosure) and describing it 'ontically'[164], but rather this larval sense of meaning exists as a highly constructed arena of many constructed meanings and their uses. If these uses were all to disappear there wouldn't be any zero level or innate meaning left, only the dark backdrop of ambivalent desire. Most of the meanings in the world correspond to that era when mammals/ Homo sapiens came into being (and succeeded) to make meaningful. Neurosis is the form of assimilation which existed before the construction of meaning (in simple cells, complex cells). It is what life is. Neuroses of assimilative, creative and vital characteristics invade thought (thought being made of matter) and condition the possibility for experience and meaning. Its process comes to the fore in phenomenal consciousness when we become aware of the inner neuroses and external neurosis (what I term desire) and see the residual conflicts of various neuroses, where the neurosis of making-meaningful has come into conflict with another making-meaningful (or where its making-meaningful accidentally betrayed the value of its meaning in the first place[165] or has traversed that of its goals, objects and projects). This elusive and almost fugitive characteristic of meaning (properly based on neurosis) ties in with the ordinary coordination of the senses, sensing these various constructs of meaning, and navigating ourselves through and towards their various axioms. It is only through conflict, survival and the power of desire transposed into human neurosis that we can begin to think of an arena of sensibility/meaning where 'world disclosure' and Jean-Luc Nancy's 'ontological responsibility' can flourish. *Before* the fallacy of these 'innate', ontological, anthropocentric, humanistic and semantic epochs came a different landscape entirely.

What is meaning today? In a more normative, everyday sense, we find a strange cultural generation of meaning in the obscure relationships we have with objects – a sense of smell, a street, a

coat, a pair of shoes, a particular building. The quality of apper-
ception – the integration of new experience into older legions of
meaning/past/custom – is part of the formulation of meaning and
could be said to be *pragmatic* in this respect.

The old relation between the 'form' and the concept it 'repre-
sents' (which would be a 'universal'–Plato), or the relation
between the judgement of mental representations with relations
of ideas is made redundant. We are not even asked to understand
the object or the *idea*, but instead we blindly accept what the object
(and its synthesis) *does* as being its reality, its meaning, the
natural furthering of an application of a conceptual rule – *use*
(this is Kant). Kant and Wittgenstein – for different reasons and
in different ways – are both philosophers of *use* in this sense. We
got here with Wittgenstein by very practical *uses* of words which
determine their semantic content and hence a subject's proposi-
tional and aesthetic attitude. How have we got here with Kant?
What we have is the fundamental correspondence theory that a
subject's understanding of what an object does is adequate
because it is the subject's understanding that *conditions all possible*
experience in the first place (Kant). The construction of the
sensible intuition of time and space (concepts such as cause and
effect that frame reality into something understandable, which
without we would fail to understand even ourselves and our
experiences) are of our own making, and hence we do not need
to look for empirical and contingent factors for their existence.
All we can seem to do is follow the natural *uses* of our perception
along with their adequate judgements that we naturally follow
and express. Meaning that succeeding this theoretical motif could
never be external or sovereignly judged by the individual,
inhuman or even irrational anymore (as meaning works on the
same premise). How do we choose our meanings if a transcen-
dental structure is imposed on us from the start, where every
cognitive act is always already the carrying out of a logical law,
where we have essentially already followed and applied a rule

(meaning) before we set out on our adventure? It would seem that any preceding *desire* compelling this theory must also conflate itself into a *sensible desire* made apparent by our sensible apparatus. Even though Kant saves the transcendental condition for the *understanding* of the object, the *meaning* of such an object can only ever be a *meaning-as-use* and a *meaning-for-us*. Meaning is therefore constructed through processes of corresponding the object's status, quality and characteristics as closely to the rigorous conceptual schema that apprehends and infers it. Even in Kant's theory of the Sublime reason still captures and holds the monstrous encounter in place, fixes it before the mind. Does meaning not simply turn into sense through this formulation?

Judgement has done the hard work of 'constructing' its object to us in the first place. I sometimes call Kant the master of tautology for this reason, or the master of assimilation (everything is assimilated into reason without the distinctions between psychological states, real universals, and real difference).

However, the object apprehended remains in the 'phenomenal' world and is only attached to the *conceptuality* of use/meaning as the closest, most accurate correspondence to the utility (or meaning-as-use) of the mind's workings. Not only does meaning become constricted within 'correspondence' to a concept and the empirical (correspondence to an object), the ideas of 'cognition', 'concepts' and 'the understanding' all become reduced to a tool themselves: a tool to test the adequation of the external world unto itself (calling this reality). Hence, even this so-called 'analytic' tendency of cognition also frames its reference to adequation *empirically* (it creates its corresponding confirmation of objects empirically)[166]. Meaning therefore is both determined within the economy that an object's use has in relation to us, and is also determined by how much a meaning proves itself as adequate *inside* of this register of cognition (meaning cannot appear to exist if its qualities prove elusive towards the Kantian model of the 'concepts of the understanding').

A condition for knowledge *of* objects is not the same as the condition for knowing the objects 'in themselves'[167], and hence the elusive, non-totalizable desire that we have been describing up until now (using the ballerina as par exemplar) has not been touched upon by Kant, or event legitimated as 'existing'. His meaning-as-use, or more aptly his use-as-meaning paves the way for succeeding generations. I wonder if this lack of exotic desire in Kant is what made Schopenhauer so fanatical about inaugurating his *Will*.

Why do I see a consequence in this Kantian theory? It assumes three things: that consciousness is operational, that consciousness is found in the relation between knower and known, and finally that consciousness is empirically verified (even if retro-actively or transcendentally). Similar to operational systemizations of thought, meaning too can easily be operated by Kant's theory to instantiate itself, spread and relate to everything: object x *means* object x, x has *meant* what x has said etc. Meaning not only becomes saturated in itself, it also becomes an operation. This means that meaning goes *beyond* itself and operates for larger systems (such as sense-making, pragmatism and capitalism). Meaning obviously becomes something immediately conscious unto itself (through the subject) if it is part and parcel of understanding/consciousness itself (as in Kant's formulation). Finally, meaning's *use* is placed on the side of the *object* and not the *subject*, because if Kant's theory makes all phenomena of objects confine to the rational structures of our mind via perception, then we naturally see objects – and the uses these objects have – as either automatically meaningful, or that the operation of meaning lies in the objects' compatibility/relation to other objects (what Heidegger calls equipment). The World could be seen as such a large piece of object-equipment and its meaning is in how this equipment places and presences itself – how it functions.

An object's meaning is now an object's *utility* (even in the smallest sense, for example the utility of reproducing sensation).

If one cannot find meaning in an object (a chair for example) then we will immediately look for the next object, the next bit of context, that will verify some sort of semantic equation that will give this chair its *place* and *relation* to the life-web of human relations (which is apparently where meaning in its strongest sense resides).

When one looks at say a rose, one would quite rightly enjoy the scent and form of the rose (this enjoyment is the affirmation of life...one is affirming the rose). The rose begs so many ostensibly 'selfless' questions. One may ask; "how are you flower attached to beauty?"... "You *are* a rose, but mostly you *point* don't you? You point to my lover. I see her hands hold and caress you. I see the red of your petal point to the red of her shoal. I see a bed of nature, of men and women...and I pluck you out uniquely just as I choose my woman...just as I *am* in this particular existence, on this unique planet, in this blink of an eye".

This encounter of meaning is merely the subsumption of the rose's novelty (and its difficulty) into the web of relations that give 'it' symbolic signification. I intentionally evoke Shakespeare here[168] because he mobilized meaning like a man tending to his crop:

> "*I look out upon meaning, our country of meaning, and everything is so closely intertwined by your grace and gaze. Meaning; you are one great monistic force, yet you take on so many faces, celebrate yourself through so many gestures*".

Here, meaning shows itself as the *familiar*[169]. One simply assumes it (probably because we think meaning is part of our *nature*). Don't you see?! There is no real *encounter* with meaning if it is in the familiar! The familiar is exactly that which is *not* encountered. Equally, if every object vouches for its mark of meaning, then nothing can be meaningful (meaning would become indifference, even to itself). And what is this constant

'pointing' towards meaning *everywhere*?![170] As you might have realized, I see meaning's *necessity* in psychology and biology, in 'the-will-to-live', and you will not see me jump into normative frameworks of meaning in everyday life. In the few encounters I have had with something culturally akin to this sensation it has never 'pointed' elsewhere, to something connected to it, to its family of meaning creating the 'whole' of life. No, it has always (if it has pointed) pointed into itself... played itself out humiliatingly through me. If there is this *meaning*, it is rather a terribly lonely encounter...with nothing communicative about it[171]. This is possibly why, at the beginning of time, when this flash of meaning struck the first lonely person, this person assumed it to be God ...i.e. people and society cannot do such to Man!

In contemporary times, meaning is a jigsaw puzzle of the everyday squalor of human existence (warts and all), and any piece (object) can be raised to the power of 'meaning' simply by finding its place within the ever-growing web of human relations. After all, it is in this ever-growing web of human relations where meaning is created and resides...right? Could meaning not be considered as a rupture within this web of human relations and experience? Kierkegaard's sense of meaning led him to break off his engagement to Regine Olsen, his attachment to that social world of love – the *familiar/* family-er.

"At Vespers on Easter Sunday in Frue Kirke (during Mynster's sermon), she nodded to me. I do not know if it was pleadingly or forgivingly, but in any case very affectionately. I had sat down in a place apart, but she discovered it. Would to God that she had not done so. Now a year and a half of suffering and all the enormous pains I took are wasted...That a man of my inwardness, of my religiousness, could act in such a way. And yet I can no longer live solely for her, cannot expose myself to the contempt of men in order to lose my honour – that I have done."[172]

And then later;

> *"Supposing that I had been free to use my talents as I pleased (and that it was not the case that another Power was able to compel me every moment when I was not ready to yield to fair means), I might from the first moment have converted my whole productivity into the channel of the interests of the age, it would have been in my power (if such betrayal were not punished by reducing me to nought) to become what the age demands, and so would have been (Goetheo-Hegelian) one more testimony to the proposition that the world is good, that the race is the truth and that this generation is the court of last resort, that the public is the discoverer of the truth and its judge and court. For by this treason I should have attained extraordinary success in the world. Instead of this I became (under compulsion) a spy."[173]*

The fundamental historical difference between these two ways of generating meaning (the *encounter* and the *familiar*) is that one is tied to thought and the other is tied to apprehension...or ignorance[174]. In the former, the rose *should* beg *thought* and *reflection* in the person that encounters it; there is a commitment to its novelty, not to subsume it into utility or older legions of meaning, not to give it a *price* (for me, this thought is one of *humiliation*). I am humiliated by *infinity* perhaps, its priceless-ness[175]. The person encounters the rose in order to reach thought that will legitimate the sensation. Perhaps the person is seduced by the specific novelty of that *particular* rose that changes the trajectory of his/her thought and sensation. S/he must be vulnerable to the world, s/he must not assume.

In the latter one reaches 'meaning' by placing the object into a mode of efficiency without thinking its quality. If s/he cannot find meaning immediately in the rose s/he will relapse into letting it be subsumed into the nearest register of meaning for him/her (i.e. a superficial enjoyment of the colour red, the scent

in which s/he associates with pleasure etc...). Meaning has become efficiency, and meaning is anything but the smooth pragmatic functioning of a task. Because efficiency is determined by despotic powers it is deemed meaningful to work involuntarily; it is meaningful to buy things etc. It was inevitable that subjective meaning was to become subsumed by utilitarianism and capitalism. One could say that the generation of this despotic meaning is produced by *meaning as familiarity*.

The trick is to think meaning subjectively, on your own terms, and not contextually. One aspect of my non-metaphysical nihilism is simply that I am tired of people telling me what is meaningful and not meaningful. But most of all I am tired of seeing human meaning turn into a set of vulnerabilities that can be monopolized by capitalism and social positivism. Is this my humanism in nihilism?[176]

When was it precisely that Man made meaning contextual, made it a web or veil *around* things? There is a philosophy of this type of contextual meaning[177]: the impossibility of severing an object from its milieu or web (the relations an object has to other objects and its relation to its function, which determines it) is the impossibility of affirming one thing without affirming everything before and after that has given rise to the particular object of affection. And one has to deploy the strange task of loving oneself in this moment, loving the life that has given you this experience, loving sensation, loving love; and Man after all is the embodiment of this peculiar feeling.

There is no real meaning to these objects. Meaning is here simply a redoubling, it is saying that the 'is-ness' of an object is meaningful under the presumption that everything that 'is' is meaningful. Here one must simply point to make meaningful (or alternatively, simply speak)[178]. The preservation of meaning, which includes the 'looking-back', 'looking-up' and 'reflecting' of meaning, is made redundant because *everything* is meaningful[179]. Hence it takes no more than a moment of repose for the sensitive

Man to realise that if everything is meaningful, then meaning has been made arbitrary and indifferent, and hence, non-meaningful. Yes, in a sense *the holism of meaning and the immanence of meaning is nihilistic*.

There are three types of Western Men out there: a strange renewal of the Greco-Roman tradition, the Christian tradition, and the modern age. The first (Greco-Roman) breaks his/her back trying to lift and hold-up the epic universal qualities weighing him/her down found everywhere in human existence, found almost intuitively and immediately in consciousness it would seem. S/he is a mystical cartographer – drawing great lines between the objects, music, words and actions that arise as human artefacts from out upon the sea-bed of civilization, lining them up with greater forces s/he sees hovering over us, making us tremble (war, love, power, god, reason, life, anguish). There is no doubt that s/he sees a plain of meaning stretch out infinitely and exhilaratingly. His/her job is to pull it in and let it out again – like a bow and arrow. S/he is part of the Greek legion – allegiance to classical Reason, Wisdom, Discourse, the liberal arts. S/he is part of the Roman legion – allegiance to Justice, War, Politics, Law. Meaning is a *commitment* to him/her and hence it is character-building: integrity, virtue (*virtus*), will-to-power, allegiance.

The Christian, contrary to popular belief, *knows* **novelty** like no other Man. Doctrines, services and narratives are all very well and good but that isn't the Christian impetus. The Christian impetus is to perpetually believe that novelty (or the new) can come out of the old i.e. that the possibility of salvation, spirit, transcendence can become incarnated at any moment and arise from an 'ordinary' object of the living world. Jesus Christ is the harbinger of this belief in novelty. So I am a Christian in the sense that I am not fooled by the *custom* and orthodoxy of things. I believe in a flower, in art, in a person, that they have the capacity to transform themselves, or me. Meaning is an *encounter* for the

Christian and myself, and it is produced through some *New* element, some reconfiguration of existing or not-yet-existing materials. The *New* is used in The New Testament to such an extent that modern readers think that this new is simply faith or a fallacy. Jairus is healed and brought back from the dead (the Christian must commit to the possibility of this happening and the commitment to the new over custom etc.). People who do not believe in the creative and transformative capacity of the New will find problems with Christianity. Universals are less important to the Christian than one might think. Faith is not predicated on universals but on a singularity. The Idea of abstraction does not hold within it the potential for radical newness.

Finally we have the modern Man. A Man who, ironically, is confronted with superficial novelty everywhere he goes: fashion, advertisements, new products – yet hasn't the integrity or vulnerability to ask for it (real newness), to pray for it...to make it *himself*. S/he is a Man of Humeian custom; s/he acknowledges that we have been taught or conditioned to think in certain ways and to expect certain things to happen (without these circumstances necessarily being rationally explained). His/her goals are self-oriented and short-lived. His/her denial and disdain towards his civilization mutates into a type of little hedonism/cosmopolitanism. The exciting thing for the modern Man is the huge gulf or void created after the realisation of the non-necessity of Morals and Ethics, that our desires seem to stem from somewhere *Beyond Good and Evil*, and that we have lived beyond the dependence of our last God. Equally I believe us to be the amateur inaugurators of Psychology, and that along with its huge insight and possibility for creation, it is a force that we do not even know how to handle yet.

So meaning isn't connected to any metaphysical realm of forms or values, because forms and values seem to change relative to a species' needs and conditions: *use* (and obviously

this metaphysical drift appears redundant in the face of scientific observation). It is not even connected to a God (but the human may by all means confer *afterwards* this meaning onto an object/ God – as homage/lament). It doesn't even seem to come – like the structure of a crystal – from inside the object itself, *causing* itself, constituting novelty, because we live in an era of interpretations and semiotics (sign system's) which create the meaning of things and do not come from the things *themselves*. Equally, in a world of utility we cannot now make the distinction between meaning and use-value, and in a world of mass-conformism Man finds it harder to assign meaning to an experience or object if no-one else seems to respond to that same meaning.

Meaning... The word 'apple' means the green/red fruit that we eat that grows on trees. But surely there are several meanings in the above statement, and those separate meanings depend and co-exist with other assumptions, grammatical and sensical (do apples really grow *on* trees, could the *act* of eating not only transform the apples meaning but also decrease its meaning)? And apple means a multiplicity of things in relation to the context in which it is uttered *by the human*, and can be trans- formed at any point to give it new references of 'meaning'. But this is not what we 'mean' is it? We want meaning to be intoxi- cation, sublimity. My paradigm of meaning is possibly a Romantic one, like the paintings of Caspar David Friedrich. We want it to be more than correspondence to a word or experience, or an adequation to a reality. Perhaps we just want it for ourselves... personally. Loneliness is the perfect experience of meaning working upon the self, whilst the self works upon and constitutes meaning. Loneliness is the possibility of a fulfilling meaning in which we are severed from. But this *striving for* meaning is **necessary** for meaning: think of all those sensitive Men that attempted to momentarily escape the world they live in (that is to escape the ambient grime of superficiality and utility) in order to 'listen more clearly', to make quiet images, collage,

textures, a watercolour painting etc... they are showing a 'silent' place *outside* of the clamour of everyday meaning. Their *stepping away* from meaning and their awareness that they are not immanently *in* meaning is a sadness and loneliness which creates the pinnacle of human sensibility. And sensibility must necessarily produce meaning. In a sense, contemporary meaning must pass through an awareness of nihilism for it to be considered justificatory at all.

> *I walked through town, past the same shops, just like every other afternoon. I felt nothing. My Being just 'was', similar to the shops I was passing. I was engulfed in an all-pervasive familiarity which stopped me from asking any questions about the nature of this experience. For these somnambulistic moments I inhabited a world with neither meaning or non-meaning, just 'what was', and the possibility of anything else was taken out of the equation like it was undertaking its own frontal lobotomy upon itself. To even bring-up the question of meaning into such a situation one must dip their toe into the water of nihilism. To ask what meaning 'is' one is already doubting meaning (the characteristic of the nihilist). To intuit meanings demise (nihilism) is to have already assumed meaning to have been hiding behind the present situation all along – i.e to have assumed meanings existence.*

The traditional conflict between an all-encompassing co-existing life which is pluralistic in its quality and immanent in its effect – in contrast to the autonomy of qualities and their transcendence (or making transcendent) – is personified in the ballerina. What the ballerina shows, with no 'essence' to it, is extremely Promethean: you cannot think concept without form, you cannot think form without space and time, you cannot think space and time without embodying space and time, sensationalizing it. In other words, the ballerina would whisper whilst kissing your ear: "what you really love *is* me" and there is no metaphor about it,

and no judgement, agency or disinterestedness on your part.

We are in the age of narcissism: we fuel the concept of love through the only reference we seem to know: self-love. This is desire eating and fuelling itself and going nowhere. This is the snake that eats its own tail. This is Narcissus obsessed with his own self-image.

The yearning towards the symbolic, if not pointing to something 'real', 'out-there' and new, is rather expressing itself in favour of its co-existence. The ballerina may again whisper to us all:

"I am expressing a potential towards something, yet moving from a deep respect and understanding of my cause. I am both acorn and tree, I dance with what conditions me yet form a fresh purpose. I am the running water that has frozen into form, and melted back, yet into something peculiarly different. Yes, I symbolise something Other, yet its features are always already embodied by the human form, its qualities always returning to the human world of sensation."

The ballerina's dance covers everything – there is no gap to think difference! How is movement or real discontinuity even considered possible if every stage of process has within it the first stage, if every discontinuity has to adopt continuity in order to express itself (or be discontinuous *from* something that existed within continuity)? We need to start from a less claustro-phobic place. Why can't we deconstruct the aspects of the ballet to see where the meaning resides? Why can't we grasp the different, separate meanings that build up the phenomenon of 'ballet'? We suspend our disbelief for the holism of an experience (the ballet). We let ourselves become distracted by exactly what they want us to be distracted by[180] (the construction of ballet), which in-turn distracts us from the *reality* of the situation, what I believe to be the 'meanings' of the

situation: the naked strange *Being* underneath the ballerina's costume, the relation between determined story and undetermined aleatoric bodies in motion, the relation between reality and metaphor within a stories tragedy. There can be a tragic story, but could a story perhaps be tragic, that is, could life's spontaneity and revolutionary impulse be trivialized through making such *tragic*, by making such a *story*? Could deviance not play a more fundamental role within the entertainment industry of ballet? The ballerina's role in the ballet-as-immanent-continuity is the same role as the denizen in society: a slave to the despotic machinery that produces orthodoxy and continuity. Philosophically she is a nihilist – she doesn't believe in what she is trying to represent, and makes *herself* art as a consequence (hence destroying the aura *between* art and subject, further making art/meaning ubiquitous). She is also an anti-realist because she cannot provide a solution to the fundamental discrepancy between the way we see the world and the way it exists independently of us (she wants to *show us the world*), and fundamentally, she cannot show us how there can be difference and change in the world. Instead she relates to everything (everything is relative to everything else), she embodies every atom in the world in her existence, she produces a further line within the gargantuan biological, chemical, physical and conceptual continuity of the world.

The greatest mistake in modern philosophy is equally the greatest fallacy of meaning. From Descartes through to Kant (and beyond), the impersonal, alien world started giving itself to us, became accessible in a different way. Whatever we could lay our eyes upon or conceptualize became *knowable*. It became knowable on the premise that we as *knower's* make the world knowable. The consequence was that if our epistemology (way of constructing knowledge) was flawed, then so too the realm of objects conferred to the realm of the *knowable* would be incorrect. This is indeed the case.

The same happened to meaning: Men have to differing extents assumed *Being* to be inherently meaningful. Hence, the argument concerning whether meaning exists or not was made redundant because if being exists then meaning exists[181]. In consideration of this, Men have been portrayed as Medusa's of meaning: everything that exists in their remit they turn into meaning. Men are the perpetual harbingers of meaning.

After the modest deconstruction of 'innate' human meaning by philosophers as varying as Schopenhauer, Nietzsche, Wittgenstein, Quinne and Derrida, one would do well in re-considering this ostensibly fundamental aspect of human life again, with rigour. Maybe one will be able to encounter something again...out-there...outside of meaning...or *not yet* meaning...

II

And now, rather modestly, but with vigorous courage, we may ask what she, the ballerina, may *also* be saying, or saying *instead*. Or is it that something is being said *through* her?

There was a time when one supposed *Thought* to be sometimes outside or irreducible to the historical circumstances that rear it, the cultural events that shape it, the language that sets it, and the psychology that tests it. One wanted a gap between thought and action, conceptual innovation and non-conceptual determinism, a gap between the relations (relativity) that Man has *to* the world, and the absolutism of a thought grasped 'in and for itself'. Are there Ideas out there that have not been 'grasped' yet (as Hegel would say)? Ideas that a distant future has not had the possibility of setting-up just yet? The materials simply not in place, the situation not constructed, the problem unthinkable to Men of our era? Are we not saying here that Ideas precede experience though (to speculate that a new idea may exist within a situation or set of experiences that hasn't been determined yet)? Just because we accept that ideas and

theories are a product of certain experiences/situations this does not cancel the notion that there are ideas 'out-there' which are not as yet activated because the set of experiences determining it have not come about yet. If Ballet is an Idea, then surely no-one has exhausted it yet, no-one has understood its potentiality completely. And vice-versa: if Ideas come from certain situations, then surely not all situations have been exhausted yet...life has not been exhausted yet! If this duality (or synthesis) between Idea and experience exists, one would expect *infinite* relations and innovations between them. Equally, one should be-able to exclaim (as did Georges Bataille) that if there are some relations between, say, the *Idea of* Ballet being portrayed by Ballerinas, and the *Ballerina's portrayal of* what she thinks ballet is, that have not been *set* yet, then there is not only infinite potential but an imminent limit which we could call *the impossible*. For example, in the moment of the ballerina finding a new or disparate relation to the Idea of ballet, she would be closing off an alternative relation forged in some other way, in some other place, at some other time...perhaps a time that could have only happened (and been) *once*. *Impossible* also because seduction, desire, bashfulness and unknowing are tangible impossibilities that are incommensurable with the world of science and banal realism. A ballerina may still have the potential to be impossible, to make an idea that was once impossible possible, to stop an idea from being possible (the impossible)...or to make ballet impossible[182].

Meaning used to be one way of encountering the *Idea* of a certain universal form or quality. For example: the encounter with love for somebody was one way of encountering an aspect of the universalizing concept of Love. The Idea of Love was also present *in* this human act, gave the Idea form: a symbiosis became thinkable. But really, only in accepting human relations and experiences as a quality of a much more holistic, totalizing form could this meaning be achieved. This would result in denouncing that meaning was found in things/persons

themselves, and instead identifying these persons/objects as expressing (or representing) some other, more abstract quality, irreducible to the pretensions of meaning given in language, intercourse, objects, and sense-perception[183].

The indiscernible, if there are still those rare select few that chase after it, are chasing a *limit*. A limit that cannot be covered up by a monism, which, like the alchemist, views the many attributes of world and consciousness as mixtures and moulds of the same singular substance, covering up gaps and voids, covering up yearning by explaining that what you are aspiring towards is already 'given'. How can we really think 'encounter', even 'mixture', without first taking seriously a duality that contracts, repels, feeds, sucks, 'is' and 'isn't'? How can we think life without death, creation without destruction, strength without weakness, masculinity without femininity, difference without identity, continuity without discontinuity etc...?

And this is where the Aristotelian metaphysical world crumbles: an uneasiness, doubt and otherness emerge[184]. One can begin to ask once again; "is this ballerina 'real'?"

Outside the *symbolic* identification of the ballerina, is there not a residual humiliating *real*? That is, what is left of the woman after she has been saturated by her symbolic identification as 'ballerina'? After she has been clothed by garments and movement (dance)? Could I find this remainder beautiful? Is she not pulled up by opposite strings; impersonal motion mixed with a woman we do not know (almost base), and then motion turned personal/symbolic (what we call 'movement/dance') ...and then a concept emerges: the historical concept of beauty....under the pretences of a category such as *ballet*, within an equally conspicuous context – the *theatre?* These qualities are all coming and going, breaking away, falling to the floor and consummating in ascension. They are all discrete, separate and disparate. There is a game at play, there is something at stake.

Because we were so wrapped up in the encompassing

synthesis of the ballerina, we had forgotten the duality that makes art possible: the duality of the imaginary and the real, the stage in which the imaginary plays itself out (like the stage the ballerina dances on), the duality that makes *representation* possible, and of course the 'play of glances' that immediately prevails: *seduction*[185].

And then we appreciate Walter Benjamin's insight that "there is no document of civilization which is not at the same time a document of barbarism" because, within the seduction of 'civilized' or 'cultural' appearance appears an ugliness; beneath the leotard is an absence, a nudity, and a humiliation of such nudity (the humiliation that Adam and Eve had in realising that their innocence can no longer be pure in relation to knowledge i.e. civilization). And so behind this knowledge/civility (clothes) is now a new instantiated knowledge of physical lust and the passions/incivility (nudity). However, this nudity is in itself only uncivil because of the secondary instantiation of the 'civil', and this instantiation of 'the civil' is itself an uncivil concept which was uncivilly entered into by Eve's sinful act of eating the apple. The barbarity of civilization belongs also to the brutality of *objects* imposing themselves *as* tools of civility or as generating uncivil desires (i.e. determined desires, capitalism). Through all of this time the objects which we have collected and compiled (and staged) in order to represent our civilization and function within our civilization have *turned on us*, have secretly had the real power over us.

Here we sit in a ballet theatre, or walk through a municipal town, trying to keep these objects of seduction in their place, trying to turn this seduction, this obnoxiousness of objects, into a controlled operating space. The ballerina is not a human to me but an object...humanism cannot win over the *other* of the object. She must try to be a subject though[186], as opposed to merely pretending. The lure of ballet is that she pretends to be both subject and object but under the guise of an overall object: not

only because she becomes a determined object within the narrative and steps of the ballet but also because her presence is dependent on an audience/voyeur, and this voyeur inevitably objectifies the ballerina (she is the *object* of our attention/ affection). It is our desire to objectify the subject – which the ballerina lets us do – that makes ballet so enticing[187].

It should also gradually dawn on us that there are at least *two* motions at work here when we confront the ballerina. It would be almost gregarious of us to mix the temporality of the spectator viewing the ballerina with the original temporality of the ballerina's dance (her incarnation of the musical score), let alone the subjective duration of the dancer encountering the demands of the music carrying her[188]: temporalities of anticipation, pressure, of receiving and of registering. Several different spaces and times are fighting over one another; if one succeeds one is illuminated, if one fails then one buffers, erasing one another like the ballerinas erasure of time through movement, like her erasure of sense of self for the dance, and the erasure of one step to pave way for the next. Such is a profundity of Messianic measure.

The ballerina is incompatible with herself and her audience. If she was completely compatible one would not call it ballet but living. If she were completely compatible she would be camou-flage, but beauty's need to be seen makes this otherwise. Beauty's seduction lies in its incompatibility with the familiar, its surroundings. The ballerina pretends to be compatible with the perpetual moment *and* the symbol (a symbol always being an *historical* construction) hence conflating the two and making both ahistorical, ubiquitous/meaningless. Her seduction lies in a double bind: she seems incompatible with difference (she seems indifferent) as she relies on herself and her movement without really portraying anything other than this – she seems indifferent to the world of stimuli (she has her own thing to do...she cannot be distracted) yet she is also incompatible with indifference

because beauty cannot be disinterested, she is on stage (!), I cannot refuse to look! She is vain and beautiful (this is what makes her stick out). She is, more traumatically, incompatible with her own dance...because she is *not* the dance. In every form of representation seduction works because one is trying to depict something incongruent (from themselves, their principle of reality or their medium). We have an incompatibility (reality/representation, medium/image) and compatibility (representation being compatible with a medium) at the same time. Otherwise the ballerina would physically merge into the music, the renaissance window of perspectival painting would merge into the reality it was itself depicting. We humans are lovers of this chafing, this double play on the imaginary and the real. Incompatibility is, in a sense, *connection* (compatibility) because to connect one needs two different things.

What this shows, albeit in a gesture of perpetual destruction and separation, is the Platonic element of the ballerina; that the idea of ballet, dance, or movement exists independently from the persons or forms embodying these ideas[189], and that the destruction/separation of ideas from their embodiment shows that such ideas and bodies were indeed there, very real, being both one and distinct from each other (the carnal fatality between human 'versus' Idea).

That ideas cannot die (ideas don't die, people do), that forms, being a creation of the idea, are therefore eternal, and that Matter, on which forms are imposed, is simply an evanescent, intangible clothing that has the modest capacity to turn potentiality into actuality, is what is showing *itself* now, and the mortal, finite ballerina must dance with this insight.

This type of ballet, where the ballerina is binding and unbinding with the idea of what she is representing, where real discontinuity can be created if she were to make a drift between the form and herself by choreographing a mistake made beautiful, made virtuous by the demand of the human body as

material, has something *fatal* to it: the very same fatal demand Jesus Christ makes through his incarnation as man, and, later, his crucifixion. In short: the human being is vulnerable to meaning (as an historical construct), he can *fail* at it. When a ballerina makes a wrong move or injures herself, she embarrasses the entire construct of meaning found in the continuity of narrative, melody and movement. But it *must* be that new meanings come from this *failure*. It must come from the body, the individual –

...and the audience are frozen in silence. The stage, façade and props continue to jitter along worryingly and self-consciously while the then ballerina now human being (?!) attempts to get up from the floor in order to continue to dance... she cannot. The light specialist continues to shine the spotlight on her for some endearing reason (or out of rabid curiosity). She embodies a strange, novel reality that appears and resonates like bas-relief from out of the winter wonderland of symbols, simulations and conventions. The audience are waiting, but soon even the convention of anticipation and suspension of dis-belief wears off. Something in us tells us that we are more curious than ever. It is from the failure of art...but it has to be art now... it has to be an ideal. A man stands up from within the audience: "Is it possible that a human can create and end things, by adopting forms out of non-meaning (the void of Man), enacting meaning – not simply inhabiting meaning; perhaps even to subsist and endure new meaning. Ballerina your failure is the most beautiful thing I have seen". Another man, who stays sitting, adds "let us keep meaning meaningful and not normal; fatal and not accommodating". He and the standing man start to clap, the entire audience follow...and people aren't too sure what to do with themselves anymore. The lighting man helps the woman up from the stage. People do not know what to do with themselves anymore.

But Plato is in no position to be deemed responsible for this sense of *fatality*. We can use his sense of dualism to re-construct

operations of difference within experience. We can use his sense of a more substantial inner-working of reality behind the veneer of appearances to tidy-up and delineate an empirical world that seems to spill and connect to everything else ceaselessly and easily. But what adds this sense of the fatal to beauty is *movement*[190], and after all, it was Plato who banned eccentric poetry and music in his *Republic*. His doctrine of Ideas are stations in which movements can be marked up and re-deployed, but for him, motion is always the image of the unmoving, the idea giving itself form[191]. It was always the Schopenhauerian's and Nietzschean's that took music and dance seriously (or mystically shall we say). Music was the Will *itself*, before it took on any guise or stable form of representation. Music was always before conceptual classification and under-standing. Music had irrational impulses.

The *Will* is the originary force and feeling of and within Man and nature, which must be studied as fundamental power. If there is one thing in which we enter with the ballerina, it is the whirring *Will* of *movement*. There is in-fact no origin to this quality of movement (dance) in that its quality is always *transi-tional*. In Henri Bergson's words: "what is real is the continual change of form"[192].

The fatal move for these philosophers of the *Will* is the refusal of the Platonic injunction i.e. the refusal to sever movement from the *Form* and the inorganic (mathematical and conceptual forms being eternal). Instead movement became vitalist – the force which animates objects and personifies a romantic movement – a *sturm und drang*[193].

Could movement *itself* be a language of meaning without recourse to its inevitable deployment or production *upon* objects? Could one be a Platonist when it comes to movement, even though Plato himself would denounce movement as a real entity? Who else wants movement without the mediating quality of the *image* of movement? Does the image not get in the way of

movement? Yes! I want fatal movement without the serenity of
the sensible image. But *fatality* would not occur without some
thing, some *being*…at stake…in the face of such impersonal force.
And only now, with this insight, can we begin to mix this
movement afresh with the small idols of form, beauty, and act
like a mad scientist. Only then will we see things at work, see
things happen! If we *add* this movement to beauty (an old
historical form) we have ballet in its best, most uncompromising
state. Fatality is specifically, and uniquely, the *human* consti-
tution of, and response to, movement. Movement working upon
itself, working upon us little humans, is almost always
destructive, messianic. Ballets current yet necessary demise is to
give this sense of movement more fatality. One must find solace
in 'pushing that which wants to fall'. Ballet must give itself over
to the fatality of messianic movement, to chaos, to termination.
This new relation to fatality not only produces novel aesthetic
effects and values *within* ballet but also attempts to destroy *the
idea* of ballet itself; to destroy the idea and form of ballet and its
nurturing of beauty through the all pervasiveness of movement
and the flooding of time. Movement and time does not want it
now – its 'accelerationism'[194] has no time for the subsistence of
forms/representations.

It is up to you which decision you wish to employ: the all
encompassing, co-existing ballerina as woman, dance, dancer,
motion, presence, cause, effect and vision, where life swells up
and extends, or the ballerina of consequence, who tackles, cuts,
encounters, … is a rage against life as it *is*. The ballerina's dance
of the fatal is the putting-to-the-test of the Idea. It is the pushing
over of that which perhaps wants to *fall*: the fall of the concept in
contemporary culture, the concepts autonomy, the traditional
concept of *beauty*, the suicidal fall of ballet *itself* against the siege
of the avant-garde or the technocratic populace.

In the first world, where difference is egalitarian and
therefore not capable of the ascension that the human encounter

of meaning presents, it rests content with the belief that meaning is generated through a difference of varying *degrees* of sensations, as opposed to a difference in *kind*. The tragedy of the second world, of the ballerina with a consequence, is that she must *find* an opening up of infinity, at the expense of the fatality of her carnal body. The question for *these* dancing terrorists of the finite is not "how can something come from nothing" (*ex nihilio*) but "how can nothing (the infinite void which creates the new) come from something (immanence)?" "How do I cut into, or subtract myself from, the base-flow of indifferent movement, the perpetual present, the excessive uniformity of desire"? "How can a new step, a *ballet d' action*[195], change the stakes, roll the dice[196], resist the artificiality of traditional orthodox dance, against the mimed passage"?

Personally, I find impetus in the balance *between* these two worlds, the tightrope between them. This balancing-act, on tip-toes, is perhaps why we must travel through the ballerina herself to get to this philosophy. The ballerina dances on tightropes on the ground. This balancing has a peculiar affinity to the role of the poet, yes?

III

For me it has always been a consideration of *Two's*. I am a slave to the duality I speak of. Even in the last two contrasting examples it is not a question of whether Plato is correct, or whether indeed Schopenhauer/Nietzsche is correct, but a synthesis of the two. Are not the Idea *and* the motion implicated in all that we do? Yet the distinction is surely essential? And do they not constantly duel with each other? That is, the Apollonian and the Dionysian, the noumenon and the phenomenon, the reactive and the active, the feminine and the masculine, the same and the different, and appearance and disappearance? Maybe not so for the natural sciences[197], but in the world of meaning this antagonism prevails.

Last night I waited at the train-crossing for a train to pass by before making my way towards the ballet studios. I waited there, frustrated but at the same time quite content with my frustration (I find waiting unbearable, but nothing is worth doing without a degree of suffering), and overheard a middle-aged couple say to their child of around seven years: "are you ready for the train? Do you think it will be a big one or a small one"? Beyond how base it is for a human to have to speak of whatever they see before their eyes (in this case it was an obstacle...to the ballet school), the interesting thing was that they were assuredly not interested in the object of the train itself but in its passing by, by its passing *away* to be more precise. Let us pretend that the train stopped right before their eyes, right on the crossing, and stayed there for two centuries. The only significance it would attain would be its gradual entrance into a type of historical realm of importance. It would gradually grow a mythic aura like how mould grows on old food. Even then the object would merely mark the *event* of its sudden halt: the day two hundred years ago when I was waiting for a train to pass and a boy beside me had proposed that it was going to be an extremely long one. It would be a mistake to make the presence of an object the constituent of the importance of the event of such an experience. It is rather its disappearance. Disappearance is what marks the event and what constitutes time. Its effect is seduction. One would find more pleasure staring out towards the farthest point on the train tracks, letting their vision wander off and disappear, rather than find themselves at odds with an immutable train, encountering one carriage at that, and stopping one's legs from being able to wonder off with their own vision.

This was my first visit to the ballet studios, and I was unsure of which way to go to get there. I walked onto a street that I had never walked down before and became all of a sudden disorientated and vulnerable. No nausea, more relief, as if I were stepping out into uncharted territories. I lost much of my

stubborn identity and what was left of me was distributed evenly across the streets I was walking through. I knew that something primordial was in store for me. No one gets away from love when one is in such an open state of naiveté. I was ready for enjoyment, nudity, but I was never prepared for the pincers of lust.

In my experience, when this lust is actualised (happens directly) it is always a game of two's. Before this, I enter an impregnated night full of all the mysterious and familiar things I love. I walk the concrete street, I adore the tarmac I step upon, I await the cold breeze that November will bring, the falling orange leaf mixed with rain from the following night, I smile at my particular gait, clumsy and careless, I find the sound of cars on the road slowly move in and out of my consciousness. The qualities that care to stick around for me wait like a loyal dog in the rain – these feelings are enough, and most of all they are mine! But then it happens; the confrontation that can only always be of *two*. I think you know what this encounter is. For me, it was the vision of a woman through a window in a black leotard, pointing her right foot forward whilst repositioning her hair that she had bunched up for dance. It was then that I became traumatised by the incompatibility of myself and the ballerina. At that point I became aware of the femininity of love *itself*. Or perhaps merely the vulnerability/femininity that Man must incarnate for love and seduction to have its proper (or improper) effects.

However certain I was of this powerful force of *eros*, it was not the young woman that I loved. The seduction was constituted by an array of self-conflicting and destructive fears. I do not find much of interest in the world, but one of the things that I find fascinating on a consistent basis is that of ballet. It stems probably from how ridiculously beautiful it is. I cannot think of any other practice that allows itself to be so intoxicatingly stunning without collapsing into a state of cynicism (beauty has its cynics…the Men of the twenty first century)! Even the word 'ballet' has something openly feminine about it.

The projects of many of the Western world's greatest thinkers were to present the world as a dance and the subject as a dancer, but without returning to the femininity of ballet. Nietzsche appeals for the Dionysian (the anti-rational dancer and lover), he appeals for the truth of the lie (the importance of appearance and *style* over stubborn hackneyed truths). He places the subject *in the middle of everything* (always being constituted and drawn towards something...always *becoming*). He has spent his life trying to constitute a platform for the dance of the *masculine*. One begins to see moments of this secret genealogy, the inextricability between masculine genius and dance: Archimedes rising from out of his bath and running down the great hall of his king's palace (the word 'eureka' being an extremely elaborate verbal dance of the Idea), Caligula's madness on the beach, Strindberg's pirouettes of insanity, the fall that Nietzsche had when encountering the Turin horse (an encounter which created the event of love for the horse, and the birth of an idea so sad that it would break his mind). This does not mean that epistemology takes second place to vitality, but that the conception of the idea and the movement of its creation are co-implicated. Thought is intensive, and its effects are tragic.

In a sense, the *braveness* of ballet's openness towards its beauty is a masculine feature. And this is another fear that seduced me: the stubbornness of my dichotomy between femininity and masculinity, my roman pillars of bravery and vulnerability, honesty and falsity, began to collapse around me. The single interlocutor between my being and my consciousness, the *cogito ergo sum* that I had grown up with, which I had always seen as being strangely masculine: "I think therefore I am" (as a type of assertion and validation) became open to its own *doubt*. What is this form of philosophical method that starts by talking to itself? Is this obedience feminine? I started talking more...and hearing more. The demand and obedience of the Cartesian conscience began to split into

Jungian alter-egos, split-personalities and traumatically indexed archetypes. "What type of man is afraid of woman, let alone 'femininity"? "Is Nietzsche telling me that the masculine asceticism of the philosopher is now the feminine asceticism of the ballerina"? "Do not be afraid of yourself *as* ballerina" one voice spoke, rather comfortingly. "Who would hold onto such fixed points of reference" I quickly added to the onslaught of 'touching' artillery? In a fit of strength I remember *the Scientist*, whose disobedience in the face of God, progress, morals, ethics, and his own body is concentrated into a desire for **experimentation**. *This* is my masculinity! I turn away from this ballerina, with condensation covering the viewing pane due to the exuberant heat and sweat created by her past dance. It must be past eight o'clock – I estimate the time because the ballet studio is glowing radiant neon, a neon which only the night can turn on. I walk home thinking about how I might calm down. "I must read" I tell myself. I then think to myself, as a chaser of certainty: "oh how I become weak when there becomes in times like these the gentle dropping of the fascination with the brain".

But the brain has not been made austere enough, scientific enough, to repel emotion *yet*! Or better, it has not yet learnt how to transfigure emotion into intellect without there being some remainder of drama (witnessed in the thinkers above).

Consciousness is still as delicate as a flower, as soft as a ballerina's complexion. It *can* be broken. The perpetual self-overcoming and transformation of what the human has been allocated 'to be' is a dangerous business. Half-broken minds seem to hold themselves together by the conviction of their own ego and the compliance to everyday routine, which slowly harnesses their identity as denizens back to them. After all, identity is constituted by the regulatory demands of the body just as much as the meditations of and in the mind. Even my archetype of the Scientist, although more modern, is under servitude to emotions: notions of 'truth' and 'objectivity'. His emotion stems from his

belief in such ideas. *This* is his vulnerability. The dominant *vertigo* of the age is yet to be uncovered, *ungrounded*: that it is not a matter of absolute 'truth' or 'objectivity', nor 'necessity' or 'continuity'; one simply needs rules, even *one* will do, whereby one can begin to play a game.

In *Love* however, one is always swallowed-up by a God or an Angel, which is incorrectly inferred by the man suffering from such delusions. Similar to that *final* tremble of vomiting one has: in this love, one sees the clarity of one's own humiliating stupidity; that one can indeed *know* this impoverishment of the *self* in love, that one *must* indeed face it, is its only reality[198].

I sit at home, after the incident with that pernicious miniature of beauty, and accept that I have been a pawn to such a game. The worst games are those which allocate you under the assumption that you are a consistent and predictable object. The football captain chooses you on the assumption that you will play football, and as best as you can at that. On the contrary, the canvas beckons the artist on the assumption that he or she will *not* abide by the rules of 'reality': that s/he use the colours s/he chooses, that s/he will depict how *s/he* sees fit; perhaps, in the end, s/he will overthrow reality itself! To play the game of art well (and the game of the artist) its imperative has always been to change the game itself.

Most people play love as a banal game. I appreciate that they have to (...what type of violence ... apocalypse would occur if love were allowed to incarnate everyone as it does me)!!

Love, *as a banal game*, can't be changed as easily as art. There is always this responsibility to the other person involved which hinders its power to create. Love is still outwardly too social. There is still too much etiquette towards love for it to be dignified with the label 'artistic'. The epiphenomenon of love holds society together, is in-fact a social practice, but the *event* of Love – its rupture harbouring infinite transformative encounters – dismisses the social aspects that confine it. I dare you to find

this love again.

I could have changed the game! I could have changed her dance from an elegant physical lethargy to an upright encounter. She would not have known that she was in love with me at the point where her eyes met mine. This unawareness is particularly attractive.

To begin to communicate would have been to begin a new game, a universe in which we were the creators. Albeit slowly and nervously, crab-like in our sidestepping, the game of love and fate would have two new dancers, with one arc for each couplet, setting course for the furthest and deepest of adventures.

Is there a new me for me to be in love? I turn away from this quixotic thought the same way in which I turned away from the ballerina (leaving a little of my subjectivity in-tact). "I still think that I would be playing a game", I tell myself. Do I accept being a 'piano key' for the sake of making a song of love? One key, amongst a piano of the infinite!

To be played by fancy! Is e-motion the motion of a single note ("e")? – reading as follows:

Love, written and composed by Charles William Johns, in the key of E.

Here is my revelation: *separate motion and form into levels of relativity.* Archimedes was a dancer of the masculine Idea: the form (scientific 'displacement') predominated him, the gallop of his joy came second (after all, the discovery of displacement is a quantitative one and not a qualitative one). The form wins for Archimedes. When Nietzsche conceived of his notion of the Eternal Return, the recurring motion (of a perpetual present that inside it had the capacity of difference) was too rapid, too loose...too vertiginous. The ideas' form returned to Nietzsche, but always as uniquely different, schizophrenic almost. Motion wins for Nietzsche: conception over the concept (or, rather, *Life*

over the concept).

Fatal love comes to those who experience this motion in overabundance compared to that of the form. What are the levels of motion and form in Munch's *Scream*? Similar to Nietzsche I think the perpetuating intonation of the scream, too fast, too dissipated, and without an origin (the figure has no ears to hear the origination of the scream).

The immediate need on my walk home was to intellectualise love so as to disenchant it (…and so to protect myself from this motion that beckons the rupture!!).

To renew form as immutable was to revisit the unwavering insight of Plato once again.

And in this thought, the concept of *beauty* gave itself a renewed importance to me (one that I will die with). Beauty has *never* been *movement* for me. Beauty has always been hidden for me in the bust of a statue, in the stasis of a painting. Not only that, but also in the very act of appreciating or thinking the beautiful, there was no propelling movement either. I realized that in beauty there is always a *looking back* for me. I had a sudden fit of anger: "how have you been so liberal with this allocation and appreciation of beauty….what a specific effect beauty has…not like any of the other acts of experiencing…and yet I had generalized it…well not anymore"!

I knew then that the ballerina was the adding of beauty into the whir of motion. Oh! And how these two antitheses balanced upon one another! Dancing upon a tightrope…on the ground! I will not hesitate to explain.

IV

Yes, the predicament I have put myself in is only superficially one of arrogance and cynicism (and perhaps Idealism). The core of my dilemma is historical. In order to take beauty seriously it cannot simply be 'had'. This is the void at the heart of contemporary Man: we struggle to find anything truly beautiful. If it can

be instantly consumed, with no humbleness or courage, then there is nothing at stake and no stage to play-out the hunt for revelation, intoxication or serenity. Because Man has made beauty instant, the only way to *qualify* such beauty is to *quantify* it, to repeat the same act of guilty consumption in order to facilitate the perpetuation of his or her greed. Or, to make such beauty addictive like wine, which reduces all the beauty of the beautiful to the titillating effects it has on the inebriated voyeur (hedonism). Beauty does not seem to be fair today. There is too much of its quality transmuted onto the subject's side, into sensations and desires. Lacking is the space where beauty's *aura* should pervade. In Theodore Adorno's words:

> *The subject is unable to return to the object what it has received from it... it is not enriched but impoverished. It loses reflection in both directions: as it no longer reflects the object, it no longer reflects on itself and thereby loses the ability to differentiate.*[199]

But what of the incompatible beauty of the ballerina? Incompatible because as her beauty is incarnated it too becomes objectified (by us spectators *and* by the ballerina *herself*); the ballerina becomes the object of what is beautiful and therefore can be consumed and deflowered. After such, she becomes like every other keepsake of the mythical: disposed, made 'human-all-too-human', made a prostitute. I cannot think of another origin of beauty that dares objectify itself carnally for its appearance before sacrificing itself through such manifestation. The *technological reproduction of the work* of art lays claim to this deflowering on a different, less immediate register[200]. The ballet dancer shows us the humiliating consequence of beauty, self-induced, as every true artist must entice. The ballerina shows us a nudity, not sexual, but vulnerable and ephemeral.

On one side we abhor the 'objectification' of experience and thought by science and instrumental rationality, appealing for the

self-reflexivity of consciousness and its self-making and changing reflection of objects. But on the other side we fear that without objectification we would fall into an active indifference where meaning and nature become conflated, where experiences of meaning become patches of disoriented 'sense data', where myth and the present lose any distinction (any power of oscillation/transportation), and hope and lament made redundant through the collapse of distance. In essence, the absence of objectification would provide the fluidity of base-consciousness and passive stupor.

The objectification of experience gives such experience a meaning[201]: the attempt to build some type of resistant shrine to the passing/acceleration of time. This is why meaning has to be seen as conservation, or what I like to term *lament*, as within the objectification of meaning comes the awareness that it will be lost to time at some point in the future. Note that this is the objectification of *experience* and not of an *object*[202]. Objectification, no matter how discrete, disconnects the fluidity of neutral experience (the neutralizing effect of time/forgetfulness) and generates the possibility of lament. The first generation of meaning is in the objectification (remembering) of an event, depicted in the mind or through the making of an artefact. All other mediations of meaning that strive for the present capture of meaning or its concrete 'use' are not in the realm of the beautiful but in the realm of science, nurture, immediacy: in other words teleonomic principles…such is pragmatism.

Beauty, being the commensuration between the conceptual and artistic objectification of meaning being so implicit within the making of one and other had to fall together after they commensurated and ascended. We have neither anymore. The advent of mass conformism, the uniformity of desire, propriety and monopolization, the forgetting of history and commemoration, the letting-go of the sacred and the beautiful and the general failure to uphold any form of sensibility made any act of

remembering or making sacred useless. The reverie of beautiful objects became supplanted by the 'having-of' pleasurable objects which were often quickly consumed, crudely interacted with, and functioned on precisely the absence of intellect or sensitivity in the process of enjoyment.

Equally, for some the idea of constructing once again beautiful objects (or homages to the beautiful) seemed useless; why bring a child up into a world not of perpetual misery and pain (which are common factors of beauty), but into a world of indifference, indifference to any form of individual or independent valuing (instead assuming value in what has been deemed as valuable by capitalism at the time – to ensure utilization of such a value in some way). I believe that such is possibly even a world built specifically against beauty.

The ballerina shows what beauty *was* by the act of destroying it (like how coal is destroyed to generate energy). It is not simply the *ballerina's* destruction (that the ballerina cannot represent beauty because she immediately makes beauty chemistry (attraction)) but it is also the contemporary technological culture that ballet is embedded in that makes it redundant (as ballet's aesthetics, synthesis and values do not correspond to those of contemporary technocratic leisure). One could argue that ballet was possibly the last sacred place of beauty before its fall. The last phase of historical beauty was its *fatality* (its encounter with its own destruction, disappearance, impotence). It too has now swung full circle in becoming a parody of itself and has returned to pure entertainment where it began. 'Funny' how the last phase of beauty presents itself through the sado-masochism of its own destruction, nude and exhausted, very much like Christianity. Through the historical event of the death of Christ, God made his last beautiful plea to the public. In the very same instance Christ makes his last beautiful plea to God. Through the historical event of the 'Death of God' Christianity made its last polemical plea to the public. Nietzsche saw this as a *weakness*, using the vehicle of

death to act as a power (within the law of *pity*). This is basically a reversal of the concept of prostitution: to engage in pseudo-procreative acts for the exchange of payment or some other benefit. But we cannot deny both beauty and meaning in these instances – the meaning of Christ's plea is a meaning that has no *use* to him as he is coming towards his termination. His plea is *his* meaning and *not* the 'meaning-as-use' of his death (Christ's death as ridding us of our previous sins). Beauty comes in through the individuation that death creates (it is Christ's death and no-one else's), whilst this death simultaneously destroys the individual. This beauty is akin to the beauty of ballet (the individuation of ballet through the specific ballerina whilst simultaneously the destruction of the subject through its determination as object within the ballet).

The beauty of the castle, however violent, has been turned into a desirable social prop[203]. It has been severed from its battle-field of horror, its soldiers of hope. Modern Man can now walk freely into what was once a feared and exclusive monolith. S/he can now subsume its history into his/her own frolicking pleasure of the present. The fact that Men prefer the weak crumbling guise of the castle *as* ruin already suggests a turn to the feminine[204]. Similarly, the usurpation of art into a deconstruction of its own form, a pseudo-intellectual awareness of its surface, a cynical appraisal of its artifice: again, as if the intensification of its presence would somehow defeat the absence, disappearance and lament implied in *re*presentation. What this shows is that Men have forgotten that beauty's integrity was in our own integrity to not cross over the limits that demarcate the individuation of death from its public inauguration, the real and the imaginary, or the law between ones disposition and ones hope.

Before I am hounded at all sides for being reactionary, conservative and metaphysical, I shall say this: the division between beauty and the subject is not primarily one between concept and appearance, the abstract and the concrete, the universal and the

particular (...or God and Man); you can *see* it in the destruction of the subject and the subjectivation[205] of destruction (to make subjective history/distance/other deaths). In this sense beauty is always disappearance or ephemerality.

In this sense one could see beauty manifest itself as a *moral* law, a *pact* if you will:

"I will not conflate subjectivity into objectivity. I will not make death something from *this* world, something completely empirical, understandable and calculable (or as a statistic within the world). I will let death have a distance and sovereignty for the subjects it takes. I will name the destruction of subjectivity (death) or its handing over to 'the other side' *beauty* and I will believe that I will one day know what it will be like to die (calling this experience *beauty*). I will believe that the meaning that resounds from the destruction of subjectivity cannot be useful for any subject, not even the one being destroyed, and that this awe-ful[206] uselessness is absolutely beautiful."

If we include this moral pact within the economy of desires we might find that it will prolong the annihilation of ourselves from ourselves. Beauty becomes a special scarecrow that keeps *baseness* at bay. Beauty becomes that which keeps desires from consuming their subjects. The truth that there are not that many sensitive aspiring Men who cannot account for the liquidation of beauty and myth today is the truth that beauty exists under the guise of this destruction. I once came upon a sentence that read: "I am a nihilist because I still believe in truth"[207]. A Man who still possesses the old will-to-truth in a new world where truth has been made a lie, a Man who still practices the will-to-knowledge in a world where reflection has been perpetually supplanted by utility and monopolization. I sympathise. Well, I am a nihilist because I still believe in beauty...or at least the remnants of its

death/demise...calling such beautiful.

The myth of Narcissus warns us of what is to come when we disavow the sacred law of distance. Narcissus makes beauty his by turning desire inwards upon himself, and is soon hypnotised by this consumption. If desire chooses to desire itself, then the head of the snake eats his own tail: disappearance is crushed into appearance, end is superimposed onto beginning, and thus time can no longer flow, hence the immutability of Narcissus.

It is only on the basis of beauty's trace (its aura) that we can begin to excavate it for ourselves (to follow Ariadne's thread). On the basis of beauty's historical existence (or ones trust in it) we appeal to join those who admired such at an earlier time. And then beauty has to then be the remembering of something, the lament of something, and the sharing of something... secret[208]. Religious as it may seem (religion and beauty are similar in many ways) this is where beauty can be located. But this religion is not some inner demand of the good, fettered by allegories and fables (orthodox Christianity); beauty's religious history is messianic and sublime. It demands respect and not self-overcoming[209]. It quietly nods to other Men in history who have honoured the *image* of Man as an historical phenomenon. That oh so distant combination of beauty and virtue that confronts one before the battlefield. It is that moment before death where one forgets whether 'Good' is universal, or rather a making true for oneself, and instead acknowledges that one is being watched, has been watched all their lives by the beautiful. And art will always be at its most powerful when it conjures up the threshold between life and death, because death makes life appear beautiful. Men before death are always searching for art: in their last moments on the battlefield they survey what they can, attempt to find beauty within it: the symbol on their sword, the crest on their armour, something in the sky, the searching for a final meeting of glances between another human ...after all, Men are the *images* of God[210]. When the awareness of one's finitude

creeps in we see life with peculiar eyes both new and old: we see the opening-up of infinity. In the short moments before death the warrior's body and soul become a small homage to the world, christens it beautiful, cries because tears of beauty will stain *his* eyes tonight, not long before the ignorant Jekyll will lay himself down and weep such tears too: he will think to himself. Walter Benjamin once proclaimed that being moved by beauty is *ad plures ire*, what the Romans called *dying*[211].

Beauty is the door into a secret messianic history, where the moments of historical coming-to-be appear dispersed and concentrated into private revelatory moments of Man with his own personal lament of the world and his little God.

Does beauty remind us of a concept that has long disappeared? Yes. The passage of loss (lament), especially in the act of dying, needs history for its retroaction, so if beauty usurps the incandescence of the old (history) that has been attached to it, then the encounter with the beautiful is also the encounter with a Concept or Idea as opposed to the mere engagement or synthesis with an object (seduction or conjunctive utility).

There is the staring into the eyes of a historically different way of looking, as if the eyes of an ancient Egyptian face depicted on a tomb really did look out upon a different world. Perhaps I would even escape its vision, it being too ephemeral an existence compared to the archaic endurance of what makes such a tomb sacred. I once met the gaze of the eyes of a statue of Thomas Aquinas, and in them, surrounded by a disenchanted nihilistic modernity, was the unwavering confidence and belief in God, as if Jesus had just walked by. What should be realised by now is that beauty is the consummation of the dialectic: something must be objectified to be named beautiful, but in the act of objectification there is a feeling that something *must* fail to show itself in order for the beauty to surface. Perhaps this failure is seen in beauty's/the art objects futility? As I have said in this book's first essay, something's manifestation always betrays something else's

presence, kills it you could say. Are we showing empathy in beauty, empathy for something that has not been shown? Beauty comes from death because beauty's character is the 'holding-on-of-life' i.e. the fear of demise; demise retroactively creates objects of beauty. So death becomes a de-objectifying process that can be seen in the object of art (the beautiful object) and equally, history's futility (the death of presents) acts as the de-objectification of time. The 'must' of beauty that is the failure of presence and the openness to futility (destruction/death) is inevitable, but there is also a moral *must* (one that comes with a decision): our moral pact with beauty. The excess of an object's beauty is very real.

Another example of this dialectic is the dialectic that is located between the caveman's drawings of an animal, which through its depiction compromises his own desire for the actual object (the animal) without fully retaining it. The act of drawing softens the lust for the object (the caveman's hunger and pride) and generates a sense of serenity and repose. The same dialectic is found in the communicative power of beauty: one wishes to own an experience or object of profound beauty, but one has the initial urge to communicate it simultaneously, that is, *to give it away*. This could simply be the communication of beauty to yourself or the object of beauty: the desire to kneel before the Virgin Mary, the very open and expressive articulation of an encounter with the beautiful. In this encounter, something is already given away by the spectator, the gift of awe in exchange for the object's beauty. There are inklings of a fair relationship with beauty that we begin to see.

I have been lucky enough to encounter the *Winged Victory of Samothrace* at the Louvre, Paris[212]. I encountered something *utterly* new. Not only in the specificity/singularity of the encounter (my unique encounter), but in the object, the likes of which I have never experienced before. I immediately refuse to give this art a 'price'; it is priceless, it is infinite to me in this

sense. It must have always existed outside the remits of 'price', perhaps, *necessarily* in the realm of faith and history[213]. I could decide to give it an Idea, or a symbol. I could decide to grant it as infinitely eternal, but instead I grant it as infinitely beautiful[214], as its beauty can only traverse the finitude of life and subjectivity (lived experience) because of its contract with death, as opposed to the finitude of time itself (eternity). I decide that it must eventually pass (this beauty will pass...and the prior civilizations that witnessed this beauty must have thought the same...and I almost begin to lament the men and women that stood in front of this Samothrace thinking this thought). There is a real infinity, but this cannot guarantee the infinity of a dogma/human feeling. Jung was simply wrong when he stated that all forms of religion are a necessary, originary *image* of a psychological desire to connect to one's world and to feel together *as* something, calling this desire eternal: the mythological archetype.

I refuse to make this *Nike of the Samothrace* familiar to me in any way; I will not place it within some superficial context, the gallery. I refuse to be able to understand it. I refuse to even sanctify my own presence i.e. the encounter of this work would be the same whether today or two thousand years ago[215]. It does not even occupy the present for me in its entirety, it is somewhere else – oscillating between different epochs, different stages of its making beautiful by men throughout time. If anything, it recoils from our current epoch and modes of spectatorship. It is so utterly different, incongruous, and difficult in this respect...but I must give it an Idea. I must give it historicity, as no other living organism can do this[216]. The encounter is new but the Idea is an age old one. I must name it *beauty*, but how? It is *ad plures ire* (dying). If Men did not die, if they were not finite, would there be beauty? I do not think so. There is nothing at stake; there is no striving to encounter the beautiful if we had infinite chances of reaching it[217]. The more people die, the more something is made beautiful, and the more someone dies for its beauty. This is

perhaps why the Idea of beauty is always incarnated via forms of Man's bravery in battle: it reminds them of the beauty they are dying for. Equally, the need for a leader, like the beautiful angel (of death) sculpted on the mast of a ship, beckoning us forward into death for beauty's sake.

On the other side of life (death) beauty is made *again*, but in a more traditional form of lament[218]; beauty's epiphany being the form of an angel. This is where beauty tends to nourish itself, upon these two shores before and after the act and encounter of death. Even after the conferral of beauty in the face of our own realisation of mortality and death, this Idea never becomes familiar: one can never be familiar with beauty nor death. One cannot *know* these things or conflate them into life (which amounts to the same thing). The Idea of beauty can seem to become universal and immutable, but the encounter rare. It is because of this that beauty's 'universality' can never be consummated to the familiarity of 'the Same'.

This is what makes the Idea of beauty different to the concepts of art. Indeed, concepts can relate, can multiply, can create further concepts qua invention in art. If there is any hope in Contemporary art it is in our enthusiasm to create, by way of concepts, "new links, of hitherto impossible connections"[219]. However, for beauty there is only one Idea at the end of an infinite variable of encounters. There is no such thing as *two* ends within the search for beauty, but only one schism that resounds in opposite directions: one is the human relation towards death as beauty and the other is the relation of death to the living (beauty lamenting the already dead and the not yet dead). Within the act of any making-beautiful one is always embedded in *time*; within every stroke, every mould and shaping of form is a temporality that is cancelling itself out, that is destroying itself and disappearing. One is always making things beautiful *in* death, death is always raising forms upon its sloping-downwards surface like ice cracking on a river.

In the gale of movement we gather our beautiful idols, a place after the storm (stillness, death, the afterlife). Serious beauty has always been a resistance to the world, the natural: the archaic 'flat' iconography of the Aztecs, the sacred tombs of the Babylonians, the roman statue, the canvas. Beauty can change its own stakes: its relation to death and its relation to its older forms of beauty. After all, ballet's affair with the acceleration of death within the concept of beauty (making beauty movement, making it fatal) is one way of defining this relation to death. But the end is always the same: the awareness of death through our intrinsic mortality, or the awareness of our mortality through the event of death. These poles transmit beauty. Beauty and its artefacts are an on-going historical account of this sense of mortality and profound history of Man's relation to finitude. Beauty sheds its many skins (a human skin) through times passing (history).

I hope I won't surprise anyone's integrity too much when I say that beauty is of Man's making. Nothing is inherently beautiful. What would it mean to deploy beauty upon something before humans had the capacity to have dreamt this quality up? Is this not a contradiction? This is why beauty for Kant is synonymous with *judgement*. This is beauty's moral character. The premature grounds for beauty, of lure, seduction, desire, fulfilment, are set up and determined, but the judgement is the making beautiful. And when one crosses this judgement, stops judging and starts consuming, then one has cancelled the beautiful, destroyed it. It only makes sense that beauty can be de-activated as well as activated if its seed is in the human mind[220].

Art's objectification has always attempted to safeguard the beautiful that it is representing by 'merely' representing. Bernini's *Ecstasy of Saint Theresa* (1652) plays with this quality rigorously. The beautiful statue of a nude woman cannot be 'had', its stony, crystallized, almost immutable quality pays homage to the metamorphosis of beauty *from* inanimate materials (death or the immaterial *Concept*). And it is not *the* woman but a depiction.

The abstraction of the woman is her ticket into beauty, her destruction into abstraction[221], her particularity (existence as human) being enjoyed only by the men of her era and proximity. Note that this quality is derived from time and lament and not simply its representation. That it cannot be 'had' is both temporally secured (she is of the past) and materially (that she can only be depicted). Beauty remained judgement and nothing more because the depiction of the female body in art (representation) would not allow any further register to be figured or exhausted (for example the narrational, the motional or physical) .

But there does remain a type of dialectic or conflict that plays itself out here, posed in the question: does beauty remain precisely beautiful because it cannot be anything else? Yes, because it cannot be anything else it negates ubiquity and remains beautiful.

In the visual arts, beauty out of its resistance to Man's desire (being only representation) refuses to be reducible to any experience, displaced into the present, and engaged with through any form of activity (Man moves quickly from the eye to the entirety of his body, to the object's domination).

Has beauty disappeared because we have replaced the gulf found in the moral viewing of the beautiful with the fullness of immediate sensations and novelty, because we are impatient – animals with clothes on[222]. Has beauty disappeared because we have refused to uphold the secret and invisible pact with beauty (or God?) That is to view and judge the beautiful that appears, but with a distance, a responsibility towards the Other.

A man may exclaim: "Beauty! Why be so alluring yet so distant to me? So pure yet so playful!?"

Ballet finds itself dangerously close to the powers invested in the beautiful. It *is* beautiful; it contains an historical element of beauty, but it also opens the beautiful up, deconstructs it through movement (movement makes beauty fatal), prizes it up through a need for its destruction... somehow (?!)

Perhaps in the ballerina's constant movement and formation she subverts the stillness of repose that we find in earlier testimonies of beauty – the sacred cannot run can it?! Beauty will always hide itself within the veil of history, distance and disappearance...but movement?! Little Archimedes is running with the beauty of Science is he not? Perhaps with the ballerina in constant flux she escapes the degradation conferred upon her by the greed-stricken hedonist. Is this how the ballerina saves beauty somehow? The consequence of ballet's preservation of beauty is its evasion of the moral law of beauty: the extermination of the very grounds that generate its condition – the decision and the responsibility to refrain from subsuming beauty through our desire. The dance is too fast, it escapes my judgement, my decision ...to make moral...to make beautiful. This *immoral* beauty has movement on her side. The whirring, the speed, the intonation, the intoxication; she has the forces of love on her side, and these forces will not refrain in the face of the 'decision' and 'responsibility' of beauty.

After ballet, one could not be a lover of beauty under the law and rigour of distance. One dances themselves, albeit with their eyes, when they watch the ballet. The love of beauty soon becomes the beautification of love.

Here is another confrontation with 'two's': beauty playing with love, love playing with beauty. Two very distinct (I believe) registers. Love seems to be a 'situation'. One is 'in' love. In this sense, love is always in the present. Love wants to exceed death, it says "yes to eternity" as Nietzsche once said. Even if it is generated by reflection or nostalgia, the capacity that loves 'starts again' in the heart, soul or stomach. It is self-generated, one could say auto-generated, by the subject. It gets its boisterousness from this sometimes sporadic gestation;

"Tell me that you love me or I will jump off this bridge"
"What?"

"Tell me that you love me or I will jump off this bridge"
"Charlie... I ..."

Love is the whirring, beauty is the form. Love is the realization that one is stupid. Love is the realization that one is nothing without the love of the other. Love is the non-love of the self. Love is the mob of the senses and hence desires. Beauty is resistance and affirmation of the solitary. Beauty is closer to death than love.

Is this what I had found in the incompatible ballerina? That her beauty was incompatible with my love for her? Yes! Her beauty faded every moment my desire advanced. I was jumping on the shadow of beauty...and missing every time!

Even she could have discerned that in this humidity of physicality, she would always be more loveable than beautiful. Maybe we should leave the statues to parade beauty in the ballerina.

Beauty is always in the past (or the encounter of an event (death) that will remain forever in the past). It is in-fact a *feeling of* the past: it is as if any encounter with beauty were an encounter with a ghost or spirit, and one must preoccupy themselves with this ghost if beauty is to be reborn, albeit momentarily. We should all ask ourselves: "*how* have we felt death before?" It is because beauty has helped us in finding it, has shown (represented) it to our world of life. In this sense beauty is never self-generated but received, observed, beckoned. Beauty is in a sense more objective than subjective: the *seduction* of the beautiful as opposed to the *desire* of love. Nevertheless, subjective in the most beautiful way, the *Idea* of beauty *must* be renewed. Men need to ask themselves once again what the idea of beauty is.

Let us not forget that beauty is a historical *practice* whereby its forms, sentiment and value are no longer found in the postmodern/contemporary world, but like the apocalypse that ensures the Second Coming of Christ, we must go *through* nihilism to reach beauty again...we must...we must! If not, the

apocalypse will come and we will only see it right before it takes us (our own deaths).

What happened to us? The encounter with the beautiful, a history of sanctifying it (believe me; all former civilizations have sanctified it)! Where is that humanity which acknowledged beauty much earlier and deeper than any other language? The swelling up inside of oneself, because they know that it is beauty, that it contains something of all beauty in it. Where is it now? Who killed it?!

Yet I sense beauty's appearance in its *disappearance* (or murder), its aura. But it can no longer *exist* if what exists must show itself and be present. It is not *in* the present and does not show *itself*. I can find it if I go back far enough, or be sensitive enough. The beauty that eludes base sensation, delightful appearance, addiction and familiarity...where are you now? And why is this strange sense of your disappearance (lament) a part of beauty itself? Why does death make things beautiful? And why does beauty keep death within it as a quality (the elixir of death is the elixir of beauty). Was this always so? Why, in moments of death, do you step inside us? I have witnessed beauty die (in my culture) and have found it (...still dealing with its) utter beauty (tragic beauty). I have witnessed God, who, in the act of dying brought me to him (before this death I was not interested). Now all there is to do is witness my own death and hope that beauty appears...or makes me beautiful. Is this a vanity?

And *after* death, every tombstone, every stasis deep within a painting's representation, every keepsake, grave, mortuary statue and urn will sing a verse of beauty for me. The beautiful will become me. That is all I want. That is all I have wanted. Who could want more?

...should we want to run away from all this destruction, all this beauty, all this faith, in fear of going insane and remaining alone? Should we not, at this point, realise that beauty is opposed to fear.

"Charlie... close your eyes to the beautiful".

One final laugh by me...and a question;

"Will Death ask beauty once more to ride the departed home?"
"What am I looking for, reflecting on, returning back to?"

I do not mind dying. I do not mind leaving the dance.

"Goodbye my ballerina. Goodbye my foolish things".

If I am right in charting the *demise* of a Moral and Ideal beauty, and the thuggish boycotting of the participation of this quality in beauty, then this book can be neither moral nor beautiful! Let the contemporary Man not have it! In fact, it necessarily *must* not be if we are to respect the destruction inherent in beauty and allow its incandescence to burn honourably within an era that is redundant to it. However, if I have caught it, even a glimmer, then this little book might end up being beauty's epitaph.

Every beauty is a type of homage. Every meaning is a form of lament.

END

End Notes

1. In many ways all philosophy is philosophical literature. This 'love of wisdom' being expounded, since Plato, through literature/written documentation.
2. We know that this 'selflessness' is another form of desire, one close to the desire of the ascetic.
3. In saying that this desire is 'mine' I am merely stating that I have chosen to identify myself with other philosophers and their behaviours: I desire this. Also, by turning philosophical desire into my own I am also saying that I share a desire to think in a certain *style* and be represented in a certain philosophical way. However, in saying both of these things I have not stated that the desire *to* think is mine, nor the origins/impetus of thinking be identified as mine (that I cause thought).
4. Nietzsche, Friedrich, *Beyond Good and Evil*, aphorism 287.
5. I take Georges Bataille's insight that "literature is Evil" as a serious departure from the traditional view of literature (traditional literature as writing that possesses literary merit, "imaginative" literature, its definition etymologically related to 'learning' etc.), which has consequences for the practice and results of contemporary writing.
6. All aesthetics (including the transcendental aesthetic of 'feeling') is the raising of one thing's power above another, the judging of one thing's importance over another. If aesthetics were not this, then everything would be aesthetically important and hence nothing would be aesthetically important as this idea supports indifference.
7. This description is not dissimilar from the 'capitalist realism' that Mark Fisher expounds in his publication *Capitalist Realism. Is There No Alternative?* 2009.
8. I have not, as of yet, objectified or made meaningful (made

neurotic) the neurotic products of mathematicians, logicians, scientists, cosmologists. My neurosis is plebeian in the sense that it complies to the schema that most denizens also comply to: the object (capitalism), the image (objectification/data/empiricism), the carnal/human (that it can be penetrated/used/manipulated/made sensual).

9. I have fundamental problems with the inherently ideological, transcendental and meaningful ontological insights of the early Heidegger; that there is a 'world disclosure' of a holistically structured, pre-interpreted background of meaning. Neurosis is immanent but its 'mood' (as Heidegger would say) is not a semantic one oriented by pre-scribed (a priori) 'situated-ness' of 'concern', 'mineness' or 'devotion'. For Heidegger, 'Being' has already become a master signifier for something other, something anthropomorphic, and something transcendental from it. I believe meaning comes only after human behaviour adapts itself to a psychological paradigm, whereby the 'use' of meaning ostensibly solves recurrent problems in human ancestral environments. This 'being' is extremely localized and based on stimulus and environment, and if 'intentions' arise it is through a form of functionalism whereby mental states are constituted solely by their functional role. It becomes, however, somewhat idealistic if we attempt to hypothesize a being which precedes our own perception and epistemology of this category.

10. "1. Extensity can emerge from the depths only if depth is definable independently of extensity" which means that there is a radical break between and intensity and extensity, and 2. Individuation, which is 'the act by which intensity determines differential relations to become actualized precedes differentiation in principle... every differentiation presupposes a prior intense field of individuation ... individuation does not presuppose any differentiation, it

gives rise to it", 246-247 Deleuzian Events: Writing – History; Conference Proceedings, 2009.

11. Even if some of those theoretical physicians are incorrect, and the hypothetical deduction of my sense-data is somehow falsified, it remains that it is my neurosis and hence my intensity (its confidence does not derive from any adequation to reality or theoretical legitimation) and this is where we touch upon the proper psychological meanings of neurosis (see either of Freud or Jung).

12. Philosophies such as Graham Harman's 'Object-Oriented' philosophy, Ray Brassier's 'eliminative nihilism', Iain Hamilton Grant's "cyber-vitalism' and Quentin Meillassoux's 'speculative materialism'. However, we see already in philosophers such as Plato a strange inclination towards the number, the mathematical symbol – a real power beyond our access to appearance and desire.

13. I have a realism of powers and desires that Man cannot give an exhaustible account of that nevertheless can be given value/made-neurotic by the human. However, if this trans-figuration of external desire into neurosis is seen to be inhuman (in the sense that these desires have not yet been articulated in the human world) then we should also grant the 'human all too human' neurosis of Man (mainly psychology and tragedy) as uncannily inhuman too (an almost in-human neurosis based on the concentration and reification of 'human' capacities to feel and act).

14. This is a reference to Hegel.

15. If we proclaim that the 'non-human' does not exist (exists could mean to denote an adequate referent to an X that is not human) then everything would have to be human.

16. I will state later on that neurosis likes to disguise itself within the semantic games of futile human intentions, values and beliefs. It gains more intensity because of the sensitivity of our affectivity within this realm.

17. Desire is the condition for neurosis (bios or life) and can also be seen as the possible material for new neuroses; the possibility that a new neurosis can be forged upon something that was once never included or thought of as neurotic. Or, desire is the realisation/speculation that neurosis comes from the outside, and that that outside is being constantly shifted through the terrain of desire.

18. How many times have we read about a philosopher, scientist, mathematician etc. who has been undertaking rigorous research in an area that has already been prescribed as valuable – whether in the discipline itself, or in the end result (humanism, positivism, theology etc) – yet have undermined that very discipline itself or the very value that compelled them to work? (Copernicus, Einstein, Darwin, Socrates, Hume etc...) There should be a taxonomy of these moments where the autonomy of neurosis tricks the intellectual into working for it (under the aegis of *value* and the discipline of the human).

19. Neurosis depends on the constitution of a certain man, his decision making, his desperation, his strange desire to 'think-through' thoughts that appear incongruent, subversive or dangerous to him and his society at the time. The productivity of higher order neurosis has little to do with historical/material circumstances, and in-fact the latter (oppressive society, culture) have debilitating effects on higher order neurosis.

20. In a sense this transformation of the non-conceptual conscious (or non-conscious) desire into the conceptual or self-conscious has been subtle, sly and, in a sense, necessarily secret. The success of neurosis is that it cannot be confined to one of these areas. There is no such thing as a binary on/off mechanism of consciousness/non-consciousness or conceptual/ non-conceptual in neurosis.

21. Creative in the sense that it creates, not in the humanistic,

libertarian and artistic appropriation of the word found in *creativity*.

22. Hegel talks about this in his preface to the *Phenomenology of the Spirit*.

23. The chronological account that neurosis comes before rationalism, and in-fact that rationalism is a form of neurosis, leads me to believe that neurosis is fundamentally irrational. It is perhaps my allegiance to a type of materialism distinct from conceptual descriptions that makes me feel more comfortable with the larger, more in-human umbrella term of associating neurosis (both in beings mentally and in things materially/externally) as irrational rather than rational. Psychologists have tried to define it, respectively, as one or the other.

24. Graham Freestone

25. Wittgenstein, Ludwig, *Philosophical Investigations*, 1953, pg 219

26. Arachnophobia is itself a form of neurosis developed as a symptom.

27. One may say that they know why their child or wife is meaningful to them but this is a knowledge of the effects meaning has upon an object/subject (or the vicarious awareness of its construction *from* the object/subject in relation to the game of meaning) and not meaning 'itself' as a totalizable form. The objectification of meaning is where the desire to make meaningful becomes strangely empty (we did not find what we were symbolically looking for/desiring). However, in objectification, meaning tends to reflect tautologically within or upon the subsequent object and therefore allows it to play as another piece within a larger context of desire again (ad infinitum).

28. Act – both in the sense of action and in the sense of acting (neurosis makes actors out of us, and we give neurosis action).

29. As many philosophers have expounded in various ways, human consciousness- within the restrictive remit of nature (physics/chemistry/biology) – creates its objects/world. We use the concept of 'object' and the custom of 'perception' to see what we call 'tree', and then we further penetrate consciousness into this 'object' by physically moulding it into our image (as boat, chair, part of a 'house'). Hence, the consciousness we give these objects in observation or in their use is the same consciousness that built them in the first place (i.e. cause/essence). To live in a reality consti- tuted by such objects of consciousness, and then to observe and use these 'objects' is a deep tautology (or a type of buffering which does not get us anywhere creatively/intel- lectually). Reality is the most epic form of tautology.

30. Please do not confuse the solipsism which neurosis produces as a form of subjective idealism because the neurosis does not stem from the individual or his agency but from the capacity in everything to accumulate its own power, to construct itself (or give the impression of construction), to mimic stages of longevity and to produce a vector which has to accelerate due to its own manifes- tation as a continual and successive concept/phenomenon. It is true, however, that the subjects mind, in all its abstraction, memory and awareness of future, is a perfect generator for this neurosis to expand and liberate itself.

31. This simply means that, for example, the *value* of believing that X is true may have implications/influence upon the manifestation/illusion of this X's appearance/reality but this X has no real (conscious/intentional) relation to the valuing of it *itself* (i.e. perception is not necessarily recip- rocal even if it is relational). The manifestation of X (X) does not hold within it the subjects valuing capacity (however it does possibly hold within it its perception/ given-ness). Consequently, valuing, in its most progressive

forms, can be seen as non-phenomenological and un-objec-
tifiable

32.　It is not a case of asking whether there are more negations
in the affirmation of something, or, affirmations in the
negation of something, but rather mobilising a "no" in the
spirit of negating all ideologies and pre-existing systems of
power. Obviously the idea of a sphere that can exist outside
of any/all ideologies is itself an ideology, but we still must
say no to this. It is the proclamation of the "no" over the
direct effect this "no" has upon the pre-existing state of
things. The infinitely refuting no of higher order neurosis is
difference and in society this difference usually manifests as
a "no" to the "yes" of conformism, indifference and
decadence. Neurosis is the saying no to older forms of
neurosis, the saying no to uniform social consciousness.
Perhaps one has to say "no" infinitely to be able to say
"yes" to their higher order neurosis (its uncompromising
nature) but then perhaps one has to say "yes" to their
neurosis in spite of all negative obstacles (which amounts to
the same thing). To be neurotic is not to say yes to this
neurosis ("yes I want to obsess over X again" for pleasure)
because the neurosis is not yours and does not care for
human pleasure. Does neurosis have a set of pleasures (of
what allows it to thrive or diminish)? One can conflate both
"yes" and "no" in all senses, even in the political sense; to
say "yes" to everything is just as anarchistic (accelera-
tionist) as the "no" we commonly see as anarchistic ("no" to
the existing state of things etc.). Outlining the problems of
saying "no" here and its semantics, I perhaps mean
upholding a series of negations which progresses third
order neurosis (difference will say no to everything but
itself, (and perhaps even 'itself') hence the no is stronger
here, and perhaps creates the "yes" as antagonistic/
deductive residue (it defines itself by what it is *not*)). The

'valuing' of "no" could also be seen as a form of nihilism, but a valuing of nihilism that says no to the liberal humanist self and paves a way for non-human enterprises (in the sciences, mathematics, consciousness studies etc.), which neurosis provokes in its 'mindless' repetition of images and scenes that seem irrelevant to the uniformity of social consciousness. Finally, the "yes" is a yes to something (or anything) but the "no" does not necessarily say no to something or other but rather could be a no to the avoidance of any real decision (without corresponding to a situation, object or preference) like Herman Melville's character Bartleby who responds to his colleagues "I would prefer not to" without saying what he would prefer to do instead. This "I would prefer not to" is an attack on the principle of valuing *itself* and avoids being supplanted into the value to say no or the value attached to the decision/consequences of a no.

33. When I say Power I do not simply mean the power of my own thoughts and other thinkers in relation to force of argument, poetic power and intellectual finesse, but also the power of transcendence (distancing, awe, selflessness) which people mistake as a form of powerlessness/religiosity but is-in fact closer to an egoistic power of total-ization.

34. Nietzsche, Friedrich, *Beyond Good and Evil*, Aphorism 290.

35. *Baudrillard Live, Selected Interviews*, edited by Mike Gane, 1993.

36. Bataille, Georges, *The Impossible*, 1962.

37. Freud, Sigmund, *The Uncanny* (Das Unheimliche), 1919.

38. In Kantian terms, presented to the subject by means of sensibility (intelligibility).

39. We want to be careful not to subordinate Being's relation to the world to the subject's knowledge of the world. This subordination is a reductivism. Secondly, to think both

elements of being and being-without-thought is to uphold a contradiction; one cannot imagine a landscape that is both raining and not raining at the same time. However, *to* think this apparent contradiction is not without admiration and merit, and *to* think of a holistic image where the content is contradictory logically and empirically has incredible purchase and power.

40. To perceive is to collect and present, as a whole, an experience with built in pre-reflective counterparts such as the 'I' that is doing the perceiving, the orientation of the body within perception and various environmental insights. This is a process of assimilation whereby we assume or simulate the constancy of an object, an environment and certain conditions in order to perceive sensibly our relation to something. Philosophically, this assimilative perception has been unveiled and analysed as non-empirical (Hume) and criticised as reductively naturalistic (Meillassoux). What I am saying is that this assimilation goes all the way down and can be seen as the foundations for physics and empirical science. I agree with Hume and Meillassoux in the sense that we should think this assimilation as a process which can be scrutinised by thought instead of simply accepting the assimilation of perception as some 'myth of the given'; giving us direct access to a pre-mediated natural reality. In some cases I believe that the real inner workings of the neurosis *of* perception cannot be seen within perception; I believe that there is an underlying hysterical neurosis that is being covered up by the neurosis of uniformity. Because the neurosis of *uniformity* (of nature and of concepts) is the most wide-spread of all neuroses, it is equally the most assimilative and hence powerful as it can determine every other neurosis within it ("under the One" as Alain Badiou often pejoratively states).

41. There is a rupturing sensation at this point, where ones neurosis has to project an Other into itself in order to search and survey experience (perception). Usually this neurotic desire to perceive leaves the body of the 'subject' and uses the residue of this subject as the Other (as if you were playing yourself in a video game and using it as an instrument of desire...or as bait). Philosophers have called this 'self-consciousness'.

42. This is not a form of subjective idealism as I believe this neurotic constitution of time happens outside of the subject too, occurring within what constitutes an object and what exists within the material world (it is what creates the material world).

43. See essay one entitled Rebellion: or what a man can do with desire.

44. However, everything is a form of fascism. I do not mean it pejoratively.

45. The 'ing' in live-ing is desire.

46. Hegel, G.W.F. *Preface to the Phenomenology of Spirit*

47. Being is both the entity and the living environment of the human being; 'presencing' is the constant attachment of these two symbiotic poles and has a perpetual impact on the living environment and the entity ad infinitum. The realization that a human has of his Being's relation to the larger Being of his environment is limited in scope and fundamentally moulded (biologically) in order for him to attain character and not be pure objectivity/immanence. I sometimes separately refer to human being (being that posits itself), being as a life-force and other beings such as animals and plants.

48. Internally necessary as opposed to externally (metaphysically) necessary.

49. There is no reducible phenomenological basis for the decisions we make and the values we uphold unless we

account for a form of behaviourism that 'represents' these actions. In a German Idealist sense, the conceptual schema set in place, prior to existence (*a priori*) is this very purposiveness I speak of (in Hegel it is termed 'conceptuality' and in Kant it is expounded by the 'categories').

50. This idealist sense of conceptuality or the innate guiding principle of the mind to 'Truth' (or adequation to reality) can of course manifest itself in the objects and actions (*Techne*) of a society. My argument is that it can already be found (albeit in a less reflexive form) within nature and before the rise of human consciousness. Hegel sees this in nature (the self-fulfilment/actualisation of a process) but he mistakes this process as having a rational structure.

51. Deleuze, Gilles, *Difference and Repetition*, 1968

52. I here refer to Hegel's famous flower metaphor (see G.W.F. Hegel, *Phenomenology of Spirit*).

53. Why would it be absurd if I were to proclaim that, at this moment, I still feel the presence of the Big Bang ring through me and constitute me?

54. 'Absolute' in the sense that within life and Being this relation **must** subsist beyond all other relations. In this sense its existence is not relative. However, this absolute necessity is contingent upon an event, entity or 'environment' that does not belong to these categories. This is the principle guiding all metaphysical materialists.

55. This is not an anthropocentric claim; everything is an instrument of the materiality of time and space insofar as it lives through this materiality and is itself material.

56. There are many philosophical treatments of the concept of immanence. Spinoza's theory of immanence, for example, considers that there is no transcendent principle or external cause to the world, and that the process of life production is contained in life itself.

57. One can already see the problem here; that the word

'creative', being poly-semantic, already conflates the artistic with the intellectual meaning of the word, and equally hides within it the religious denotation (creationism) and hence that these events of creation must be novel, divine and *causa sui*. All such meanings have a pernicious relation to biological, physical dynamics of 'material' creation as their respective frameworks of belief contradict themselves; theistic/atheistic, non-mechanistic/ mechanistic, non-natural/natural, humanistic/non-humanistic etc.

58. That is, if creativity is seen as developed by the individual (and not by God) a-la the renaissance, or later (in the enlightenment period) as part of the imagination or as a specific quality of genius.

59. Second nature is usually associated with an acceptance/ compliance towards a custom/habit which naturally builds from the first nature or is superimposed on it by humans. First could be seen as a kind of 'mechanistic' naturalism that determines various reflexes and responses. This third nature could be seen as the reflexes of mediated desires stemming from the second nature: the reflex to turn on the television, social awareness, mediated desires through social media and mass conformism; the more obscure rituals we superimpose onto our more traditional habits.

60. 'Humour' is one of these social desires; a simulation which decides what is deemed funny or serious through the rules, regulations and rituals of a certain class and demographic, presented through various channels such as radio, television, film.

61. The gaming industry is a good example of this construction of an environment that constitutes its own desiring subject (the creation of a virtual gaming context can produce a new desiring subject based on the objectives, sensations and various other modes of desire created within the game).

62. One only has to turn to Plato's *Republic* or Hobbes' *Leviathan* to see how such philosophies sit with the then current political landscape. This is not a critique but simply to state that this is inevitable and necessary.

63. Nietzsche, Friedrich, *Ecce Homo*, 3.2.3, (Kaufmann's translation).

64. In a sense this is pluralizing Kant's notion of a transcendental constituting subject, making it a framework for all beings without relapsing into this constitution of reality being anthropocentric, rational or even conceptual. The question would then be how such pluralizing realities are continuous and co-dependent on one another. There are many unique constructions of reality that would seem to adhere to each organism and could perhaps be transcendentally accounted for by each organism. This does not refute the claim that thought can be formulated separate from being (as in Meillassoux's polemic) but simply claims that not all entities will be able to register this thought outside of their own being (or *as* universal).

65. The physical determinations within an entity create certain modes of being (whether it is a rock or a tiger etc.).

66. Unless we absolutize life (or this relation) as monistically universal/univocal.

67. This does not mean that consciousness pertains to a 'bottom-top' model (or a form of epiphenomenalism).

68. Content-less insofar as this content can never be externally or absolutely verified but only interpreted and built upon *within* this very same content-less consciousness. It is not content but a self- interpretive system for living. Equally, the content of our thoughts do not share any physical or embodied qualities that pertain with the objects, images and language that we infer such 'content' from. This could be seen as a form of Platonism or Kantianism (representationalism).

69. In photosynthesis we see that almost all life is fuelled by the

sun's energy, located around 150,000,000 km away from Earth. If we are to regard this relation as a relation *to* an object then it remains speculative. If, however, we are to suggest that the plant naturally responds to the sun's *sunlight* with its cells, it could then be seen as auto-affective. However, even in this last option it could be argued that the cells of a plant are acting as an organism, a speculative whole or a whole bigger than its parts.

70. 'More', not in the sense of being more complex, but in the sense that Beings qualities will never be exhausted by reducing it to identity and its artillery (language).

71. In this instance I understand Nietzsche's phrase as the prosaic ingrained prescription of the human as 'herd mentality'; determined by civil and social projects and values. In this sense the 'human' here is another form of animal, but not in any liberating, irrational, ideal sense.

72. Sartre's notion of bad faith is based upon an initial notion of the subject as free-agent exposed to the external pressures of utility and objects, mimicking this utility and therefore betraying his essence (which is in a sense fundamental solitude, individualism). This has pernicious consequences.

73. In a sense we see the loneliness of noumena (devoid/ preceding the phenomena of space and time) in relation to its attributes (that only exist within this remit of space-time). We also see this rigid separation in the philosophy of occasionalism.

74. See Wittgenstein's ambitious attempt at this in his Tractatus.

75. This lost and loneliness traverses two registers then; the notion (or concept/induction) of loneliness/lost and also the identity (by this I mean the experience) of being lonely and being lost.

76. This also reminds me of the philosophy of occasionalism;

that there is no direct interaction between entities (no efficient causes), that objects lie side by side, and that there are only 'occasional' causes as the one true cause is God.

77. Do these separations/reactions in chemistry/biological chemistry not create that which we refer to as feelings, emotion, sensibility, pathos?

78. I am loosely following a line of thought from F.W.J.Schelling here (see his Naturphilosophie).

79. Or logic of polar opposition (through which nature expresses itself) as Schelling described it.

80. Not simply that the terms lost and lonely *stem* from the tension between conscious and unconscious productivity seen in nature but also that they attain the same characteristics; the same affectivity. One could say that the production of the correspondence between word and object, which in turn presupposes a dualism of linguistic substance and objective substance, has stopped us from seeing the fundamental continuity between human semantic language and material determinations/characterisations.

81. Even if one is to dismiss the separation of subjects and minds from other subjects and minds (or the rest of the world/universe) one could still say that in the last instance of formulating a concept/sensibility one must appropriate such *as* ones own (the *'mineness'* of Heidegger or the subjective judgement of a concept in Kant). The question could then be; does the affirmation of loneliness create the concept as *a* judgement/concept, or, does the essentially non-identical/identity of loneliness, through the generation of thought, give identity to such concepts, similar to the cogent concept of the 'I' that follows all acts of thinking?

82. Promethean in the sense that only a being that is of the privileged human kind can seem to have enough disinterestedness, memory, intuition of time/mortality and

conceptual longevity to see the world and experience it as torment on the brain/absurdity. Promethean in the Schopenhauerean sense; "human consciousness is suffering", the battle of ego-centric view-points, the body being pulled by that irrational force he called *the will*. To be Promethean is to suffer the consequence of Prometheus; an eternity of torment. Promethean in the sense that there is an impulse in the human to overreach and create unintended consequences.

83. I am referring to the dialectical relationships that exist between subject/object, self and other, antithesis and thesis. Also I am referring to the Hegelian notion of the dialectical process as progressive and constitutive of experience (the old self developing under new conditions and grasping more of a profound consciousness of itself and its context).

84. This description is analogous to John Carpenter's *The Thing*, in the sense that there is some "parasitic extra-terrestrial life-form that assimilates other organisms and in turn imitates them". There is an all pervasive imitation of reality (banal realism) within late capitalism that seems to act similar to 'the thing'. Equally, when this 'assimilation' is uncovered, a horrifying existence presents itself to us, similar to the real identity/appearance of Carpenter's 'Thing'.

85. Georges Bataille, *The Impossible*, 2001

86. See Friedrich Nietzsche's works, especially *The Genealogy of Morals* and *The Anti-Christ*.

87. Entities are subjects insofar as their determinations and conditions are necessarily centred (this centre being the most essential part of the entity insofar as it reflects the rest of its characteristics most adequately). Without there being this functioning centre there would not appear to be an entity that can be subjected to something else, or subjectivated by something else. To reiterate, this does not mean

that the subjects of entities have some essence that cannot be exhausted by their relations, nor that this centre **intentionally** causes things or has some identity that is fundamentally different to something else (dualism).

88. I do not use the word neurotic in the psychological sense alone but as an umbrella term to identify most processes, whether biological, social, psychological, perceptual, behavioural, physical, symbolic etc.

89. Descartes, Rene (1596-1650). Doubt, for Descartes, is a methodological scepticism where one doubts all 'truths' or beliefs and is simply left with doubt itself. If one is anything at all one is foremost a doubting thing/thinking thing. One cannot doubt if one does not exist.

90. Not only does the obsession with certainty stem from a fear of uncertainty but, as I have stated in essay one, fear is the making subjective of external, disoriented stimulations of pain; making the 'I' an awareness of pain, and placing a history of pain within the 'I' of the subject. Hence, if fear constitutes the subject of pain (the 'I' that fears pain as opposed to merely the disjointed states of pain encountered), then all questioning *as* this subject stems from a subject of fear.

91. I title this section 'words' as opposed to 'language' because even though I believe that language has determined many layers of the subject (its literature, its society, its politics, its psychosis, its epistemology, its physical reflexes, its theology, its values) the construct of language does not always correspond to itself internally, hence the significance of it is always left to an holistic sphere/a larger context of association. It is in the power of the almost atomistic word, mantra or sentence that I am interested in (which gives words a sovereign, neurotic power). The repetition, reification and circulation of single words is more akin to the repetition-fixation of certain sovereign

images/traumatic memories within neurosis and allows the sovereign word to break out of its milieu (similar to how the single neurotic thought breaks out of its larger uniform consciousness). Such is the muttering, neurotic background of words that come from our private consciousness which only half-relate to anything in the external world and is usually broken or acting as some cacophony; it doesn't always correspond to anything other than itself, or even communicate anything such as signification or correspondence between subject and subject.

92. It was David Hume, our most note-worthy sceptic, who claimed that man has to fundamentally believe in the existence of the world above and before anything else.

93. When I say 'primitive' I do not mean to say that our contemporary language is more in-tune to a form of truth but rather that such 'primitive' language seems based on fatality; words that need to be said, to avoid death and to uphold some form of organised life.

94. I argue that the same thing happens in the construction of meaning within society, and that we must make it subjective (see Incompatible Ballerina).

95. Children, after experiencing some form of pain, commonly blame their parents or the instrument that caused such pain (bicycle, nettle etc.) asking; "why give me this pain"?

96. The value of thinking one thought over another (because it attains more sense or one desires it more). Nietzsche taught us the productive merit of thoughts that come from idleness.

97. Deleuze, Gilles, *Difference and Repetition*, 2004

98. What does anyone (any epistemology) know about infinity? It cannot even be apprehended let alone known, through language or otherwise. The finitude of language and its correspondence to finite objects is perhaps opposed to infinity.

99. Sartre, Jean-Paul, *Being and Nothingness*, 138; beautifully cited by Nik Farrell Fox in *The New Sartre*, 2003, pg 39.

100. Writers such as Georges Bataille, J.M.G Le Clezio, Friedrich Nietzsche,

101. In this way the child desires to be kernel of creativity, harbinger of the novel/new. Following this line of thought I propose consciousness to be primarily productive as opposed to receptive (as in Deleuze's 'primary production') and that 'receptive' consciousness is *awareness* and to be aware is in a sense to be cautious and compromised (perhaps unproductive). The awareness of a 'social consciousness' that is incongruent from ones own is the problem of 'The Outsider' (Colin Wilson, 1965, *The Outsider*). Less controversially, language, although functioning externally and relatively (with other words and within various contexts/games) could also be seen to oscillate between the poles of Self and Other; "I am feeling this way or another", "you make me feel like this" etc. Hence, language synchronically models the self (as the "I" within these experiences) and the Other (as descriptive entities with observable actions).

102. Language presupposes that it refers to things outside of language which will validate this first language (the language of inferral/extrapolation). One must also assume that the 'self' can be understood through language for any form of analysis and judgement to take form; that the 'I' of the self is thinking, that the 'I' has desires and intentions as opposed to the language itself determining these aspects of 'the self'. When one learns a language, they must learn a language of the self in which this 'external' language *returns* to.

103. An example of this futile, ubiquitous questioning which has actually been planted in your head is the question "what is the meaning of life?" or "why am I here?".... these are

stupid questions whereby people are not aware of the flaws in their language and the construct of what a question is.

104. Of course, as George Bataille has polemically stated: one *must* try to say things which may break out of linguistic determination. The declaration *itself* becomes interesting as it is almost subjective (the need to say above the actual saying). It is, as Bataille has mentioned, almost an *impossible* saying. This is not to say that thought is above linguistic conditioning (in a Cartesian sense) but that language rarely *touches* things and rather just refers or classifies 'things'. In short; language is the opposite of real communication.

105. Which also determines – or at least denotes – other fields such as the semiotic and semantic.

106. I refer here to one aspect of the Nietzschean concept of joy; as a process of de-individuation – joy as the affirmation of everything *eternally* and not causally or objectively. There is also a vitalist element in Nietzsche's joy whereby it affirms itself and passes further outside of itself (where does this joy go, and how does it return)?

107. Firstly, this is an appeal for the irreducibility of consciousness to language and an admiration of those projects that speculate various forms of reality outside of the Kantian Copernican revolution. Secondly, this ambivalence of language is, in essence, one of the evils of literature. That, in a supposedly 'true' world, literature would break down all delineations between the real and the imaginary; a word would signify, through continuity and contiguity, yet another word, and this would be enough. Many serious novelists attempting to tackle philosophical problems loose themselves in pseudo-resolutions of metaphors and rhetoric. Nowhere more abundant than in literature is the paradox and the ironic found. There is an evil here whereby communication is subordinated for

artistic fulfilment. There is sometimes a need for a *physicalist* criterion of words as opposed to words merely validating themselves contextually, referentially or logically.

108. Perhaps this is a further evil of literature; that the concreticity of reality has become fragmented by language and its various descriptions and associations. We are left high and dry when we encounter the transparent serenity of an object, looking instead for some schizophrenic excess of description or meaning. Nowhere can this be more readily found than in the names of writers; where we have had no experience of their life and personality apart from their own words. It would seem that the author is haunted by such reduction to language from the beginning, as if he were already a headstone with an epigraph. In Dostoevsky's words; "All my life I did not want it to be only words. This is why I lived, because I kept not wanting it. And now, too, everyday I want it not to be words." Dostoevsky, *Demons*.

109. Is anything radically different from anything else? Are not all objects situated in a similar relation to what we call space-time? If so, these objects must share these similar conditions. And for me to perceive something as an object must these 'differing' objects not share similar qualities such as depth, colour, shape, texture, weight? Must they not share a certain relation to the viewer in my viewing them? We could obviously use the atomistic theory to make the same point (that everything is made-up from the same thing). And language seems to merely play with itself and our surface reflexes of communication (to ourselves or to others). And if we take the word 'self' out of our dictionary and the idea that we 'cause' things to happen... something vertiginous takes hold of us. We are no longer 'situated' but perhaps 'active'...perhaps we are LIFE.

110. This relation, between sensitivity/sensibility and the 'ego' or self-importance, demands an entire essay. I am a strong believer in the inseparability between sensibility and self-importance (this is perhaps my elitism).

111. "Why have I come here? Where am I taking myself? ... I am running away from something dreadful and cannot escape it. I am always with myself, and it is I who am my tormentor...I want to fall asleep and forget myself and cannot. I cannot get away from myself'. Tolstoy, Alexei: *Memoirs of a Madman*, pp210.

112. Giorgio Agamben, *Homo Sacer: Sovereign Power and Bare Life*, 1998

113. Georges Bataille; Bataille, speaking with Madeleine Chapsal only months before his death, rhapsodically praised Saint John of the Cross, not of course for his piety but for the rabid "rage" that inhabited him. "A rage against what?" Chapsal asked. Bataille responded: "Against the existing state of things. A rage against life... as it is".

114. Dostoevsky, Fyodor, *Demons*, 1872

115. I.e the notion of Absolute value (a transcendental value which verifies everything immanent to it), as opposed to relative value (the value of something being determined by its relation to money, status, gain, semantic importance etc.).

116. Emmanuel Levinas 1906-1995

117. Georges Bataille touches upon something extremely Promethean when he talks of sacrifice as self-sufficient unto itself. In a sense, after feeling humiliated by the agency of natural selection over the ambivalent spirit of man, man rebels and kills himself before selection can occur. There is also the self-sufficiency of man creating his own expenditure out of his own body in the act of sacrifice. Like the burning of coal to create energy, the sacrifice of man creates an energy which is given beyond the economy

of needs (an energy given to God or to nothing).

118. Dostoevsky, Fyodor, *Notes from the Underground*, 1864

119. Dostoevsky, Fyodor, *Notes from the Underground*, 1864

120. I am alluding to Jean-Paul Sartre's thesis in *Being and Nothingness*.

121. This has nothing to do with identity in the Cartesian tradition (which popular culture has appropriated as its paradigm of consciousness). It is simply a parasitical coming together (or proliferation) of forces which holds onto some frame of reference, some perspective, in order to generate something of its own vitality or continuity (its own impersonal will-to-live); the non-conscious into the conscious, the propelling vectors of perception.

122. Are we not tightrope walkers between consciousness as inhabited by ourselves and consciousness which comes from farther out and touches us/conditions us? Do our thoughts and feelings not have to travel out of ourselves to reach a type of pinnacle? Is this not catharsis, emotion? Are we not creatures of sensation/love? Do we not awake and find another pointing out with his finger towards the world saying "go, run towards it, find things in it, and find yourself in it"?

123. Arthur Schopenhauer, *The World as Will and Representation*, 443-44, 2010.

124. The yearning feeling of abstract expression is most likely to be content-*less*: the incomprehensibility of knowing, experience, substance or self. Georges Bataille frequently said that he was more interested in expression over content.

125. In a sense this alludes to chaos theory. Even if we were to accept a loose determinism, the deterministic nature of a system (such as mathematics) does not make them predictable. Edward Lorenz: "Chaos: When the present determines the future, but the approximate present does not approximately determine the future".

126. Nietzsche, Friedrich. *Beyond Good and Evil. What is Noble,* Aphorism 287

127. One of my claims is that the self-generation of meaning through finitude/awareness of one's mortality, through authentic, creative, self-realizing projects, seen in philosophers and writers as varied as Montaigne, Bataille, Nietzsche, Hesse, Dostoevsky, and Camus, have been made redundant because of the subjective *commitment* one has to make in order to 'live more abundantly' or in the 'salvation of extreme's' (Colin Wilson's description of the Outsider). This effort, being far too uncivil and arduous for our contemporary society, is instead repressed, but the spectre of death that beckons these promethean acts of mortality lingers. It lingers within the nullity of the work-place, the somnambulistic glaze of the cinema screen, the calm austerity of the domestic household, the emptiness of the contemporary arts and culture. It simply exists in a critical and non-romantic way today.

128. Endearingly referencing Colin Wilson's *The Outsider*, 1956

129. Is this not the great insight of psychology? The 'norm' is definitely the impetus of our repression.

130. Nietzsche, Artaud, Kierkegaard, Nijinsky, Van Gogh, De Sade...

131. Of course I am one of these baboons.

132. The only value you men uphold is the value of being 'sane'; because they have shoved it on you (they need you to be efficient). Family, loved ones, career, income and appearance of yourself, comfort, aspirations – all shoved on you. You were never given the chance to make these things valuable for you. You really do not have any values of your *own*. There is something far too efficient and immediate about these meanings; one may immediately and pragmatically love their mother, but to love ones mother is to love the mother who conceived your mother as well – *ad*

infinitum. Your mother would not have been born without this other mother. So how do we conceptualize this larger love before resorting to the simple objectification of your immediate mother, the symbol of the maternal, what she does for *you.* All these meanings are vain – All is Vain!

133. This repetition has become a banal, neutral and consistent desire. It is discrete yet repulsive. Capitalism has bombarded us with models and images of what happiness is. We have been enslaved by the seduction of this promise of happiness and choice that we no longer realise that we are unhappy. We are indeed unhappy...wake up! This somnambulist world of happiness is the worst history has ever seen. The more powerful the process of brainwashing, the more we don't realize its presence. Perhaps we have told ourselves, over and over again, that we are happy, so forfeiting our position as powerful makers of a new world. This repetition of desire, on a micro-scale, is within every ideological form that culture accommodates; a pop-song, an environment, furniture, clothes, etiquette, the concept of the social itself. Between these various 'discrete' objects and contexts, other subjective desires are formulated and dispersed *ad infinitum.*

134. Nietzsche, Friedrich, *Beyond Good and Evil*, Aphorism 146.

135. Claude Levi-Strauss, *The Savage Mind*, 1966. Later, Derrida extended this technique to all discourses (see Derrida, Jacques, *Structure, Sign and Play in the Discourse of the Human Sciences*, 1978).

136. Letter VI : F.W.J. Schelling *Lettere.*

137. Is vertigo the consciousness of this void; the awareness of an infinite difference and distance, which *we* (being part of this void) are forced to think, are forced to-play out? Parmenides said that the void of the cosmos necessarily must be *One* with us. How do we exist in relation to this infinity?

138. In this sense, the fallacy of the absolutization of knowledge is supplanted by the relativity of varying absurd perspectives; there are only varying degrees or levels of absurdity, as opposed to a fixed point of certainty in which we could reference all other activities.

139. Nijinsky, Vaslav, *Diary of Vaslav Nijinsky*, Gollancz, 1937, pg. 21.

140. Consciousness is in many ways 'Absolute' because one can never get out of consciousness to see what it is relative to, in order to gauge its equivalent. For example; one cannot think 'non-thought'. This vicious tautological circle, running in various ways through Plato, Descartes and Kant, grounds knowledge through the consequence of a form of anthropocentric rationalism or solipsism. Loneliness within this tradition of philosophy (what we could call Kant's 'Copernican Revolution') has nothing but the products of his or her own mind ('Idealism) and therefore cannot form any genuine relationship with the world.

141. Schopenhauer, Arthur, *Parerga and Paralipomena*, 42-43, (2014 revised edition).

142. Apart from the traditional Buddhist consensus, that 'life is suffering', there can be found a western philosophical pessimistic thread running through literary figures of modernity such as Albert Camus and Simone Weil; "All the tragedies which we can imagine return in the end to the one and only tragedy: the passage of time". One can sense the metaphysical, Platonist and Christian implications in this denial of times passing, through the value judgements of 'eternity' (Christianity), 'the immutable' and Absolute' (Metaphysics/Platonism). However, consciousness does not have to be transcendentally or symbolically coded to be a cause of suffering. We see in materialist and neurological research the destruction and degeneration of brain cells

and its myriad effects and consequences on the 'self-phenomenal' model of consciousness (first person consciousness). Equally, time does not need to be construed in opposition to metaphysical truths or states of bliss/peace/ataraxia in order for it to be perceived as suffering. Chronophobia is the traumatic awareness of time and its relation to consciousness, which is a suffering immanent to the material workings of time in and of the subject.

143. Schopenhauer, Arthur, *The World as Will and Representation*, 137.

144. Nietzsche, Friedrich, *Beyond Good and Evil*, 4.

145. Nietzsche, Friedrich, *Beyond Good and Evil, Aphorism 95*, 1885, 48.

146. The dictation of symbolism, which seemed to underlie most of the Renaissance ballet (representing a certain province, mythical hero, natural element, royal figure etc.), has disappeared in 'Classical ballet'. The lack of the classical ballets symbolization of the external or transcendental results in a 'self-symbolization' or metamorphosis; for example, there is no symbolization of the white and black swan in *Swan Lake*, Odette *is* both swan and princess. If *Swan Lake* is symbolic, it is perhaps symbolic of certain *movements* (passion, fear, escape, lust, suicide...) as opposed to *forms* (monarchy, gods, narrative/myth, concepts such as virtue, nobility, and bravery).

147. The destruction and de-mystification of symbols and their holistic or transcendental guarantee can be seen to be nihilistic. The ballerina seems to be upholding a version of social behaviourism; that ideas and symbols do not exist as entities outside of the behaviours and expressions we use in order to represent or present them. A man (and a ballerina) knows pain by inferring what he has empirically seen in another Man's behaviour, and attributing it to himself.

148. Her entire discipline conflates the pathos of distance (the

distinction between both the narrative and her portrayal of the narrative, and the distance between her presence and the historical inscription of events.

149. This perpetual presence is etymologically and theatrically linked to the 'presence' of Renaissance ballet; an entire ballet being directed towards the 'presence' of the royal party and the ambassadors in whose honour the entertainment was staged. Clarke, Crisp, *Design for Ballet*, 1978, 10.

150. Nietzsche, Friedrich, 1844-1900, German philosopher who prophesised a de-valuation and re-valuation of all values in western Christian civilization.

151. Because there is nothing other than, or outside of, Man's perpetual experience of their present, one cannot further experience anything else. There is nothing other than the presence of one thing (or the one-ness of everything within the present…which amounts to the same thing).

152. In-fact, the schema that I am setting here, between our immediate understanding and our compliance towards the world of 'projects', that is, the world where we play-out our ambivalent desires, is not as straight forward or as causal as I have articulated it here. Our immediate understanding is full of desire from the get-go; the desire to understand (the inferral of its legitimacy), the mediation and presumptions fuelling even our most fundamental decisions and opinions.

 I use the term 'meaning' as a type of umbrella term which generates any form of desire, even if at first it would seem incongruous from traditional semantic notions of 'meaning'; for example sexual domination or self-harm. These vectors of desire, even if esoteric or immoral, have to assume a form of meaning (that is symbolism) or else they would collapse into a form of reflex or determinism. Where antagonism in the conscious subject lies, there too lies the

possibility of meaning.

153. Resolution in the sense that meaning must correspond with the desire it has been given (the identification of meaning as a meaning that has been identified). In this sense there is a type of soft tautology here. In many ways the object of meaning has always already been prescribed by an originary (deep social, historical construct) meaning in the first place. Most meaning corresponds back to the subject (is in-fact tied to the subject) as the subject auto-produces it, hence, almost all meaning in the normative sense is related to the development of the subject (as individual or collective) via identity. Have many of us corresponded the meaning "we are made up from various molecules and atoms" to a form of desire that constructs an on-going identity (in relation to a moral-ethical-normative-political activity within our everyday habits)? Equally, Hegel could be seen to equate meaning with the term 'synthesis' ; there is a thesis in conflict with an anti-thesis and the *meaning* arises through the cancellation of these terms for a new one or the totality of these terms. I am against this teleological inclination, and it probably stems from a further disagreement on the nature of time as an attempt at self-reconciliation as opposed to a site of active difference.

154. The ballerina is peculiarly modern because she affirms the 'slipping of the signifier' as many post-structuralist's contended; she affirms the infinity of interpretation over any master truths (capital T). Equally, the oscillation found in dance, between the search for identity and non-identity, is analogous to the modernist literature and philosophy of Existentialism. However, the 'affirmation' of these modernist traits (i.e. irreconcilability of language, disassociation, irony, existence preceding essence, non-existence of god) in Nietzsche's case, makes them absolute truths. Affirmation makes you accept the future, past and present

as fundamentally the same thing with equal value and hence, the impetus of existentialism (to find one's authentic self in the face of impending finitude/mortality), is eradicated. The ballerina may, then, have something of Nietzsche's *stronger* modernism in her, as well as the *weaker* modernism of writers riddled with torment, ambiguity and a sense of their own mortality.

155. There is something of this 'nude, 'bare' encounter with experience (a pre-mature meaning perhaps) in Emmanuel Levinas' description of the encounter with the face (the face-to-face relation), and this encounter is certainly not registered rationally or phenomenologically; there is no *Reason* involved, not in the Western Philosophical use of the term anyway.

156. I fear that this sounds too dualistic in the binary construction of subject and object. Within the subject, desire too can traverse the subjects intentions and appropriation of itself by the subject (I have called this neurosis – see preface).

157. Referencing the film Dark City, the main character Murdoch is under the impression that he was originally from a coastal town called Shell Beach but in locating it he finds it to be a simulacrum of a place that never existed. In finding this 'answer' to the question of his origin lacking, his desire surpasses the devastating truth and continues to pervade outwards across the ocean. Murdoch, however, directs his desire back into an object when he leaves with the female protagonist, and so it starts again, in different form.

158. Meaning as a despotic social construction that underpins and prescribes other practices.

159. Literally meaning "Storm and Drive", it was seen as a proto-Romantic movement in reaction to the rationalism imposed by the enlightenment.

160. The unobjectifiable, un-representational sensation of music has been metaphysically reified as an absolute, inexhaustible desire by philosophers such as Schopenhauer and Nietzsche and although I am more prone to point to desire empirically (perception itself being a form of desire to manifest and reflect oneself symbolically) it is the extraction of the human figure/embodiment that makes music in a strange sense un-desiring; without the consequence of directly stimulating the subject, without the need of a voyeur of the subject, without the finitude of the tragic subject, mainly without the possibility of effecting a subject to do something tragic (as he is not innately tied within the music). There needs to be an elusive 'cause' and 'effect' (music – man) in order for the synthesis of desire, suspension of disbelief, the scene and the obscene to generate. It is perhaps a question of where the 'spectacle' is located which allows desire to focus in and manifest itself as futility, as Jean Baudrillard states "the 'look' is simply this: I exist, I am here, I am an image, look at me, look, look!" (Baudrillard Live, 41, 1993) which I feel music, although having presence, lacks the conditions for presence (the human voyeur).

161. Did the so-called Logical Positivists realise this – counting only on scientific, empirical proof instead?

162. The suspension of reality via the imaginary, the suspension of disbelief being the metaphorical suspension of time itself etc.

163. How many times have we seen men reify poetry by giving it a mystical origin i.e "poetry attains a seductive character precisely because it transcends the reductivism of science and allows us to intuit our irreducible essence"? Some even call this elusive irreducibility 'Truth' which seems contradictory as poetry is then being reduced to the criteria of a truth.

164. Ontic – the plain facts of something's existence. What 'is' regardless of any ontological purchase (i.e its nature or meaning).

165. There are infinite examples of this but here is two; Paul's conversion is a realisation that his older constructions of meaning are in conflict with his belief in Christ. He may have also realised that what faith meant to Paul was internally conflicting with the values of the Pharisees that he was earlier practicing. Baruch Spinoza the philosopher (amongst other things) had an intense enthusiasm with the notion of Ethics in relation to his Jewish social community to the point where he traversed the pre-existing religious Jewish values and constructed values in conflict with it (pantheism, an "authentic" Jewish religious attitude contra the orthodox attitude and the Hebrew bible).

166. Equally, we could argue that the analytic proofs of Kant are simply linguistic tautologies ("a triangle has three sides") and that the sensible intuitions such as 'cause' and 'effect' are actually inferred through experience, or as David Hume described it, learnt through 'habit' as conjunction.

167. The qualities of an object that do not exist in the phenomenal realm of space and time, or the qualities of an entity that subsist regardless of the human's presence or concepts of the understanding (see Kant).

168. Shakespeare eludes to the notion that a name (nominalism) holds no significance in relation to the Being of the name, and that a certain Being would pervade regardless of what we name it and how we construct it as such and such – "What's in a name? That which we call a rose by any other name would smell as sweet" (Romeo and Juliet). We could epitomize this notion and suggest that the world is one substance and that, if all nominated attributes lead to this same one substance, then we would do better in suggesting that all the entities in this same one world are equivalent to

each other and have the same identity. We could never be brave enough to state that something is more or less important than anything else, because its *importance* is *imported* through other things. We believe that nominalism has a very real consequence that cannot be subordinated to the unwavering pre-reflexive 'being' of a thing. We believe that the word creates a quality of *difference* (even if solely linguistic).

169. Interesting how Hegel contrasts the familiar with the encounter of the concept. For Hegel, familiarity is precisely that which is the unemployment of knowing; "Subject and object, God, nature, understanding, sensibility and so on, are uncritically taken for granted as familiar, established as valid and made into fixed points for starting and stopping. While these remain unmoved, the knowing activity moves back and forth between them thus moving only on their surface".

170. I am a conservative when it comes to *Meaning*. Simply put, it is because I do not want to confer everything as meaningful, or, leave meaning as a matter of opinion/perspective. It is a dangerous territory when everything becomes meaningful. And equally, if meaning is a matter of opinion or inclination then we are basically saying that there is no power of beauty/meaning outside of ourselves, inspiring us, seducing us.

171. This loneliness in meaning is possibly historical, in the sense that there is simply a paucity of sensitive men (or men of sensibility) in this day and age to share this encounter with. Religious people are lucky enough to still have this sensation of the shared secrecy of meaning; in prayer.

172. Kierkegaard, Soren, *Journals, IV A 97.*

173. Kierkegaard, Soren, *The Seducer's Diary*, 1848.

174. I am creating a dichotomy between thinking an object/content specifically (singularly) and assuming an object/

context ignorantly or epiphenomenally. However, the singularity of the object needs to be considered too, as alien to thought; this is what creates the encounter. In this sense I believe all generic sets and classes to be un-true; every flower is unique and holds its own authentic capacity to over-ride what is commonly considered to be 'a rose'.

175. Thank you Alain Badiou.

176. This is evidence that I am not a nihilist to the highest degree yet (inhuman nihilism). Nihilism is in-fact the tightrope that leads man across into the inhuman (the overman).

177. Martin Heidegger, *Being and Time*, 1927.

178. Ludwig Wittgenstein's 'language-game' theory moves from diagnosing meaning as a semantic association with words which correspond to objects/experiences, to meaning as generative of the use of words in a certain context, a certain 'game'.

179. Platonic meaning could be construed as platonic love; an inclination or discipline that orients human love to the Divine or supernatural. This type of Platonic meaning could not be practiced if all meaning is immanent (hence non divine); the gap between the natural and supernatural cannot be discerned hence executed. The gap between the non-ideal form of something (say a tree) and the ideal form (perfect tree-ness) cannot be practiced either, as this distinction is conflated into each other. No passage of meaning can be attained.

180. More accurately we are in-fact distracted 'in' it.

181. We can see this in the 'projects' of *Dasein* (being-in-the-world) in Heidegger's account of human existence. For Heidegger "Being is inherently meaningful" and is oriented through projects (e.g. civility, society) towards meaning (for others and towards oneself). However, on the contrary, *Being* may even be the *opposite* of meaning: the

harbinger of non-meaning; a dog may whimper in the cold, or before being shot, but man has the power to be indifferent to death in order to refuse its meaning. A man has once muttered underneath his breath, before being hung, "what hanging? I care nothing for it". William Udale 23rd March 1827 Lincoln, England. The power of indifference or non-meaning may be a specifically human quality. However, what William Udale may be expressing is that even though his life is ending, his now immanent sense of mortality and ephemerality of life does not constitute a meaning for him in relation to the event of his death. His own personal meanings have nothing to do with his death or hanging. This is a triumph is it not?

182. Similar to how Schoenberg made traditional tonal music 'impossible' after his 12-tone system. Similar to how Walter Benjamin made egalitarian communication 'impossible' after he stated that "there is no document of civilization which is not at the same time a document of barbarism". Similar to how Theodor Adorno contended that poetry is 'impossible' after Auschwitz.

183. However, this does not denounce the *encounter* itself (the 'event' as Alain Badiou so convincingly articulates) as simply a type of secondary realization of a primary quality. The 'event' of the encounter is 'concrete'; the Idea is 'abstract'. Why? The event is a chance procedure; it cannot be symbolically coded prior to its taking-place. Meaning and feeling are processes of symbolically coding a unique experience. A concrete encounter is immediately trans-coded into a social relation, that is, a symbolic relation, with further symbolic connotations; of how to act, etiquette, the symbolic coding of 'romance' whenever a man privately encounters a woman. The context in which a chance encounter plays itself out is already symbolically coded; speed dating or internet dating could be seen as the

epitome of such symbolically coded contexts, where chance and transgression are vanquished from the encounter.

184. Is it not possible to feel a sense of Hegelian alienation from this Aristotelian world-view? Equally a Cartesian duality of thinking substance/extended substance could re-emerge.

185. If we take the term reality in the same vein as scientific realism (the world described by science, independent of what we may take it to be) then the remit of human representation and seduction must necessarily stem from a human construction that sets itself apart from this scientific realism. This *setting* apart is a type of *staging* of normative meaning in an otherwise meaningless world. It creates a simulation of possible meanings (signs, conventions, art, ballet, romance, music etc) and a subject who may possibly desire these meanings (who necessarily will because he himself is constituted by the instantiation of these meanings within his culture).

186. The victory of the subject within ballet will be the impossibility of traditional ballet (within traditional ballet the ballerina is slave to the narrative, mimed passages and steps of the overall expression).

187. The ballerina personifies the fundamental conflict; the need for the subject to make herself meaningful -almost against the clutter of objects (like how the ballerina signals distance, detachment or repudiation of situations and men within the ballet) – yet in the face of objects that will eventually determine her (as X or for X). This for me is seduction.

188. These three durations have incongruous demands made upon them (different fatalities); social, historical and psychological. The social duration of the voyeur, the historical duration of an older piece of music competing with a new or 'deeper present' (Hegel), the dancer's individual duration which could be a non-time (of losing

herself within the dance) or alternatively, one fraught with pressure and self-consciousness. Also, these three elements do not exist together in harmony but, rather, are *forced* to act with one another in a pseudo-naturalistic artifice. This is another tragic incongruence; the spectator could die from a heart-attack and the ballerina would carry-on, the ballerina could suffer from an aneurysm and her dance would still hold her for seconds afterwards, and the voyeur would make this literal death figurative within the dance, the music (classical) may have been made redundant through its subordination to dance (tempo, lyrical qualities, mime, or narrative). There is no equality within the encounter here.

189. The Idea; eternal in the sense that new physical and aesthetic configurations will always expand the definition of what ballet is. Abstract; in the sense that one must invest in ballet's abstract quality an Idea of it that has not been fully exhausted yet.

190. This is very simple; movement gives fatality to the beautiful by imbuing the quality of the beautiful with a price (something at stake). Movement gives beauty a decision; its movement into disappearance, its movement into dangerous new territories, which might add to or change the quality of beauty itself. The vulnerable existence of beauty is its fatality.

191. And Form for Plato is something that 'always is', distinct from the flux of 'unreasoning sense perception' as opposed to the immutable reason of unchangeables.

192. Bergson, Henri, *Creative Evolution*, 1944, 328

193. German Romantic movement, in many ways opposed to the enlightenment project (or at least its mobilization of *Reason*); literally translated in English as 'storm and drive'.

194. A movement we can see within the figures of Karl Marx, Friedrich Nietzsche, Gilles Deleuze and Nick Land.

195. "Noverre called for radical change to free dance from what he saw as excessive artificiality and a denial of naturalism. He is the best-known publicist for the theories of the *ballet d' action*. This was the ideal of dramatic ballet in which the story was carried forward through the dancing and not divorced from it in mimed passages." Clarke, Mary and Crisp, Clement, *Design for Ballet*. Jean-Georges Noverre (1727-1810)

196. The rolling of the *bourée*; quick, even movements often done on pointe which gives the look of gliding.

197. I am sceptical of the notion that the dialectic cannot be found in the natural sciences (the claim that symbiosis radically changes the conceptual oppositions between the 'Law of the Two' in dialectics). Surely an insect is conditioned to notice the difference between prey and predator, food and non-food, security and danger? Perhaps in Chemistry we see a fundamental dialectic everywhere in the bonds and reactions between elements.

198. Note that this 'humility' does not primarily point to the act or situation that has humiliated the subject. When one is truly humiliated, one realizes that it has nothing to do with its cause; the humiliated man is too busy feeling his humiliation to care about its superficial origin in social relations etc. Humiliation is a subjective embodiment; its intensity is in the individuals own self-endurance/purification of its quality. Humiliation will never be objective, and, perhaps, more controversially, it will never be *relative* but *absolute*.

199. Adorno and Horkheimer, *Dialectic Of Enlightenment*, 2002:155.

200. See Walter Benjamin's famous essay *Art in the Age of its Technological Reproducibility*.

201. If meaning outside of use is to exist then we must fabricate it ourselves (without any immediate use apart from the desire to make meaningful things outside of use). We can

also do this by remembering the futility of older fabrications of meanings or how the use of older meanings become redundant and hence possible as renewed sites for uselessness, idleness, dogma etc. Remembering and lament are in a sense useless passages to these meanings. Why? Because if it were useful it would be familiar and hence we would not need to remember it. Remembering stems from attaining something that has lost use. Equally we use remembering when we wish to renew older forms of meaning that have since lost their use.

202. When we have previously given meaning to an object we have given it to it 'as-use' (the meaning of the object is what it does, the utility supplanting any other quality i.e. X means X, or X does specifically X, or X is X). Meaning is allowed to be more when we stop the economy of uses from dominating it.

203. I appreciate the artistic objectification of a feeling or moment (the artefact) but not the social subordination of fatal objects into the pleasurable (such is the castle and the ballerina) because the indifference to subjective meaning within the social, and the constant pleasure of life found in the sociality of objects, are fundamentally opposed to the unique difference of the artefact and the awareness of death that generates the vulnerability of life in appreciating the arts.

204. Then again, there is something feminine about the need to keep the appearance of something (or the thing itself) together (the domesticity of the castle). The ruin's openness to its entropy is perhaps masculine.

205. Subjectivation or subjectification is a philosophical concept coined by Michel Foucault and elaborated by Gilles Deleuze and Felix Guattari and refers to the construction of the individual subject.

206. Playing on the affiliation this term has with the word awful.

I believe they are extremely close to one another in meaning.

207. Ray Brassier.

208. There is, necessarily, this paradox between sharing and the personal secret…it is based on the *prayer*.

209. In this sense, beauty is sublime; larger and more powerful than us, giving us the sense of our own infinitesimal existence. The question is then; how have *we* made something larger and more powerful than ourselves? The two answers to this are found within this text; when man thinks the universal and thinks archaic history outside of the immediate remit of one's historical-cultural existence, then one confronts two epic forces. The first being spatial (the existence of an ever-extending concept of the universal) and the second being temporal (the weight of history and its building up of meaning through myth, subsistence, death). These are not transcendental qualities in the supernatural or metaphysical sense, but simply transcend the immediate empiricism of human sense-making.

210. God made man in his own artistic image.

211. Benjamin, Walter, *The Arcades Project, 1999*, pg. 471.

212. Winged Victory of Samothrace (or alternatively titled *Nike of Samothrace*) was created in 190 BC and is presented at the head of the sweeping Daru staircase within the Louvre.

213. Matthew 21: 12 – Jesus entered the temple area and drove out all who were buying and selling there. He overturned the table of the money changers and the benches of those selling doves. Matthew 23:17 – Fools and blind men! Which is greater, the gold or the temple, which sanctifies the gold?

214. We must affirm the infinity of qualities within the finite determinations; there are infinite qualities within the artwork, an artwork could even attempt to express this very infinity, but it is not an infinity of time or sustain-

ability of form (eternity).

215. This does not make the encounter arbitrary, as there still remains only one encounter, whatever time it takes place. I am simply stating that it will always have that same effect.

216. "The absence of reason restricts the animals to representations of perception immediately present to them in time, in other words to real objects. We on the other hand, by virtue of knowledge in the abstract, comprehend not only the narrow and actual present, but also the whole past and future together with the wide realm of possibility". Schopenhauer, Arthur, *The World as Will and Representation*, 1:84

217. We could not in-fact precisely because finitude is not there to generate death – the harbinger of beauty.

218. Man laments life in the face of death to generate beauty in the first act. In the second act (after ones death) beauty returns to lament death itself.

219. Badiou, Alain, *The Adventure of French Philosophy*, 341; in reference to the philosophy of Gilles Deleuze.

220. Even though beauty is an Ideal in this sense (from the Idea), there will always be artefacts that will have been made by other civilizations and peoples, with the Idea of beauty 'in-mind' (but not primarily in *my* mind) and hence, even without personally thinking and constituting beauty, it can still pervade from an external source. We can encounter it through these other people and their artefacts...their faith in the beautiful. One *trusts* their idea of beauty...one really *knows* it in the heart. Something in *this* beauty relates to a notion *you* share of beauty. One must *believe* this. Is this belief religious?

221. In a sense all abstraction is destruction of the particular. Beauty's abstract quality is the destruction of the particular (subject or object).

222. Is it because we began to see this vista as a *lack* or *absence*?

Bibliography

In order of appearance:

Barthes, Roland, *Camera Lucida:Reflections on Photography*, 1993, Random House

Nietzsche, Friedrich, *Beyond Good and Evil : Prelude to a Philosophy of the Future*, 1997, Dover Publications, INC.

Georges Bataille, *Literature and Evil*, 1976, Marion Boyars Publishers Ltd

Mark Fisher, *Capitalist Realism:Is There No Alternative?*, Zero Books, 2009

Heidegger, Martin, *Being and Time*, Blackwell Publishing, 1962

Deleuzian Events: Writing – History, 2009, LIT Verlag

Hegel,G.W.F, *Phenomenology of Spirit*, Oxford University Press, 1976

Wittgenstein, Ludwig, *Philosophical Investigations*, Blackwell (4th Edition), 2009

Melville, Herman, Bartleby, *The Scrivener: A Story of Wall Street*, CreateSpace 2013

Mike Gane, *Baudrillard Live: Selected Interviews with Jean Baudrillard*, Routledge, 1993

Bataille, Georges, *The Impossible*, City Lights Publishing, 2001

Freud, Sigmund, *The Uncanny (Das Unheimliche)*, Penguin Classics, 2003

Deleuze, Gilles, Anti-Oedipus: *Capitalism and Schizophrenia*, Penguin Classics, 2009

Hume, David, *An Enquiry Concerning Human Understanding*, Cambridge University Press, 2007

Meillassoux, Quentin, *After Finitude*, Bloomsbury, 2012

Badiou, Alain, *Being and Event*, Bloomsbury, 2007

Deleuze, Gilles, *Difference and Repetition*, Continuum, 2004

Hobbes, Thomas, *The Leviathan*, Broadview Press, 2011

Nietzsche, Friedrich, *Ecce Homo: How To Become What You Are*, Oxford University Press, 2007

Sartre, Jean-Paul, *Being and Nothingness: An Essay on Phenomenological Ontology*, Taylor & Francis, 2013

Wittgenstein, Ludwig, *Tractatus-logico-philosophicus*, Continuum, 2006

F.W.J. Schelling, *Ideas for a Philosophy of Nature*, Cambridge University Press, 1988

Schopenhauer, Arthur, *The World as Will and Representation*: Volume 1, Cambridge University Press, 2010

Nietzsche, Friedrich, *On the Genealogy of Morals*, Oxford University Press, 1996

Nietzsche, Friedrich, *The Anti-Christ, Ecce Homo, Twilight of the Idols*, Cambridge University Press, 2005

Descartes, Rene, *Meditations on First Philosophy*, Cambridge University Press, 1996

Le Clezio. J.M.G, *The Flood*, Penguin Classics, 2008

Wilson, Colin, *The Outsider*, Pan books LTD, 1970

Farrell Fox, Nik, *The New Sartre: Explorations in Postmodernism*, Continuum, 2003

Dostoevsky, Fyodor, *Demons*, Penguin Classics, 2008

Giorgio Agamben, *Homo Sacer: Sovereign Power and Bare Life*, Meridian:Crossing Aesthetics, Stanford University Press, 1998

Dostoevsky, Fyodor, *Notes from the Underground* , Dover Thrift Editions, 1992

Lorenz, Edward, *The Essence of Chaos*, University of Washington Press, 1995

Adorno, Theodor.W, *Prisms*, M.I.T Press, 1981

Nijinsky, Vaslav, *Diary of Vaslav Nijinsky*, Gollancz, 1937,

Schopenhauer, Arthur, *Parerga and Paralipomena*, Cambridge University Press, 2014

Montaigne, Michel De, *Complete Essays*, Penguin Classics, 1993

Clarke, Mary and Crisp, Clement, *Design for Ballet*, Studio Vista, 1978

Hand, Sean, *The Levinas Reader*, Wiley-Blackwell, 1989

Proyas, Alex, *Dark City*, New Line Cinema (USA), 1998

Bergson, Henri, *Matter and Memory*, MIT Press, (New Edition) 1991

Kierkegaard, Soren, *The Seducer's Diary*, Penguin Classics, 2007

Bergson, Henri, *Creative Evolution*, CreateSpace, 2014

Land, Nick, *The Thirst for Annihilation*: *Georges Bataille and Virulent Nihilism*, Routledge, 1992

Adorno, Theodor.W. and Horkheimer, Max, *Dialectic Of Enlightenment*, Verso Books, 1997

Benjamin, Walter, *Selected Writings 4: 1938-1940*, Harvard University Press (New Edition), 2006

Brassier, Ray, *Nihil Unbound*, Palgrave Macmillan, 2007

Badiou, Alain, *The Adventure of French Philosophy*, Verso, 2012

Kant, Immanuel, *Critique of Pure Reason*, Penguin Classics (Revised Edition), 2007

Kant, Immanuel, *Crltique of Judgement*, Hackett Publishing, 1987

Levi-Strauss, Claude, *The Savage Mind*, University of Chicago Press, 1966

Derrida, Jacques, *Structure, Sign and Play: In the Discourse of the Human Sciences*, University of Chicago Press, 1978

Harman, Graham, *Towards Speculative Realism*: Essays and Lectures, Zero Books, 2010

BOOKS

Iff Books is interested in ideas and reasoning. It publishes
material on science, philosophy and law. Iff Books aims to work
with authors and titles that augment our understanding of the
human condition, society and civilisation, and the world or
universe in which we live.